THE BLACK AND WHITE HANDBOOK

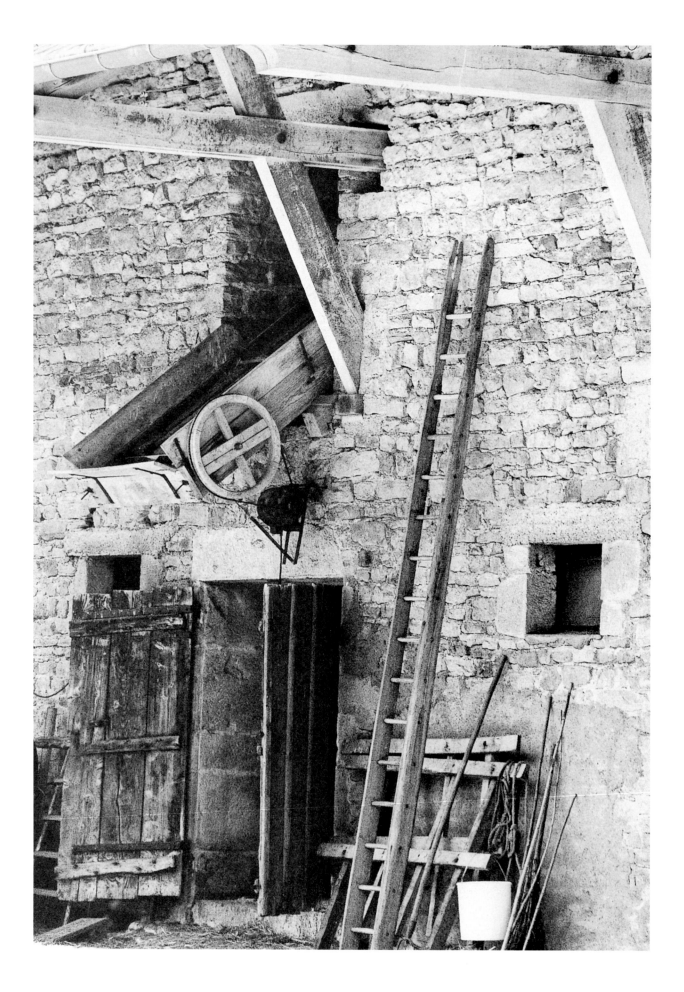

THE BLACK AND WHITE HANDBOOK

THE ULTIMATE GUIDE TO MONOCHROME TECHNIQUES

Roger Hicks and Frances Schultz

David & Charles

FOR MIKE NEWTON

A DAVID & CHARLES BOOK

First published in the UK in 1997
First published in paperback in 2000
Reprinted 2004

A catalogue record for this book is available from the
British Library.

ISBN 0 7153 0572 7 hardback
ISBN 0 7153 1124 7 paperback

Printed in Singapore by KHL Printing Co Pte Ltd
for David & Charles
Brunel House Newton Abbot Devon

PAGE 2 **TEMPLE, Hagar Qim, Malta**
*Infra-red – this was shot on Maco 820c through an R72 filter – is
(perhaps) about as black-and-white as it gets, with dramatic contrasts
but also with the potential for considerable subtlety.*
Leica M2, 35/1.4 Summilux (RWH)

CONTENTS

INTRODUCTION
AND ACKNOWLEDGEMENTS

There is an old saying that you always teach what you most need to learn, and that has certainly been the case with this book. In more than 30 years' photography, we thought we had learned quite a lot about monochrome, but when it came to writing it all down we began to realise where the gaps lay – and just how extensive some of them were.

Our intention was to provide some of the technical background to black and white photography, cutting through as many myths as possible and explaining how basic, theoretical considerations have real, everyday implications. In order to do this, we had to think hard about some of the things which in the past we had simply accepted without question, and about things which we had hitherto skirted because we found them too difficult.

We can say without hesitation that making this effort has improved our own photography markedly: we can make better negatives and prints, and if things go wrong, we know why. Usually. What is more, we believe that anyone can do the same – all you need is enthusiasm. This is not a workbook, with exercises, and still less is it a Zone text with exhaustive instructions on how to test anything and everything. Rather, it is a book which we hope will move you to challenge some of your own assumptions; to try some new ideas, or re-explore old ones; and above all, to get out and take more pictures.

A very great deal of what we learned came from two people, Mike Gristwood and Tony Johnson of Ilford Ltd, whose technical advice was invaluable: we cannot thank them enough. We should also like to thank Ed Buziak, editor of *Darkroom User*, Tim Goldsmith of Paterson International, and Bob Shell, editor of *Shutterbug*, who again gave valuable advice and encouragement after reading early drafts of the manuscript. The usual disclaimer applies: all remaining errors (and especially the pigheaded ones) are ours, not theirs.

Moving on to practical support, Ilford Ltd was generous with film, and John Herlinger was extremely generous both with his own Fotospeed materials and with paper from Sterling, which he imports. Pat Wallace kindly gave us a good deal of Polaroid material, including their long-established but often underrated pos/neg material. People often assume that journalists and authors use whatever is free, but this is not true: unless it's the best, we just cannot afford to use it, free or at any price. Kodak kindly provided samples of film and paper, as did Charlie Satter of Omega Satter, US importers of Forte materials and Pébéo dyes (which we also used). Kentmere and Luminos kindly provided samples of paper, as did Agfa, who also gave us some of their remarkable Scala transparency film. Veronica Cass gave us a set of her excellent hand-colouring oils, and Tonya Evatt's invaluable SpotPens disposed of numerous dust spots and other blemishes.

Paterson International loaned us Gossen meters and gave us all sorts of small but surprisingly useful

darkroom gadgets, as well as materials. Graham Wainwright persuaded us of the merits of four-blade easels with a Photon Beard 16×20in (40×50cm) – truly a Rolls Royce among easels – and Dr Ross of RH Designs loaned us his remarkable and surprisingly affordable Analyser for determining exposure and paper grade. Robin Whetton of Nova lent us additional darkroom equipment on top of our own three Nova tanks – we had already been using them for years – and our negatives are stored (as they have long been) in Print File sleeves and cleaned with Kinetronics antistatic brushes.

Finally, we would like to thank the members of the Photo Forum on Compuserve, both for specific information and for helping us to gauge the 'feel' of photography today. It would be invidious to single out those who were particularly helpful, but then again, it would be equally invidious to single out those who were particularly unhelpful. We must, however, thank Mike Wilmer, the SysOp, to whom we are all beholden. Look for us in various sections of the Forum (Go Photofourm – and yes, it is spelled like that), including, of course, *Shutterbug* magazine.

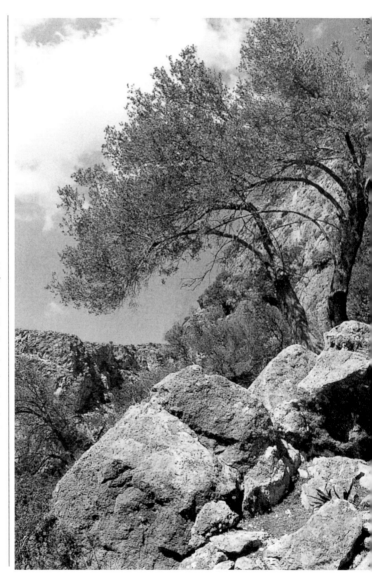

TREE, Crete
This isn't a large-format shot: it's 35mm, but used like large format, with a tripod, filtration, and plenty of time to compose. We had just walked several miles, up one canyon, down another, and half-way back again, and without a tripod the picture would have been considerably less sharp. Nikon F, 35mm f/2.8 PC-Nikkor, Ilford XP2. (RWH)

WHY MONOCHROME?

A well-made black and white picture can be inherently beautiful. This, more than anything, will ensure the continued survival of monochrome photography; and it explains why, after decades as the poor relation of colour, monochrome has now become a premium medium which is widely used by fine-art photographers and well regarded for upmarket advertising campaigns.

Increasingly, a monochrome picture has novelty value. Not so long ago, monochrome photographs were the norm, and colour was the novelty.

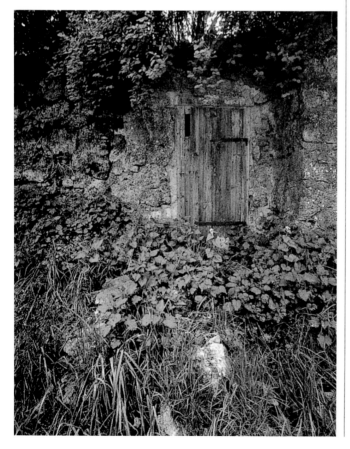

Newspapers were printed exclusively in black and white, and the vast majority of people watched black and white television. Today, the exact opposite is true, and if we see a black and white movie on the television, or better still, on a cinema screen, it is hard not to be struck by the wonderfully pearly quality of much black and white cinematography. There is a tremendous tonal range, with details in the shadows and the highlights which simply cannot be captured in colour. This is (or can be) as true of a still picture as it is of a movie.

Monochrome and 'authenticity'
Long after colour became commonplace, 'hard' news tended to be reported in black and white because colour films were too slow, had too little latitude, took too long to process, and could not be transmitted on the wire machines of the day. Because of this, monochrome is to this day perceived by many as more 'honest' or 'authentic' than colour photography, and this can be exploited by the photographer. Of course the camera can lie – indeed, a case can be made for saying that it always lies – but just as we trust some people more than others, we trust some pictures more than others.

'Less is more'
Because monochrome provides fewer obvious variables for the photographer to play with than colour, it gives greater scope for skill, subtlety and elegance

DOOR, Bavaria
By removing the dimension of colour, black and white can concentrate attention on texture and shape. You can almost smell the damp earth and the musty stone. See also page 178. Nikon F, 35mm f/2.8 PC-Nikkor, Foma 100. (FES)

▶ WINDOW, rural France
There is a timelessness about black and white which is particularly well suited to old buildings, weathered wood, rusted iron... This was shot in Burgundy. Nikon F, 70–210mm f/2.8 Sigma Apo Zoom, Ilford XP2. (FES)

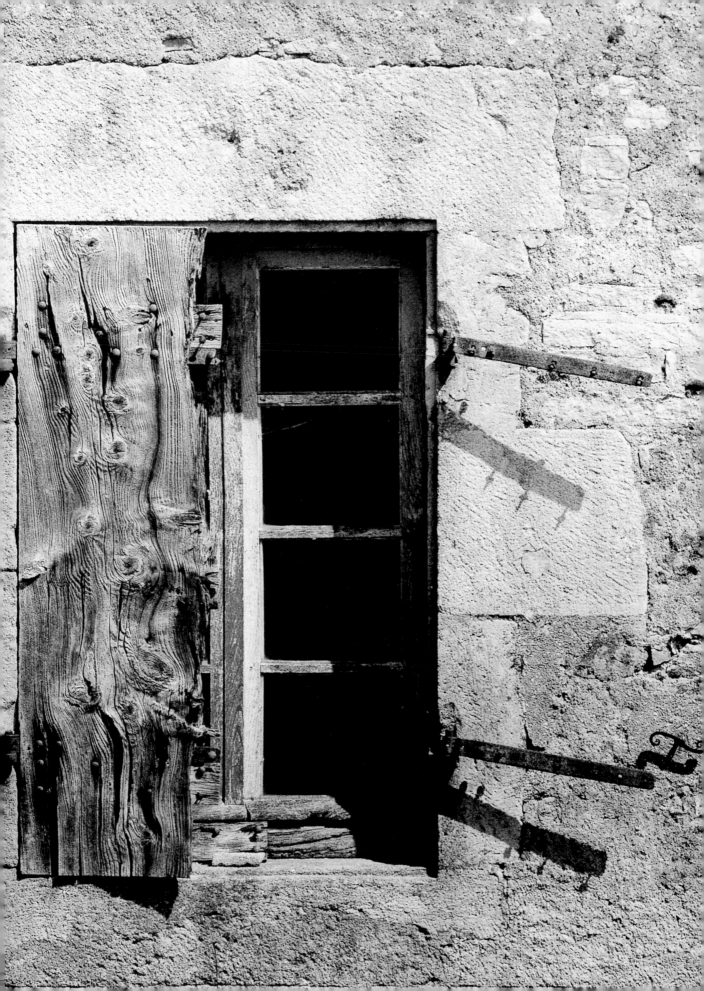

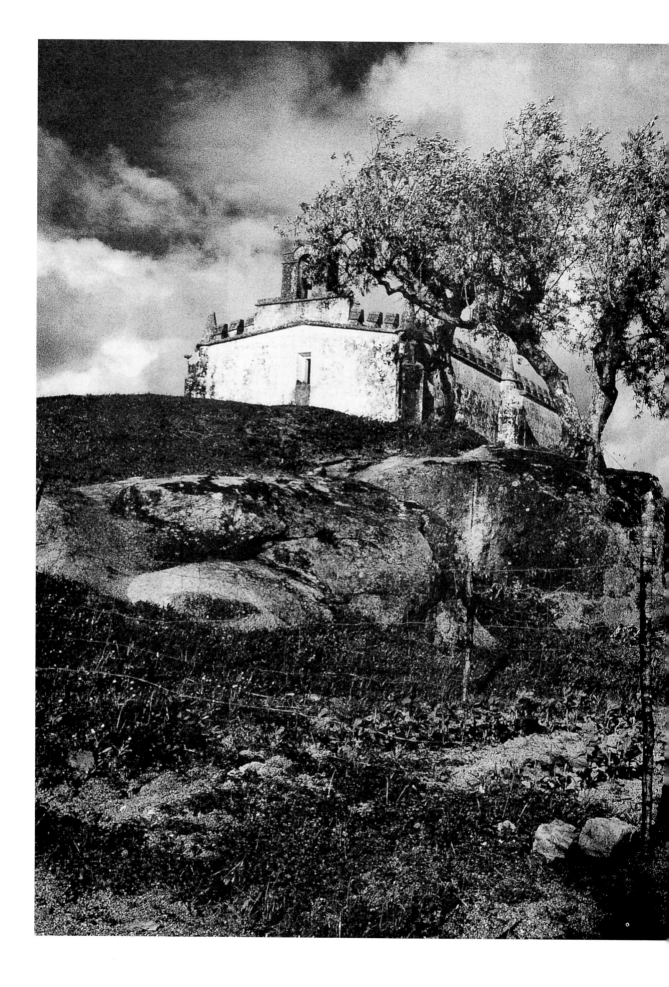

PAGES 10–11 **ABANDONED CHAPEL, Portugal**

The light was wonderful: fast-moving, heavy clouds, with the sun breaking through frequently but briefly. Colour could never capture this sort of tonal range. Nikon F, 35mm f/2.8 PC-Nikkor, Ilford XP2 with heavy red filter. (FES)

within that range. It is rather like the difference between billiards and snooker, or between the ancient Japanese game of go and chess. This is why colour is sometimes decried as 'too real' or 'too literal'. On one level, this is a completely meaningless criticism:

Photo-Realism is a recognised school of painting, and 'Realism' (often qualified with another word, such as 'New Realism') has been a part of the name of many schools or styles of photography. On another level, the complaint that colour is 'too real' reflects how it removes certain of the freedoms of technique which are available in monochrome.

A dedicated advocate of colour might well point to those techniques which are available in colour but not in monochrome, such as the counterpoint of colours and the use of colour harmony, but our aim in this book is to be inclusive rather than exclusive. It is true that there are some things which can be done in colour but not in monochrome. If you want to do them, then shoot colour. But equally, there are other things which you can do in monochrome but not in colour. If you want to do these, then shoot monochrome. It is fruitless to stake out your territory and then decry the other photographer's choice simply because it is not your own.

COMMERCIAL ADVANTAGES

As well as what might be called the aesthetic advantages, listed above, monochrome enjoys a major commercial advantage: as a rule, it is a lot cheaper to print monochrome in a book or magazine than it is to print colour.

For basic black and white reproduction, you need one piece of printing film, one printing plate, and one pass through the printing press. For colour, you need four pieces of printing film, four plates, and four passes through the press (or a big, expensive four-colour press which will print in a single pass) – and unless the printer overseeing the press is highly skilled, the colours can go all over the place. No one who has ever watched a master printer overseeing a four-colour press can doubt that printing is as much an art as a science.

Admittedly, the finest monochrome printing is done using four-colour presses or in

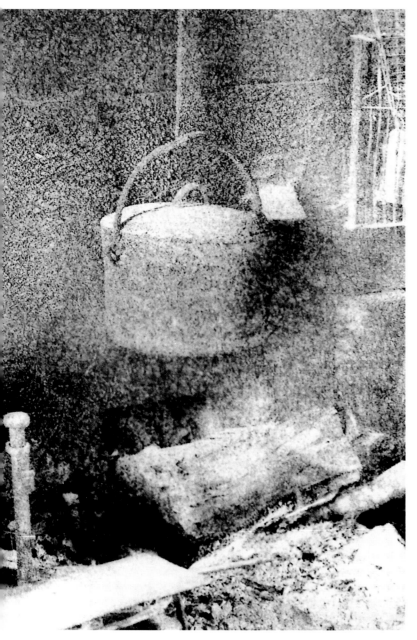

POT AND FIREPLACE, Burgundy

An ancient soup kettle, crusted with soot, above a slow-smouldering fire makes a timeless picture. This looks like something William Henry Fox Talbot might have shot – but the Calotype look was achieved by sandwiching a 35mm negative with a paper neg bag and printing through that. Nikon F, 70–210mm f/2.8 Sigma Apo, Ilford XP2. (FES)

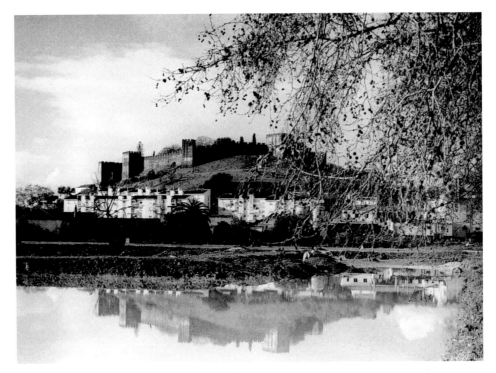

FORTRESS, Silves, Portugal
The device of including a tree for depth may be a trifle hackneyed, but without it this picture would be somewhat flat and dull. The attraction lies in the tonality.
Linhof Technika IV, 105mm f/3.5 Schneider Xenar, Ilford XP2. (FES)

duotone, where one colour is used for the highlights and the other for the shadows, but single-colour printing remains the norm: with the exception of the last part of this book, all reproductions in these pages are single-colour. There is more information about photomechanical reproduction, and about printing for reproduction, on pages 186 and 187.

ARCHIVAL ADVANTAGES

Another practical consideration, quite different from the one above, is that monochrome can be far longer-lasting than colour: we have all seen colour pictures which have faded most horribly, even after making allowance for the fact that colour dyes have improved vastly over the years. If we could see a 1950s colour print which was perfectly preserved and perfectly acceptable when it was made, we might still find it very flat and dull by modern standards.

Although a poorly processed monochrome print can fade and discolour very rapidly, a properly processed print can last for a very long time indeed: at least for many decades, and with modest care in storage, for at least a century or two. By 'modest care' we mean placed in an acid-free album, or hung in a reasonably gloomy corridor or trophy room in an environment with reasonably fresh air: even a well-processed print is vulnerable to oxidising pollutants, principally ozone and the peroxides and oxides of

nitrogen. Intriguingly, some recent Fuji research indicates that well-washed prints are more susceptible to this sort of degradation than those which are not 'archivally' washed.

Add appropriate toning (see Chapter 16) and the life of the print is measured in substantial fractions of a millennium. Go to the limit and make a platinum print on rag paper, and the picture should last as long as the paper itself: around several thousand years, barring mishap.

Admittedly, it may smack of hubris to want your pictures to last beyond your own lifetime. There is, however, a certain fascination in looking at portraits of ancestors and suddenly seeing as a youth a person whom you had only ever known as an old man, or recognising your own face (or that of a niece or cousin) in the portrait of a great-great-grandmother who died before you were born. Perhaps more to the point, it is not unreasonable to want your pictures to survive without significant deterioration for your own lifetime at least, which at present is the exception rather than the rule for colour prints. Some colour processes, such as Ilfochrome Classic (formerly Cibachrome) or trichrome Carbro or dye transfer, are much more permanent than conventional substantive materials, but at the time of writing they are comparatively rare and cost much more than most people are willing to pay.

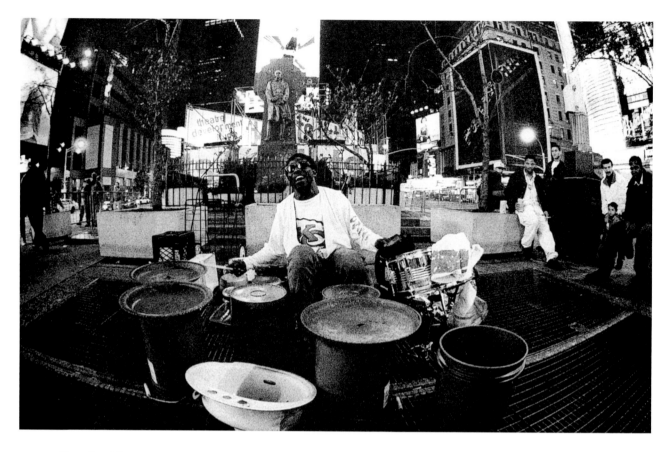

Negative life

Although a print will often deteriorate before a negative, the difference in lifespan between colour and monochrome negatives can again be an order of magnitude or more. Current wisdom is that colour negatives will last a very long time indeed – many decades – if they are refrigerated in a humidity-controlled environment, but how many colour negatives are actually kept in this way? If they are not, then detectable fading may well occur in only 20 or 30 years, even under average conditions.

This may seem a long time to some, but when a parent has been dead for 30 years, it is not too much to ask that you should be able to reprint their portrait. What is worse, differential fading may result in 'crossed curves', where it is impossible to guarantee good colours in both the highlights and the shadows: losing a colour cast in the shadows will introduce one in the highlights, and vice versa.

By contrast, countless millions of monochrome negatives stored under average conditions have already survived for decades, and if there is any fading it can be easily compensated for by increasing the contrast of the printing paper. Indeed, the durability

DRUMMER, New York City

New York City offers endless street theatre and entertainers. This is an 'available darkness' shot on Kodak TMZ rated at EI 12,500 – an option which simply is not available in colour. Nikon F, 15mm f/2.8 Sigma fish-eye (wide open). (FES)

of the film base may be of more concern than that of the emulsion (see page 35).

DARKROOM COSTS

A practical argument, which is of more interest to the amateur than to the professional, is that a mono-chrome darkroom is cheaper to set up and to run than a colour darkroom – and monochrome printing is a good deal easier, too. Admittedly, this advantage is decreasing all the time, but it still remains.

There is a professional counter-argument to this, however. For reproduction in colour, most advertising and other editorial photographers normally use colour transparency film, while newspaper photographers normally shoot colour negative. Although colour transparency film and processing cost more than monochrome film and processing, the additional expense stops there. To make a monochrome

OLD NEGATIVES
Some of these negatives date from the 1930s; they were shot by the late Art Schultz, Frances' father, on 120, 116 and quarter-plate. You can still print them today: as we were working on this book, we saw an old quarter-plate enlarger for sale for less than the price of half a dozen rolls of Kodachrome.

print, on the other hand, involves further expenditure of both time and materials. It is no exaggeration to say that the true cost of producing three or four 8×10in black and white prints, taking account of the printer's time at a reasonable hourly rate, is considerably more than shooting a roll of 35mm slide film or two or three sheets of 4×5in colour. To an amateur, printing for fun, this is irrelevant; but it helps to explain why monochrome is regarded as a premium medium among leading professionals.

TONING AND HAND-COLOURING
A further advantage of monochrome is that it can form the basis of striking, original and unique coloured images. Not only does this permit a subtlety which is often unobtainable with conventional colour processes, it also opens the door to a wide range of other effects, including partial colouring. It is true that you can derive monochrome images from colour, but it is generally less satisfactory and there is seldom the same justification for it.

AMATEURS AND PROFESSIONALS
By definition, an amateur is one who takes pictures for love. On the other hand, it is disputable which drives most professionals more, love or money. Photographers are notoriously likened to whores: they start doing it for fun, and end up doing it for money. Either way, monochrome has its advantages.

The amateur applications of monochrome photography are almost limitless. The only reason for the word 'almost' is that for happy-snaps in the family album, the majority of people will prefer colour. For pictures to hang on the wall, to take to a photographic club, or even to submit for publication, the amateur can cheerfully use monochrome for any subject.

Indeed, when it comes to black and white prints for publication the amateur can often have the advantage over the professional, as making a good monochrome print may well consume more time and effort than many professionals want to invest. Also, as anyone who has ever judged a magazine competition will tell you, many amateurs can produce prints which are actually better than most professionals could manage; the big difference between an amateur and a professional is that a professional has to deliver the goods, while an amateur can simply write off a picture which doesn't come out right.

Although top advertising photographers now treat monochrome as a premium product, all too many high-street photographers would never dream of suggesting monochrome to their clients in this way rather than as a cheap alternative: they are stuck in the rut of the 1950s and 1960s, when monochrome was still the poor relation. They could, however, consider selling

MILLIONAIRE
Le Tiphany is a wonderful, traditional bar-restaurant just outside Calais. It is full of characters who look like something straight from a movie set. Kodak TMZ rated at EI 12,500 and shot at f/2.8 allows just enough depth of field for the Millionaire scratch-card advertisement and Buck Rogers video game to be read behind the principal subject. Nikon F, 35mm f/2.8 PC-Nikkor. (FES)

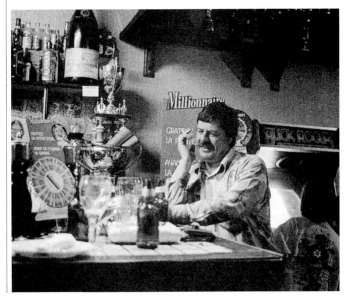

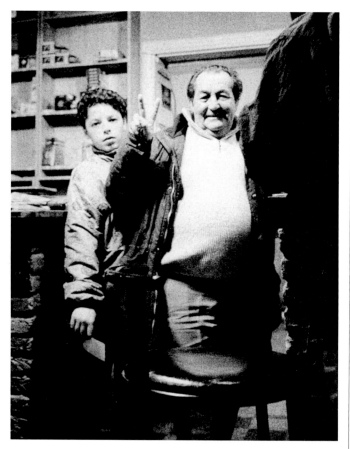

PATRONS, LE TIPHANY

Pearly tonality must sometimes be sacrificed, just to get a picture – but both long and short tonal ranges are firmly in the tradition of 35mm reportage. Leica M2, 35mm f/1.4 Summilux, Kodak TMZ rated at EI 12,500. (RWH)

Again, corporate communications can look stunning in monochrome: with the literalism of colour removed, a good photographer can convey moods, emotions and impressions far better in black and white. Such things are central to industrial photography: often, the very same machinery or process can be made to look like the worst excesses of the industrial revolution – all smoke and grime and toil – or like a Utopian future with clean air, wide open spaces and leisure for all.

Then there is architecture. A building beautifully photographed in monochrome has a classical and timeless look which is next to impossible to replicate in colour. And timelessness, with its implied concomitants of solidity and prestige, is often precisely the quality that an architect, vendor or letting agent wishes to convey.

Professionals will doubtless be able to think of other examples in their own fields, but the point is that unless you are already skilled in monochrome photography you cannot sell it. We use monochrome because we like it, which on its own is a good enough reason. But we also know that it sells.

weddings in monochrome – especially in sepia. The young bride and groom will get a tremendous kick out of the 'old-fashioned' photographs, and you can tell them that they will really come to appreciate their wedding pictures when they can show them to their children, grandchildren and great-grandchildren. With a clear conscience, you can promise that those pictures will be as good in 50 or 60 years as they are today; while colour pictures, from any photographer, may well have faded badly.

MAN AND DOG

The verité of monochrome can be accentuated by a number of means. Here, the time imprint facility of a recording back has been used purely gratuitously to increase the documentary impact of the picture; the deliberately off-centre framing also makes it look like a grab shot. Samsung ECX-1 compact, Ilford XP2. (FES)

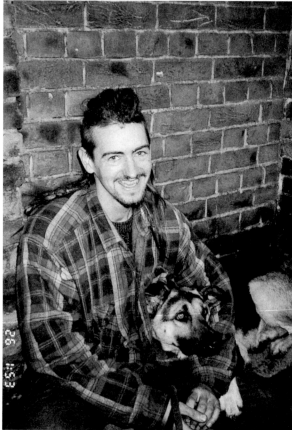

▼ ▶ BEACHCOMBING

In 35mm, monochrome can render texture far better than colour can. A walk along the beach always provides plenty of textural shots: these were taken with a 35–85mm f/2.8 Vivitar Series 1 Varifocal (one of the sharpest zooms ever made) on Ilford XP2. Nikon F. (RWH)

THEORY AND PRACTICE

Photography is at once an art, a craft and a science. These three aspects can work together, or they can be in conflict. Those who follow only Art (you can often hear them pronounce the capital 'A') will all too often disdain anything so mundane as technique: you can recognise the prints they produce by their flat, muddy tonal range, liberal sprinkling of dust spots, and dog ears. On the other hand, those who prize craft above all else may turn out prints which are technically superb, but utterly devoid of content or aesthetic merit; at best, they merely repeat hackneyed pictorial formulae. And those who cleave only to science may never shoot real pictures at all: instead, they endlessly photograph test charts to test their lenses, and calibrated grey cards and grey scales to test their films and developers.

The trick lies in taking what you need from all three areas. The art and the craft can both be improved by practice, both in taking pictures and in printing them, while the vast majority of the science that you need you can acquire from reading.

You do not necessarily need a lot of science, either. There are things which you really need to know and to understand, like the D/log E curve which describes how films and papers respond to light. There are things which will help you to make informed choices, thereby cutting out a lot of trial and error, such as how developers work. And there are things which are merely interesting, such as when things were introduced or how historical processes worked – although

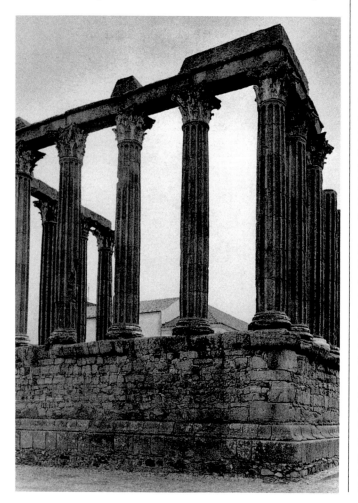

RUINS OF ROMAN TEMPLE, Evora, Portugal
A flat, dull day meant that there was no sky detail – so Frances shot this in a deliberately literal nineteenth-century style, descriptive rather than interpretative. She could not get quite enough rise from her 35mm f/2.8 PC-Nikkor, so the camera had to be tilted slightly. It will not show here in reproduction, but she printed it on a warm-tone paper (Sterling RC VC) with a warm-tone developer. Nikon F, Ilford XP2.

▶ STICK AND WALL, Aosta
This is a textbook illustration of a long tonal range, from the specular highlight on the head of the cane to the (almost) maximum black of the recesses of the window. It also illustrates how 'black' is as much a matter of perception as of reality: the 'black' of the shadows under the broken stucco is the same as the 'black' in the window, where in the original print (although perhaps not in reproduction) texture is clearly visible. Nikon F, 35mm f/2.8 PC-Nikkor, Ilford XP2. (FES)

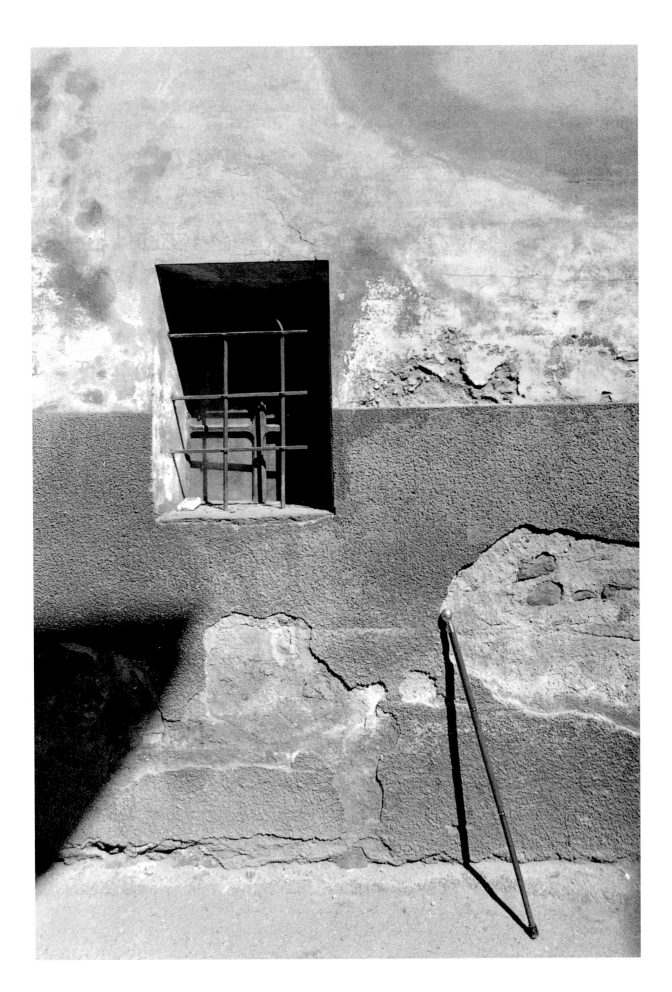

what one person finds to be merely interesting may for another person turn out to be the basis of a lifelong passion.

GREY CARDS AND DENSITOMETERS

Reading some books on photography, you might think that 18 per cent grey cards and densitometers were an essential part of the serious photographer's armoury, and that endless testing and measurements were quite indispensable to successful picture-making.

Although the 18 per cent grey card has its place (see page 82), there is little or no need for endless testing, let alone for a densitometer. Photography is about as empirical as anything can be. The golden rule is: if it works for you, it works for you. If you are not happy with the results you are getting, then the changes you need to make are easy to understand, and easy to execute.

To be sure, you have to be methodical. There is no sense in simultaneously changing your film, film developer, printing paper and print developer, because if you do you won't necessarily know which of them was responsible for the different 'look' of your prints. But if you just change one variable at a time – the same film, film developer, printing paper and

ABANDONED CHAPEL, Portugal

This was taken with a 'baby' Linhof Technika IV dating from the late 1950s or early 1960s. The swing back allowed both the tree and the chapel to be held in focus, but the wind has blurred some leaves while leaving others sharp. Schneider Xenar 105mm f/3.5, Ilford XP2 with yellow filter. (RWH)

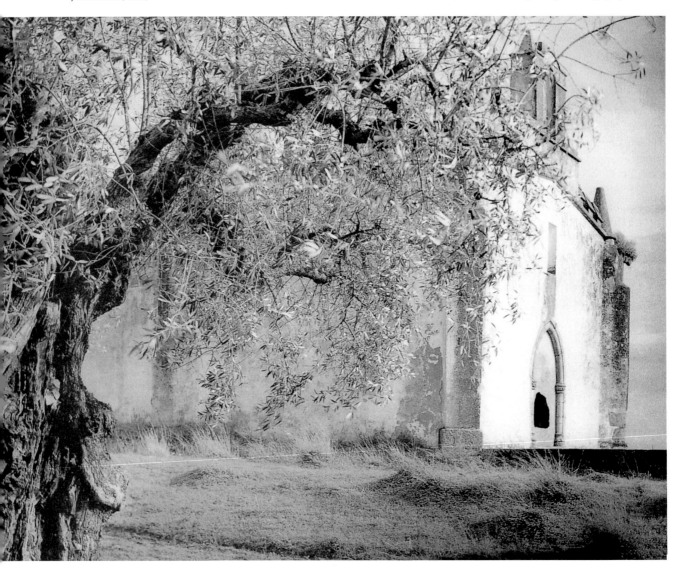

print developer, but a different film developing time, for instance – then you will be able to see whether that one change gives you better or worse pictures. Now take those same negatives, but change your printing paper. Are the prints better or worse? It is all a process of refinement, of working towards the best possible result.

USE MORE FILM AND PAPER

If you really want to improve your photography, buy more film and paper. People will spend a small fortune on cameras and lenses, then hold back when it comes to buying film and paper. Why? For the price of a modest new lens, you could buy 100 rolls of film or 500 to 1,000 sheets of paper. The lens will do literally nothing to improve your photography, unless you actually use it – in which case, you will need to buy the film and paper anyway.

Any professional-quality 35mm camera made since the 1960s, any professional-quality roll-film camera made since the 1950s, and any professional large-format camera, ever, should deliver sharpness which cannot be improved upon. Likewise with lenses: most lenses made since the 1970s, and many medium-format and large-format lenses made since the 1950s, will deliver all the quality you need. Unless you want extreme wide-angles, ultra-fast lenses, or zooms, where progress has been significant, there is no need to buy the latest and the best. Forgo your next equipment 'upgrade', which will probably be illusory anyway, and spend the money on materials.

WALL OF DEATH RIDER

Most of the information in this picture is in the light mid-tones. If the dark tones block up, it is a nuisance, but it does not destroy the appeal of the image. Nikon F, 35–85mm f/2.8, Vivitar Series 1, Ilford XP2. (FES)

'BABY' LINHOF OUTFIT

Something like this late 1950s/early 1960s Linhof Technika IV, with as few as three lenses (65mm, 105mm and 180mm), can deliver all the technical quality you could wish for. Once you have a decent camera, the place to spend money is on materials, not illusory 'upgrades'.

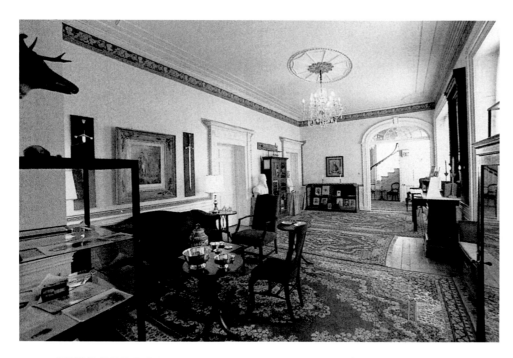

MUSEUM INTERIOR, Richmond, Virginia

Exotic lenses – this was shot with a 14mm f/3.5 Sigma – are much sharper and more distortion free than even the more modest designs of yore, but the biggest improvements in less demanding coverages and speeds have been seen at the bottom end of the market.
Nikon F, Ilford XP2. (RWH)

THE D/LOG E CURVE

Earlier in this chapter, we said that one of the fundamental pieces of theory which you need to understand is the D/log E curve. This may seem forbidding at first, but apart from the logarithmic scales (which you may well have forgotten since your schooldays) it is very easy to understand. In fact, the logs are not that hard to understand either.

Photographers are well used to the idea of working in 'stops'. An extra stop means doubling the amount of light falling on the film; an extra stop of density means that the film passes half as much light. Two stops means four times or one-quarter; three stops means eight times or one-eighth; and so forth.

A graph of stops against exposure therefore gives what is known as an exponential curve (Fig 1). We can, however, plot our stops against the logarithm of the exposure instead of against a linear scale (Fig 2). The runaway exponential curve now becomes a straight line. In other words, 'log E' is just a way of expressing exposure in a way that we already understand. If we use logs to the base ten (the usual sort from your schooldays), then each single stop corresponds to a change in log exposure of 0.3; a change in log exposure of 0.1 is ⅓ stop.

A great advantage of using log scales is that they free us from actual units – what we are comparing is proportions. It does not matter if you are dealing with brilliant sunlight or a murky room: a change of 0.3 units will always double or halve the amount of light

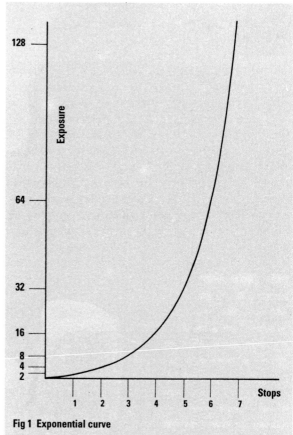

Fig 1 Exponential curve
If you plot exposure increase against aperture, you will get an exponential curve like this.

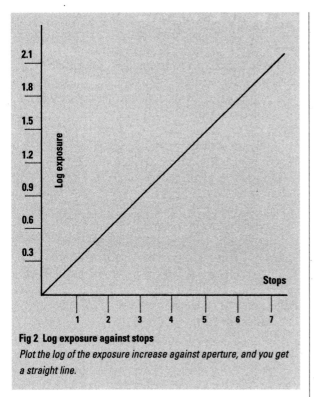

Fig 2 Log exposure against stops
Plot the log of the exposure increase against aperture, and you get a straight line.

you are talking about, just as opening up or closing down the lens diaphragm by a stop will double or halve the light reaching the film.

Film density

Density, meanwhile, is always measured using logarithms. A transmission densitometer shines a light through a film and measures how much is absorbed. Clear film would be density 0.0, but such a thing does not exist: even a clear film base and a clear emulsion will absorb some light. If (as is often the case with 35mm) the base is tinted, it may absorb a full stop. The minimum density of a 35mm film is typically around 0.3, representing 50 per cent transmission, although 120/220 roll film runs around 0.2 to 0.25 (up to about 60 per cent transmission) and sheet film can often be as low as 0.15 (around 70 per cent). These figures refer to visible light; in practice, densities are often calibrated to blue/green light as this gives a better idea of printing densities, especially with variable-contrast papers.

At the other end of the scale, the blackest black on a negative is still partly transparent and transmits between 0.5 and 0.1 per cent of the light falling on it; a transmission of 0.5 per cent is equivalent to a density of 2.6, while 0.1 per cent is equivalent to 3.0.

As with exposure, each density increase of 0.3 represents a doubling of density, or a halving of the light passing through. The equivalents are therefore as given in the table below: ⅓ stop variations have been given for the first few stops, just to clarify how they work.

Density	Transmission (%)	Reduction (stops)
0.0	100	0
0.1	80	⅓
0.2	62	⅔
0.3	50	1
0.4	40	1⅓
0.5	31	1⅔
0.6	25	2
0.9	12.5	3
1.0	10	3⅓
1.2	6.25	4
1.3	5	4⅓
1.5	3	5
1.6	2.5	5⅓
1.8	1.5	6
2.0	1	6⅔
2.1	0.75	7
2.3	0.5	7⅔
2.4	0.375	8
2.6	0.25	8⅔
2.7	0.18	9
3.0	0.1	10

Base density is constant, and is unaffected by variations in exposure, so it can simply be subtracted from the overall density: the proportions of light passed will still remain constant, because this is a logarithmic scale. If base density (plus fog, the irreducible minimum of emulsion density) is 0.3, and the maximum density is 2.5, the overall density range is therefore 2.2 or 7⅓ stops. The density range which is proportional to exposure will normally be in the range of 2.0 to 2.4 log units, or between 6⅔ and 8 stops.

What you can do, therefore, is to plot a graph showing the relationship of density (D) to the log of the exposure (log E). This is known, logically enough, as the D/log E curve, also called the 'characteristic curve' because it shows the characteristic response of the film, or the 'H&D curve' after Ferdinand Hurter (1844 – 1898) and Vero C. Driffield (1848 – 1915), who originated it in the early 1890s.

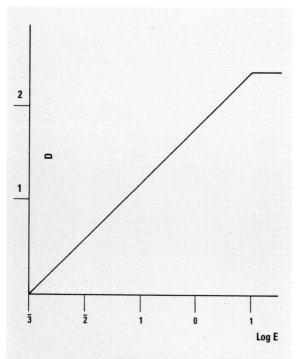

Fig 3 Straight-line D/log E curve
A perfect D/log E graph would look like this: zero density at zero exposure, and the two rising in a constant relationship thereafter.

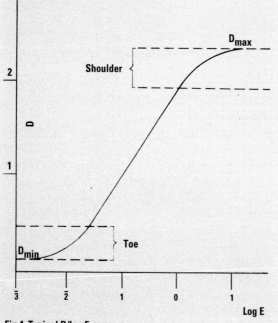

Fig 4 Typical D/log E curve
A real-world D/log E curve has a degree of inertia, a 'toe', a (more or less) straight-line portion, and a 'shoulder'.

The shape of the D/log E curve

A perfect D/log E curve would be a straight line, intersecting the axes at zero for both exposure and density and going straight to maximum density. At its maximum density, it would suddenly change direction and parallel the exposure axis: no further increase in density would be possible, no matter how much you increased exposure. This is shown in Fig 3. There is, however, no such thing as a perfect D/log E curve. A representative D/log E curve is shown in Fig 4.

At the base of the curve, there is always a little exposure which produces no density at all. This is the 'inertia' of the film – the minimum exposure which it must receive in order for anything to happen.

Next, density builds relatively slowly as exposure is increased. This is the 'toe' of the curve, where shadow details record on the negative. Inevitably, there is some compression of shadow detail, because quite large increases in exposure result in only modest increases in density.

At a certain point, the relationship between exposure and density becomes almost linear: increasing the exposure increases the density by an exactly proportional amount, or as near as makes no odds. This is known as the 'straight-line portion' of the curve. It is rarely dead straight, however; curves and kinks may be present for all sorts of reasons, deliberate or not.

At the top of the curve, this linearity peters out again, and more and more exposure is required to get a given increase in density. This is the 'shoulder' of the curve. Just as shadow detail is compressed on the toe of the curve, so is highlight detail compressed on the shoulder.

The maximum density of which the film is capable is known as the D_{max}, but if there is tremendous over-exposure, the D_{max} may actually decrease again: this is true solarisation, so called because it was first seen when the sun recorded on a plate as a clear disc, not a black one.

Regardless of the extremes of shadow and highlight in the subject, the extremes on the D/log E curve of general-application films will represent a range of something between 1.8 and 2.4 density units (6 to 8 stops, transmission of between 64:1 and 256:1). In practice, this range is in fact very rarely used to the

▶ **MORRIS MEN, Canterbury**
Monochrome is not the sole preserve of fanatics with top-of-the-range SLRs or view cameras: this was taken with a Pentax compact, using automatic exposure – and yet it has the characteristic 'sparkle' of a good print. Ilford 100 Delta Professional.(RWH)

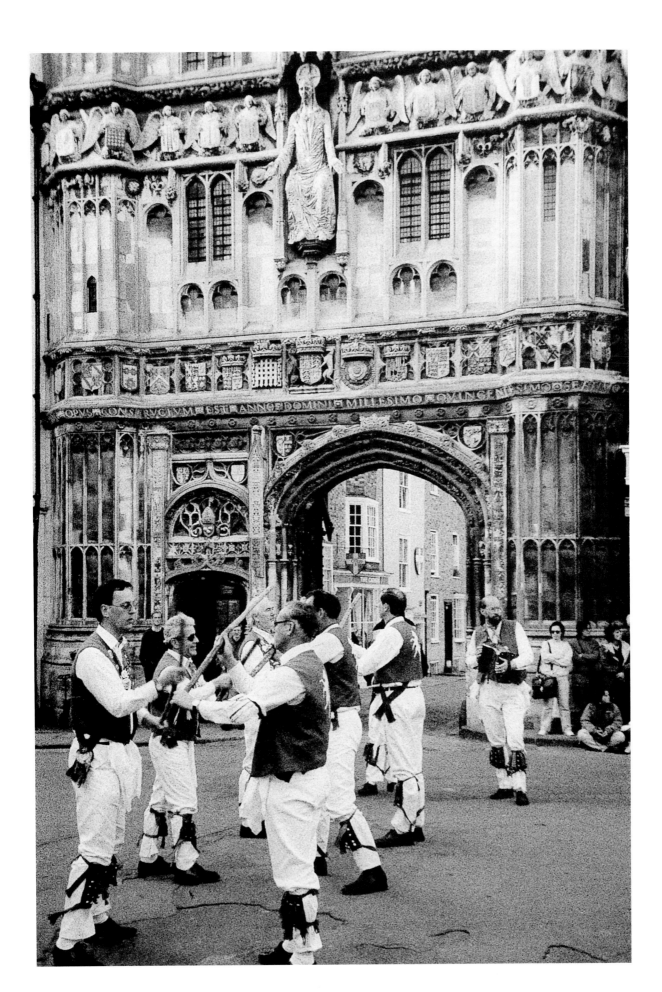

full. In order to understand the reason why, we need to look at the relationship between subject brightness and negative density.

Subject brightness, contrast and the D/log E curve

A landscape with the sun in shot can have a luminance range of 1,000,000:1 – no film can record this in a way which will give an aesthetically acceptable image. But if you take out the light sources and the specular reflections from them, which will record as a featureless white, and the very blackest shadows, the subject luminance range from diffuse highlights to shadows with detail is surprisingly often within about

▶ **BOOKSTALL, New York City**
Roger wrote the Ferrari book he is pointing to. The tonal range is immense, from self-luminous sources to black sky, and the gradation is unsubtle; but as this picture shows, this is no bar to impact, while resolution is astonishingly good. Nikon F, 15mm f/2.8 Sigma fish-eye, Kodak TMZ rated at EI 12,500. (FES)

7 stops: 2.1 log units, or 128:1. This comes down to about 6 stops at the film, principally as a result of lens flare: 1.8 log units or 64:1.

This is not normally recorded as a linear relationship on the film, even though this could be done, because such a negative would be very contrasty and

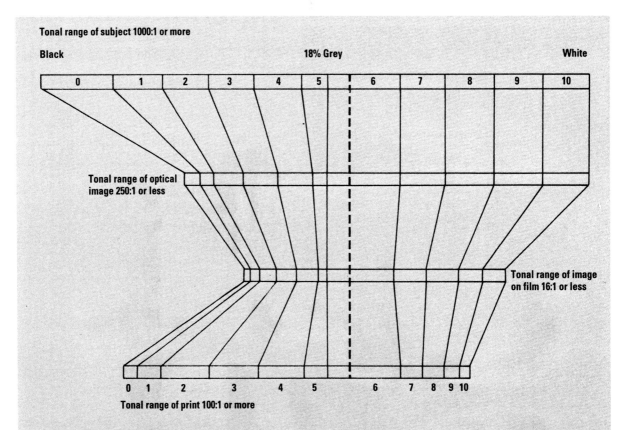

Fig 5 Idealised representation of tonal compression and expansion
The line along the top in the diagram represents the tonal range of the subject. Zones 1 to 9 represent the maximum that a film can capture; Zone 0 represents shadow detail which will record as clear film, while

Zone 10 represents highlights which will be recorded as a maximum black.

Principally because of lens flare, the optical image – the next line down – has a smaller tonal range; the dark values are said to be compressed. A still smaller tonal range can be captured on film, the third line

down, and because of the 'toe' and 'shoulder' of the D/log E curve, both shadow and highlight tones are still further compressed. Finally, when the image is printed onto the paper (the bottom line) the shadows are expanded to something nearer their original values, while the highlights are once

again slightly compressed.

This is only a sketch: the exact details will depend on the flare of the lens, the choice of negative material and how it is processed (in other words, the shape of the D/log E curve), and also the choice of printing material.

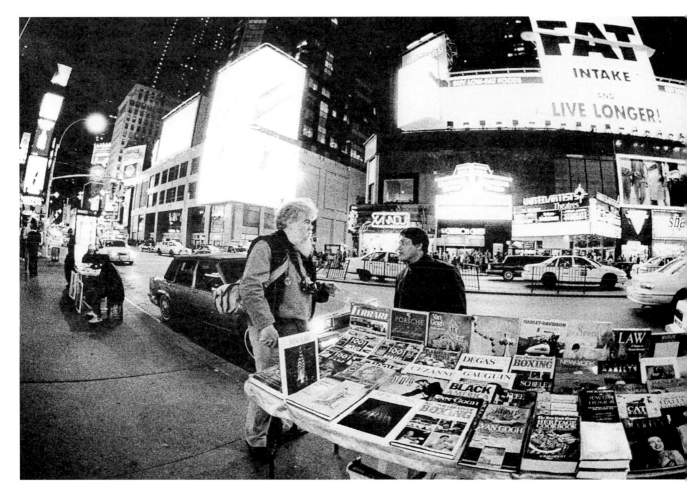

hard to print. Rather, the tones are compressed. In order to understand this, we need to study the average slope of the curve. There are a number of ways of doing this, and deciding exactly which parts you measure can involve a great deal of controversy;

however, it is easy to see that if you simply divide D by log E at any point on the straight-line portion of the curve, you will get a number. This is the slope of the curve, often known as 'gamma'.

If the straight-line portion of the film curve has a slope of 0.62 (in other words, doubling the exposure increases the density by 1.3×, rather than 2×), then the density range of our 128:1 subject on the film will be around 16:1, equating

CEILING PAINTINGS, Rhodes

The tradition of frescos and wall paintings in Greek Orthodox churches is alive and well in Rhodes, and the relatively high contrast of this picture seems the best way to capture the vividness of the colours. The slightly awkward framing is due to the unusual method of aiming the camera, which was laid flat on the church floor and aligned by guesswork. M-series Leica, 21mm Biogon, Ilford XP2. (RWH)

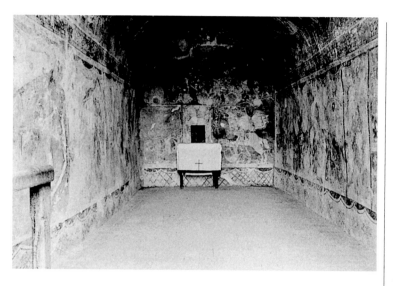

UNDERGROUND CHAPEL, Rhodes

Both the lighting and the subject matter conspire here to create a very long tonal range. The chapel is lit only from the door behind the photographer; the far wall has both dark (and barely visible) frescos and a white altar cloth. Ilford XP2 captures the mood of the place, although colour would be necessary to show detail in the frescos. The camera was rested on a step, as tripods are banned at this site. Nikon F, 28mm f/1.9 Vivitar Series 1. (FES)

to 1.2 log units or 4 stops. This fits neatly onto grade 2 paper for easy enlarging.

This is hard to understand at first, but it is much easier if you compare three D/log E curves (Figs 6,7 and 8). In all three, the minimum density is 0.1 (above base density plus fog) and the maximum is 1.3 – a density range of 1.2 log units, 4 stops. But in the normal-contrast film, with a slope of 0.66, this corresponds to 6 stops of exposure. In the high-contrast film (steep slope, 1.0) it corresponds to only 4 stops of exposure, while in the low-contrast film (gentle slope, 0.5) it corresponds to close to 10 stops of exposure.

In other words, a negative density range of 16:1 (1.2 log units, 4 stops) may correspond to a subject luminance range of anything from 16:1 to 1,000:1 (1.2 to 3 log units, 4 to 10 stops). The final density range in the print will (or can) be the same in all three cases, so the difference between subject tones is greater in the contrasty negative than in the 'normal' negative (tones are 'expanded'), while the difference between subject tones is less in the low-contrast negative (tones are 'compressed').

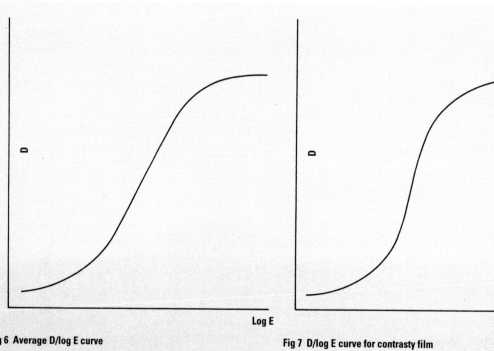

Log E

Log E

Fig 6 Average D/log E curve
This film has a short toe, a (fairly) straight area in the middle with a modest slope, and a gentle shoulder: an average sort of film with average contrast.

Fig 7 D/log E curve for contrasty film
After a short toe, this film builds contrast rapidly with relatively modest increases in exposure: it is therefore a contrasty film.

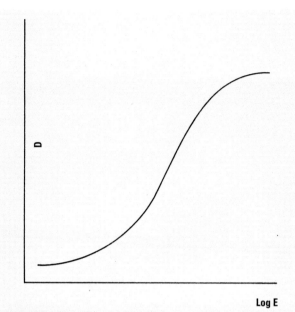

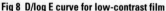

Fig 8 D/log E curve for low-contrast film
At the point where the other two films have already reached their maximum density, this film is still slowly building contrast – although the maximum density is identical in all three cases.

Fig 9 Average contrast
Establishing an average gradient for a D/log E curve is a matter of interpretation. Kodak's Contrast Index (CI) approach is probably the most reliable, but it requires a special template – a sort of protractor – to do it. This sketch gives a general idea of how overall contrast can be judged.

Speed and the D/log E curve

As well as contrast, you can derive film speed from the characteristic curve. The starting point for modern ISO film speeds is a density of 0.1 above base plus fog. The choice of 0.1 is essentially arbitrary: it allows you to clear the worst part of the toe of the curve.

The film is then developed so that another point, which has received 1.3 log units more exposure than the starting point, is 0.8 density units (2⅔ stops) darker than the base point. Then, by dividing 0.8 by the exposure at the base point, you determine the arithmetic speed of the film (the old ASA, now known as ISO arithmetic).

You can quite feasibly replicate all this for yourself, if you have a densitometer. The question is why you would want to, unless you were a film or developer designer. In practice, the overall effect – the look of the photograph – is far more important than the ISO speed. Also, because ISO speed is under controlled development, it can never be changed. The old 'fractional gradient' system was arguably more meaningful, but in the days before computers it was hard to calculate, so the slightly inferior system described above was adopted.

Development and the D/log E curve

A point which few photographers realise is that with the right developer, the straight-line portion of the D/log E curve just goes right on climbing: the shoulder is not reached until density is very high, maybe 8 log units or more. But because most developers have a compensating effect – in other words, because they act more energetically on areas which have received less exposure than on areas which have received more exposure – the curve can be made to shoulder off at around the maximum density which is useful for printing. This shoulder is, however, a result of the developer chosen and not of the film.

Increased development, or the use of a more energetic developer, can therefore give an effective increase in speed. The ISO speed will by definition remain constant, but the exposure index or EI can rise. The effective gains in film speed while still retaining shadow detail will not be all that great – anything from ½ stop to 1½ stops, depending on the criteria chosen – but they are real. Beyond those gains you will start to lose shadow detail and get contrast which may be uncontrollably high, but you will get more and more apparent speed.

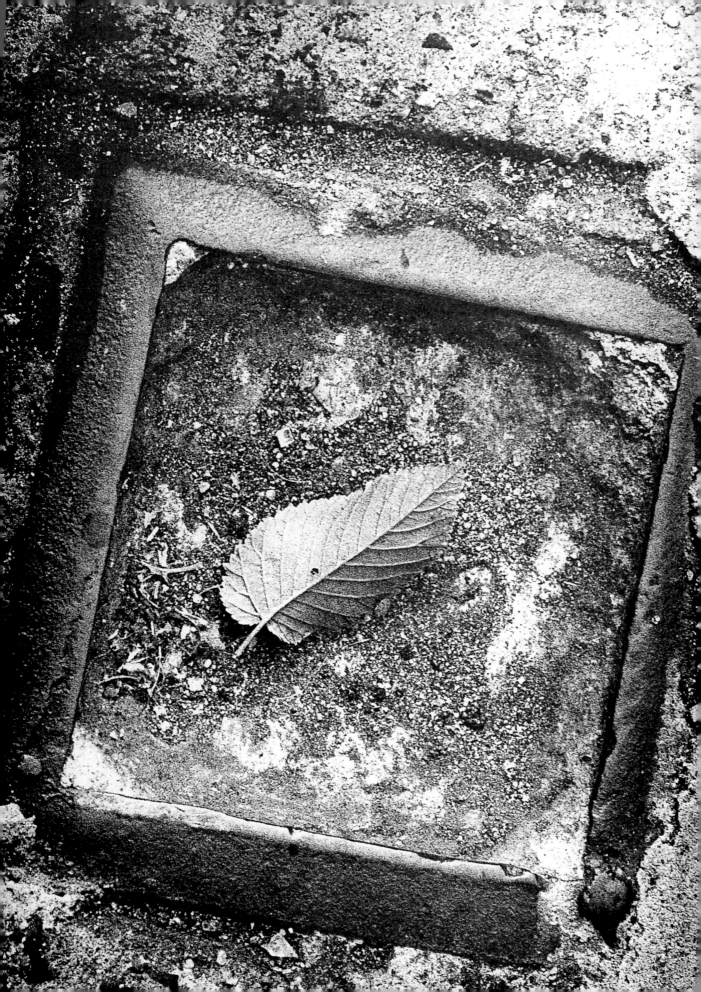

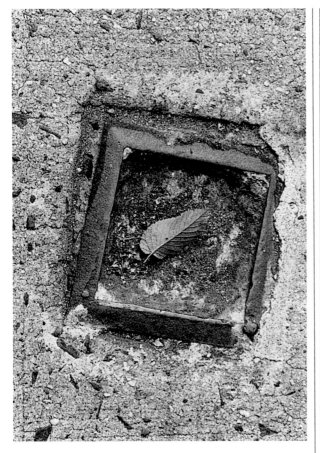

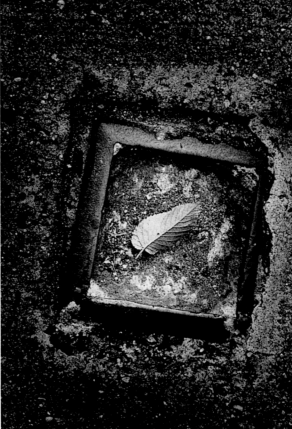

LEAF, New York sidewalk

Ansel Adams said, 'The negative is the score; the print is the performance'. Performed 'straight' (above), this score is pleasant but not exciting. Increasing the contrast (above right) makes it much more dramatic; and for the final print (left), a tight crop emphasises the textures around the stone 'frame'. Nikon F, 90mm f/2.5 Vivitar Series 1, Ilford HP5 Plus. (FES)

D/log E curves for paper

Measuring the light transmitted by film is quite easy: you just shine a light through it, and see how much of that light is absorbed by the film. This is all a transmission densitometer does, although the colour of the light will have a considerable influence. Measuring the light reflected by a print is more difficult, as a lot depends on exactly how you do the measuring.

The convention for reflection densitometers, therefore, is to shine a beam of light at the paper at 90°, and then measure the amount that is reflected at 45° (Fig 10). You can of course reverse this light path, with the beam at 45° and the measurement at 90°. There are certain other ways of doing it, but the 45°/90° approach gives repeatable results which are

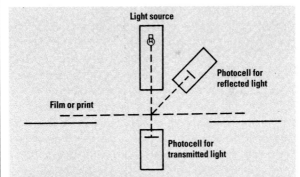

Fig 10 Transmission-reflection densitometer

Light is directed perpendicularly at the sensitised material. For a transmission densitometer, the photo-cell on the other side of the film measures the amount of light passing through. For a reflection densitometer, a photo-cell at 45° to the light path measures the amount of light reflected from the print.

meaningful when compared, and also simulates reflection-free viewing.

Just as no film is ever perfectly clear, no print is ever perfectly reflective. In fact, no white surface is

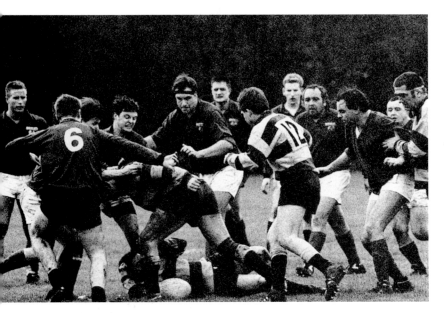

RUGGER PLAYERS

Sometimes, the application decides everything for you. This called for a long, fast lens (Tamron 300mm f/2.8) and fast film (Kodak TMZ rated at EI 3200). Nikon F. (RWH)

perfectly reflective, although modern photographic papers are about as good as you get: densitometer readings of an Ilford Multigrade FB step wedge, carried out for this book, revealed a minimum density of 0.03 log units (93 per cent reflectance).

Similarly, even the blackest area of a print reflects some light. The same test, with the same step wedge, gave a maximum density of 2.2. This corresponds to about 1.5 per cent reflectance. In other words, the maximum tonal range on the measured sample was 2.17 log units: better than 7 stops or around 150:1.

If linear, one-for-one reproduction from film were possible, this would mean that a density range of 2.17 log units could be accommodated at all stages. As we have already seen, however, a typical density range for a negative is about 1.2 log units, but the slope of the curve is only around 0.62. Printing a negative with a density range of 1.2 on a paper with a density range of 2.17 allows the brightness range of the subject with a 6 to 8 stop range to be restored with pretty much a 1:1 correspondence, although there will be some compression of both highlights and shadows because of the toes and shoulders of the film and paper curves.

YOU STILL DON'T NEED A DENSITOMETER

This chapter is, we readily confess, heavy going – and at the end of it, you may wonder if you can ever really understand all this stuff without a densitometer and endless film and developer tests.

The answer is that undoubtedly you can. The basic concept of the D/log E curve is really simple enough: density is proportional to exposure, and the curve just describes the way in which it is proportional. An understanding of contrast flows from that, along with an understanding of how development can affect the look of a picture by changing the shape of the D/log E curve. You don't actually need to understand speed determination at all.

After that, you can apply your knowledge of the D/log E curve to real-world observations. Too much contrast? Cut your development; change the slope of the D/log E curve. Shadow detail blocked up? Check the shape of the toe of the D/log E curve of your film and paper. Can't get detail in the mid-tones of your print? Look at the D/log E curve of the paper. Poor highlights? Look at the shoulder shape of the D/log E curve for the film and developer you are using. Throughout this book, we shall be doing this sort of thing. All the information you need is published by the manufacturers, and you can get the results you want by simple variations in technique and material choice. You don't need densitometric tests, because you can get all the information you require about your own negatives and prints just from looking at them.

Come to that, you don't need to understand the D/log E curve fully, even to read this book. It is quite possible to get perfectly good pictures without it. But if you do understand it, you will be able to understand the reasons for both your successes and your failures more quickly and more easily. It's just a vocabulary, a way of describing what you can see. It is certainly the most concise way, and many photographers find it the easiest; but if you don't understand, don't worry about it. You will probably come back to it when you are ready.

▶ **CHAPEL, fortress of Forcalquier**

The couple to the right of this unusual chapel give it scale – and also, unexpectedly, furnish the lightest tone in the print. Expanding the tonal range of the chapel, by using a harder paper or increasing development, would 'burn out' both the woman's dress and the Christ figure. Nikon F, 35mm f/2.8 PC-Nikkor, Ilford SFX 200 with tri-cut red filter. (FES)

FILM STRUCTURE

Most people tend to use the terms 'film' and 'emulsion' more or less interchangeably, but of course the two are quite different. The 'emulsion' is the light-sensitive part, while the 'film' can mean either the whole thing, or just the base on which the emulsion is coated; and there is rather more to the film as a whole than might immediately be suspected. As well as the support, there are non-emulsion layers: the subbing layer, the supercoat, and anti-curl and anti-halation layers, although the last two may be combined. Moreover the emulsion itself may vary in

thickness, and some films have two emulsions, one on top of the other. All of these factors can have a considerable effect on both the performance of the film and its processing.

THE SUPPORT

The support has two functions. One is simply to support the emulsion, which is very thin and fragile, and the other is to retain the geometry of the image. Both the gelatine and its support will swell and shrink as they are heated and then cooled, or when the image is processed and dried. Precise dimensional stability is normally a minor concern, but having said that, for some scientific applications, for photogrammetry, and for photomechanical printing, even tiny distortions can be significant.

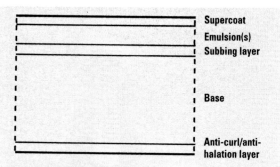

Fig 11 Film section
This is not to scale at all – in particular, the film base would be far thicker and the subbing layer far thinner – but it gives some idea of the layout of the various layers.

◀ STATIC DISCHARGE
In cold, dry weather conditions, a motor drive can pull a film past the velvet lips of the film cassette fast enough to cause static discharges. This picture, from a Tessina sub-miniature (14x21mm images on 35mm film in special cassettes) is the most impressive example we have ever seen. (RWH)

Acetate and polyester bases

The most common film support for many years was cellulose triacetate, also known just as 'acetate'; diacetate base was used in the 1930s and 1940s, but this is badly prone to shrinking, even to the extent of the emulsion wrinkling and coming off the support. Triacetate bases can also decay, although a great deal depends on both humidity and temperature: at 2°C (35°F) and a relative humidity of 20 per cent, triacetate should last for over 1,000 years, while at 32°C

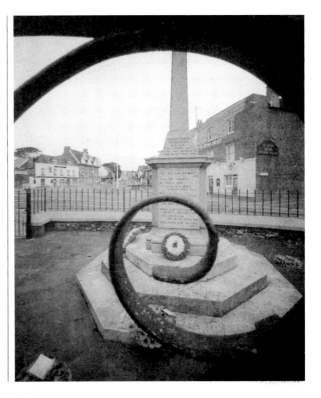

▶ BIRCHINGTON AND ACOL WAR MEMORIAL

Polaroid materials do have a negative on a plastic base, but the image is diffused onto what amounts to an RC print. This picture was shot on Type 54 using a Rigby pin-hole camera, which gives infinite depth of field. (RWH)

▼ HÔTEL DE VILLE, Paris

The 'starbursts' around the street lamps, especially the one on the left, are nothing to do with film or with special effects screens: they are reflections from the edge of the diaphragm leaves, an effect which can be seen with many lenses but most especially with wide-angles at small apertures. Nikon F, 15mm f/2.8 Sigma fish-eye, Ilford XP2. (FES)

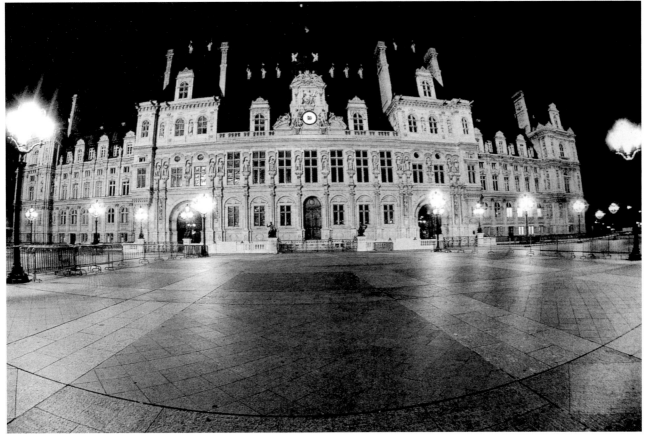

(90°F) and 80 per cent humidity it may start to deteriorate in as little as five years. In a cool cupboard (16°C/60°F) life varies from about 35 years at 80 per cent humidity to well over 150 years at 20 per cent humidity (*IPI Storage Guide for Acetate Film*, Image Permanence Institute, RIT, Rochester NY, 1994). All acetate bases are vastly less flammable than the old cellulose nitrate (see below), and are therefore known (and sometimes edge-marked) as 'safety-base' films.

Today there is an increasing tendency to use polyesters, which are extremely tough, dimensionally far more stable, and much longer-lasting. They also absorb less moisture during processing, which improves dimensional stability and allows for faster processing and drying.

The normal thickness of flexible film supports runs from about 0.06mm (0.0025in) to about 0.22mm (0.009in). For example, Ilford sheet films are coated

▶ **BAR, Mokelumne Hill, California**
There are times when ease of use is everything. California's Gold Country is probably the most laid-back part of the United States. This is no place for fussiness: you have to be as casual as the patrons and the owner. This was shot on Ilford XP1, the predecessor (logically enough) of XP2. Nikon F, 17mm f/3.5 Tamron SP. (RWH)

on polyester (PET, polyethylene terephthalate) bases 0.18mm (0.007in) thick, while their 120/220 films are on a triacetate base 0.11mm (0.004in) thick and their 35mm is on a triacetate base 0.125mm (0.005in) thick. Ilford aerial (70mm, 126mm and 240mm) films are on 0.1mm (0.004in) polyester, while surveillance films go as low as 0.075mm (0.003in) – which is, incidentally, horrible to handle – in order to allow for extra-long loads. Kodak likewise use a 0.18mm (0.007in) base for their 'Estar' thick-base films, while their 70mm aerial films are coated on 0.06mm (0.0025in) 'Estar' (thin base) and 0.1mm (0.004in) 'Estar' (thick base). 'Estar' is a Kodak trade name for their polyester support.

Other polymers which have been tried include polystyrene and polycarbonates, while Advanced Photo System film, for example, is coated on PEN (polyethylene napthalate). For most general-application 35mm films, the film support is tinted slightly, principally to reduce halation (see page 40) but also to reduce 'light-piping' down the exposed tongue. Polyesters are particularly prone to this, and also to static, which is why they have never really caught on in 35mm. They are also extremely tough, and in large enough quantities can actually wear the film path in the camera – but you would need thousands upon thousands of rolls to do this to a well-made camera.

Cellulose nitrate

Cellulose nitrate (or just 'nitrate') base is both stronger and more dimensionally stable than acetate, but it is terrifying stuff. Even when well stored and

EDGE MARKING OF NON-SAFETY FILM
After safety film came into common use, nitrate-base films were sometimes marked like this – but not all *nitrate films are marked.*

OVERLEAF PACIFIC COAST HIGHWAY, California
Regardless of technical considerations, one should never forget aesthetics. Without the splashing wave, this would be a rather dull picture; but with the wave, the full ruggedness of the coast is brought to your attention and there is also a centre of interest. Cover the wave with your fingers and the picture collapses. Nikon F, 90mm f/2.5 Vivitar Series 1 Macro, Ilford XP2 with heavy red filter. (FES)

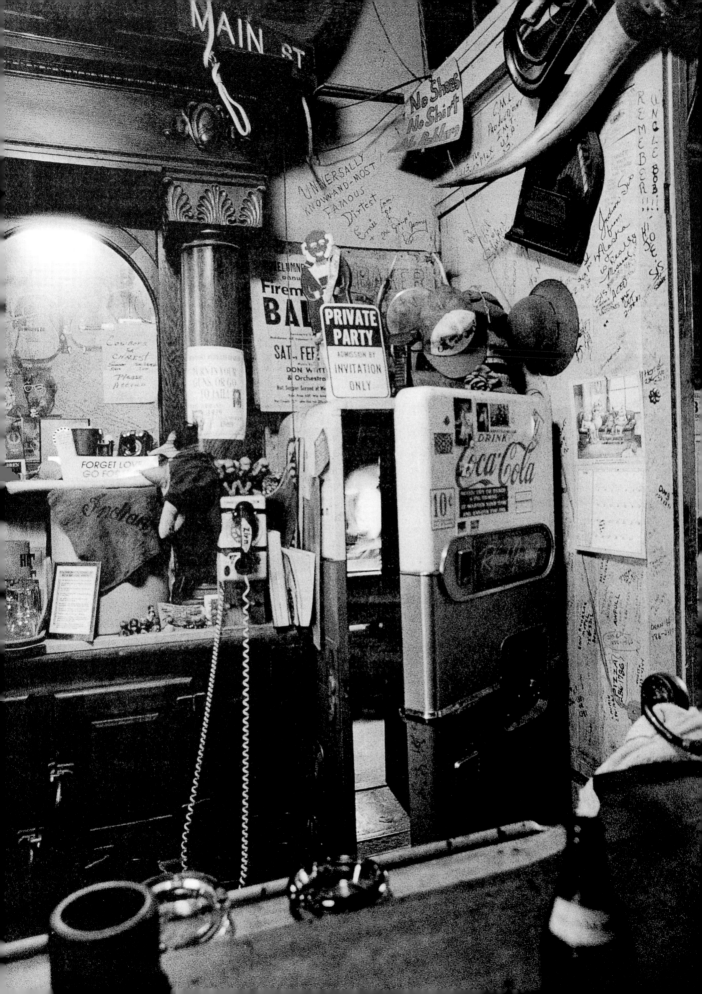

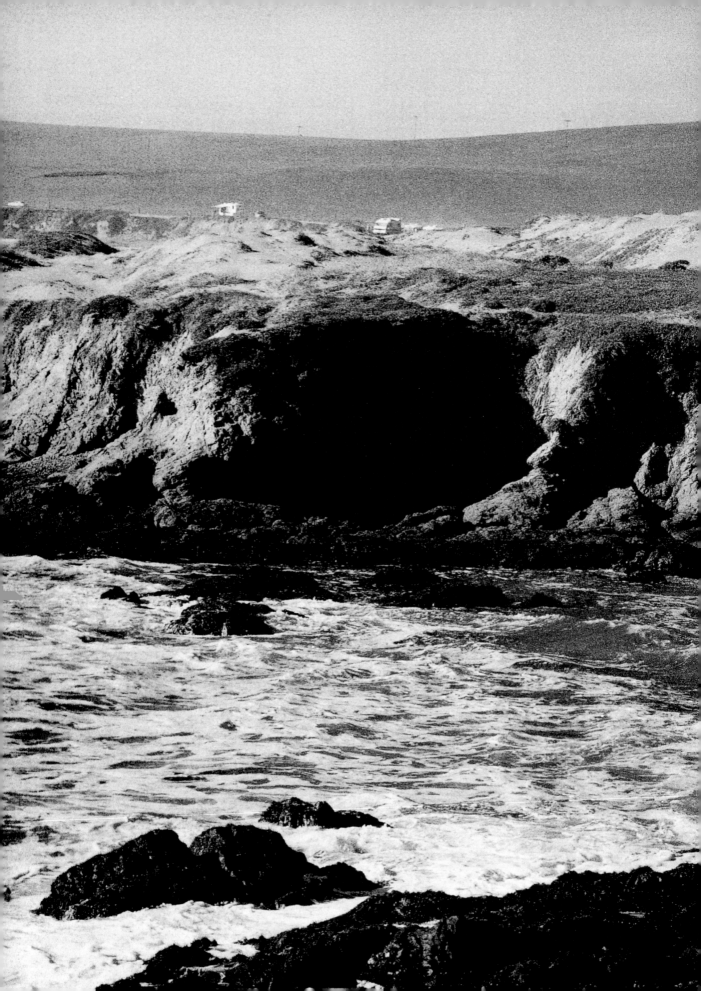

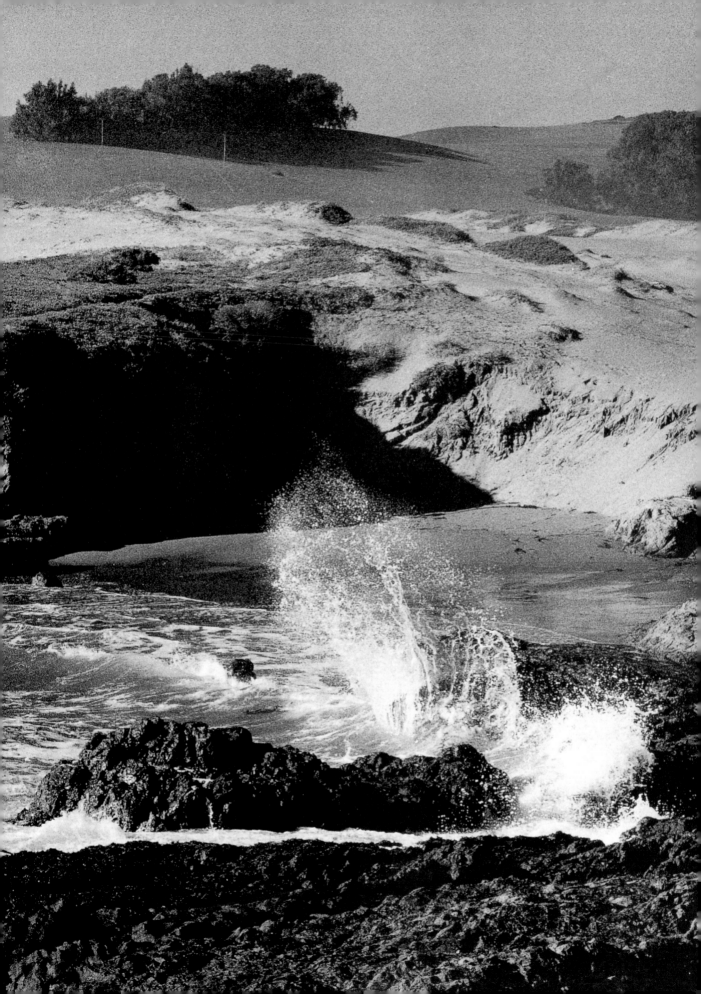

fresh, it is extremely inflammable: if ignited at one end, half a metre (20in) of non-safety-base film will burn too fast for the eye to follow. When it ages and begins to decompose, it is still more inflammable and apparently may catch fire or even explode spontaneously. Non-safety-base films began to disappear in the 1930s and were almost completely gone by 1950.

Plates

Plates are normally coated on glass 1mm to 1.5mm (0.04in to 0.06in) thick. Glass offers the ultimate in dimensional stability and, barring accident, will last half-way to forever without deterioration. The rigidity of plates is convenient when loading and processing, and the registration in the image plane is vastly superior to that of film, but their fragility and weight are a curse. Also, gelatine does not stick as willingly to glass as to most flexible supports, so 'frilling' at the edges as a result of poor processing or over-washing is a much greater risk. Plates are very rare nowadays: few emulsions are available, and prices are much higher than for sheet films.

An intriguing aside is that you cannot easily strip and re-coat old, exposed plates. The image somehow gets into the glass, even if it has been cleaned with boiling caustic soda, and as a result there will often be a 'ghost' image of the original photograph as well as the new exposure.

NON-EMULSION LAYERS

The subbing layer is a non-sensitised gelatine coating which is applied to the support to help the emulsion stick to it. It is commonly mixed with a solvent for the film base, and forms a layer beneath the emulsion which is too thin to measure. Subbing layers are normally added during film-base manufacture.

Most unprotected emulsions are very sensitive to pressure, and unless they are protected with a super-coat – a thin layer of hardened, non-sensitised gelatine – they may be marked either in the camera or during processing. The supercoat also contains anti-static agents and other additives to prevent sticking.

Many films have an 'anti-curl' layer of gelatine on the other side of the support from the emulsion. This shrinks and swells at more or less the same rate as the emulsion and therefore counters the curl. With large-format films, this layer may also provide a 'tooth' for retouching on the non-emulsion side as well as the emulsion side. For 35mm film, anti-curl is achieved by shrinking the back of the base.

Yet another layer is the anti-halation backing.

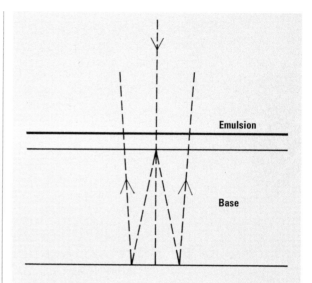

Fig 12 Halation
Halation is caused by light passing through the emulsion and the film base, then being reflected back into the emulsion from the back of the film base.

Halation has already been mentioned, and it is exactly what its name suggests: the tendency of a point source to be represented with a halo around it. The problem is easier to draw than to describe, but what happens is that some light passes through the emulsion and the support, strikes the back of the support, and then bounces back to create the halo. The classic anti-halation layer is a heavily dyed, soluble gelatine backing, which dissolves during processing. A more modern approach is to use a dye which is changed chemically during processing so that it either disappears or leaves a very faint tint; this is applied as an underlayer between the film and the emulsion, rather than as a backing.

A tinted film support (usually grey) greatly reduces halation, but this cannot be carried to extremes or printing times become over-long and part of the recording range of the film is 'used up'. A plate without an anti-halation backing can produce spectacular halos, being ten times as thick as most films.

THE EMULSION

The term 'emulsion' is strictly a misnomer, because it generally refers to liquid-in-liquid mixtures; what is normally known as an emulsion in photography might more properly be called a suspension of silver salts in gelatine.

The gelatine is derived from animal hides and

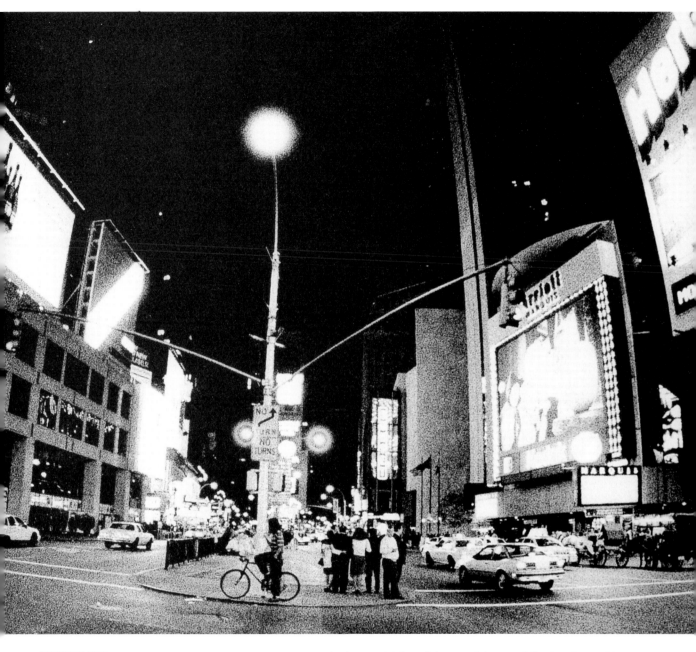

NEW YORK CITY

The main reason for including this picture is to show the textbook halation around the two lights by the NO TURNS sign positioned above the cyclist. Nikon F, 15mm f/2.8 Sigma fish-eye, Kodak TMZ rated at EI 12,500. (FES)

hooves: anyone who has ever made a strong meat stock and seen it set on cooling will have extracted gelatine from whatever was being cooked. Strict vegans may have a problem here. Gelatine contains all kinds of impurities, many of which actually increase the sensitivity of the emulsion, and further impurities and sensitising salts (in particular gold complexes) may be added at various stages of manufacture to make the emulsion faster still.

Traditionally, emulsions were made by adding a solution of silver nitrate to a mixture of gelatine and alkaline halides (of potassium, sodium, lithium, ammonium and cadmium), but this makes it hard to control crystal size and shape. Precise control of the proportions of the various ingredients – one of the secrets of modern emulsion technology – is made

MELT WATER, California

To some extent, textures like these can disguise grain, but even so, there seems to be an extra sparkle in the water when grain is reduced. Over-exposing Ilford XP2 (EI 200) reduces grain, unlike with conventional film. Nikon F, 90mm f/2.5 Vivitar Series 1 Macro. (FES)

much easier with 'double jetting', where the halides are added to the gelatine via one jet and the nitrate solution via another. The gelatine is normally at more than 35°C (95°F), and silver halides (bromides, iodides and chlorides) are precipitated; they are held in suspension by the gelatine.

The isoelectric point of gelatines – the point at which there is no charge on the molecules – varies according to how the gelatine is extracted (with acids or alkalis); with the pH of the gelatine solution (its acidity or alkalinity); and with temperature. The way in which gelatine traps silver ions and controls the growth of silver halide crystals can be controlled by varying all these. Choice of the appropriate alkali halides also controls crystal shape – ammonium and cadmium salts, for example, create a tendency towards triangular grains – but this is very much in the realm of trade secrets. Control of crystal size and

shape is what has made possible the 'new technology' films, with their markedly better speed/grain ratios.

To a large extent, this sort of control replaces the old 'Ostwald ripening' (or 'physical ripening') in the initial manufacture of the emulsion, where heat (and the presence of a silver halide solvent such as ammonia) influenced competitive crystal growth. Ostwald ripening and recrystallisation still play a part, as they did in the old ripening processes, but they are less important than they used to be.

Also, in place of the old empirical methods of emulsion manufacture, all kinds of analytical tools are now available including electron microscopy, energy-dispersive X-ray analysis, X-ray photon spectroscopy, X-ray diffraction and microwave conductivity, so more is now known about the structure and behaviour of photosensitive crystals than ever before – although empiricism still plays a substantial part.

The newly made emulsion is washed to remove reaction by-products and the excess of soluble halide. This is now done by coagulating or flocculating the emulsion, rather than by 'noodling', which involved adding more gelatine in order to make the emulsion set and then cutting it into noodles to wash. The washed emulsion is redispersed by warming with additional gelatine.

Now comes the 'digestion' or 'after-ripening' for a few minutes at 40°C (104°F) or above. Historically, the degree of after-ripening was judged by eye, from the colour of the emulsion in the kettles. Heat alone produces considerable increases in sensitivity – typically around sixteen-fold – but too much heat also increases base fog, so a compromise has to be struck, and anti-foggants such as 1-phenyl-5-mercaptotetrazole are often added. Other ingredients may also be added at this stage: chemical sensitisers to increase overall speed (mostly gold salts and sulphur compounds, including the familiar sodium thiosulphate), sensitising dyes (see page 55), hardeners to increase scratch resistance, plasticisers to keep the emulsion flexible when dry, and spreading agents to facilitate coating – for which the emulsion is now ready.

Core shell and T-grains

It is worth reiterating that 'new technology' films do represent a real improvement in sensitivity for a given grain size, or in graininess for a given speed, but what is less obvious is that the different manufacturers do things in different ways. For example, Ilford's core-shell technology uses an iodide-rich core as a 'positive hole trap' to prevent the electron which has been hit by a photon from recombining with its 'positive hole', while Kodak's T-grains persuade the crystals to accept more dye, thus leading to an increase in sensitisation; but these are very arcane points which are of interest principally to theoretical physicists and emulsion designers.

The reason these big crystals can give fine grain is that each of them is designed to form image centres at the edges, so each crystal gives (or can give) several image centres. Develop these and you are left in effect with lots of tiny image centres which overlap: fine grain, but high speed and good density. This is called 'annular' development, and it explains why over-exposure and over-development can lead to such bad results with 'new technology' films: the whole grain develops, and you end up with worse grain than you would get from a conventional film.

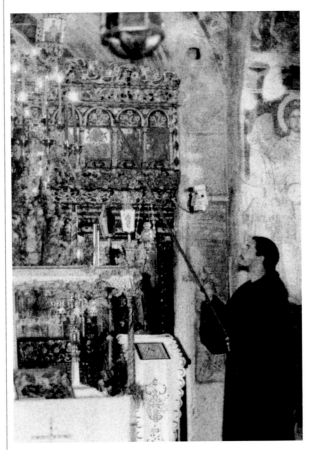

LIGHTING CANDLES

Traditionalists hate grain, but sometimes it seems to echo the subject, as in this Greek Orthodox monastery lined with centuries-old frescos. Even the slight loss of sharpness seems somehow appropriate. Nikon F, 50mm f/1.2 Nikkor, Kodak TMZ rated at EI 12,500. (FES)

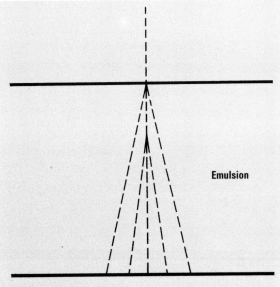

Fig 13 Irradiation
Irradiation is caused by the turbidity of the emulsion itself – the way that light is scattered within it. Thin emulsions obviously present less of a problem than thick ones.

Coating the emulsion

First, the film base is subbed: note that roll and sheet films are subbed on both sides. Next, the backing coatings are added (for roll and sheet film only – 35mm is normally unbacked) and finally the emulsion-side coatings are added.

These coatings must be as thin as is consistent with getting a good D_{max}, as a thick emulsion inevitably reduces sharpness because of the turbidity of the emulsion: light scatters as it passes through. This is known as 'irradiation' and is not quite the same as halation (see above), although the two can interact to create still greater problems than you would expect from either on its own: thin-emulsion films are definitely sharper than those with thick emulsions. In practice, monochrome films often have two emulsion coatings – one fast and one slow – but in order to understand the reasons for this we need to move on to the next chapter, which deals with speed, latitude and sensitisation.

OLIVE GARDEN RESTAURANT, New York City
Halation, irradiation and lens flare can be difficult to distinguish, but the glow around this neon sign is principally irradiation, with some halation. Nikon F, 15mm f/2.8 Sigma fish-eye, Ilford HP5 Plus rated at EI 800. (FES)

SPEED, LATITUDE AND SENSITISATION

Speed, the most familiar of the subjects in this chapter, is a measure of how much (or how little) light is required to form an image. We have already seen how ISO speeds are determined, but regardless of how you measure it, speed is influenced by grain size and by a host of sensitising factors.

Sensitising factors can be dealt with quickly because they are not something the average photographer wants or needs to get into. Apart from innumerable trade secrets, the interaction of gelatine and silver salts is still not fully understood: there are all sorts of micro-impurities which affect sensitivity, including even the diet of the cows from the hides of which the gelatine is made. It is little short of miraculous that films are as consistent as they are.

Grain size is something with which photographers are more familiar, and all that they really need to know is that bigger grains are more sensitive. Any individual grain may or may not be affected by light, but once it has been affected, it will develop. In truth,

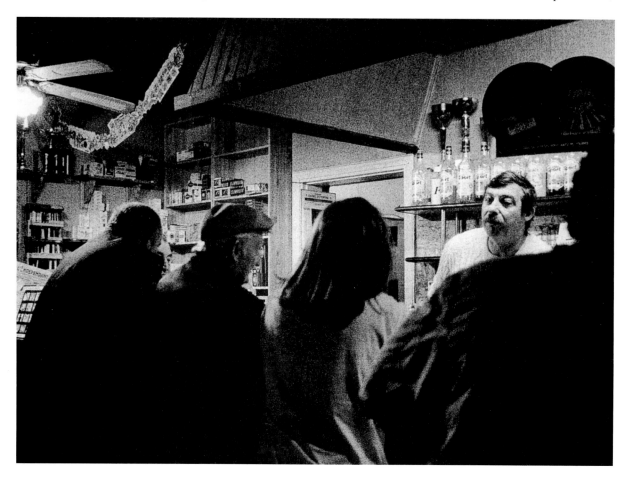

PLOUGHED FIELD, Kent

Contrast is a matter of taste. More contrast would make this a more graphic shot, but it would also lose the texture of the earth. The white flecks are not flaws: they are birds, as is visible (just) in the original print. Canon FTb, 35–85mm f/2.8 Vivitar Series 1 Varifocal, Foma 100. (RWH)

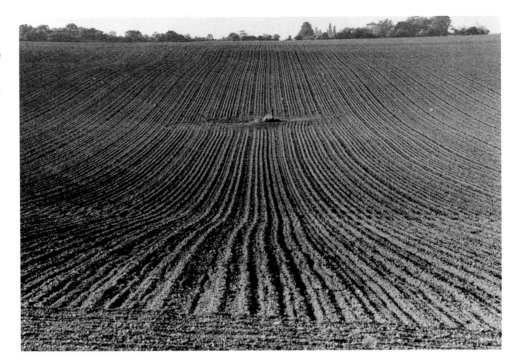

'grain' as perceived in a print is actually clusters of grains; look at photomicrographs and you will see that they are commonly at magnifications of 1,000 times and more.

While 'fine-grain' films have very few coarse grains, coarse-grain films have plenty of fine grains as well as the coarse ones. Improving the consistency of grain sizes can make for films which are both faster and finer grained than films where grain sizes vary widely and, as we have already seen, this (together with multiple image centres on a single grain) is what is done with 'new technology' films. Unlike some things, these are genuine scientific improvements, not marketing hype. Indeed, the constant flow of new or improved materials is driven by the technologists, not by the marketing men: they genuinely do keep making better and better films.

Obviously, grain is more relevant with smaller formats than with larger ones, since with cut film you rarely make big enough enlargements for it to matter. Also, both exposure and development affect grain size: an excess of either will increase granularity,

◀ **LE TIPHANY, near Calais**

Mere speed does not necessarily preclude resolution. In the original print, a 6x enlargement from Kodak TMZ rated at EI 12,500, it is possible to read the mast-head of L'INDÉPENDANT to the left of the first patron and GITANES (upside down) on the shelves above the head of the second. Nikon F, 35mm f/2.8 PC-Nikkor. (FES)

except with chromogenic film such as Ilford XP2 and Kodak VT400CN (see page 115).

Working speeds

From a photographer's point of view, what is important is not the ISO speed (see page 29) but the working speed or exposure index (EI). This is governed not only by the photographer's working habits and preferences, but also by the developers used.

When using the manufacturers' recommended developers at the recommended times and temperatures, EI and ISO are likely to be quite close, although many photographers habitually over-expose by ⅓ stop or so because this practice often confers slight gains in the shadows without any corresponding losses in the highlights.

Fine-grain developers commonly reduce the working speed by ½ stop or 1 stop compared with the ISO speed, while 'push' developers often give ⅔ stop increase in speed without any loss of shadow detail and (with the right films and developers) negligible increases in grain. Further pushes generally result in some loss of shadow detail or increased grain or both.

In other words, an ISO 100 film might work perfectly well for one photographer at its rated speed; another might rate it at EI 80, for extra shadow detail; a third might use a fine-grain developer, and rate it at EI 50; a fourth might use a speed-increasing developer which gave EI 160 without significant loss

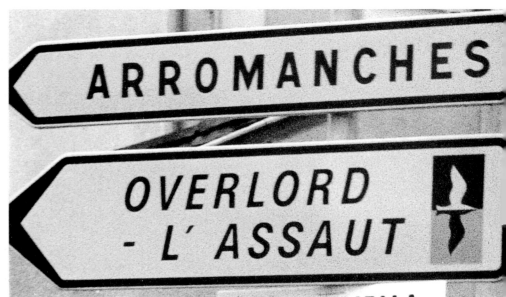

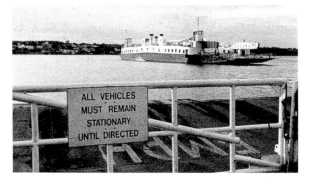

GRAIN AND SHARPNESS

The full-frame pictures are printed 'all in' from Ilford Delta 100 (Arromanches), Kodak TMZ (rated at EI 12,500 – Torpoint ferry) and Ilford XP2 (AA outfit)). The three sectional blow-ups are all reproduced at the same magnification so that you can see the effect on grain and sharpness. Both the Delta 100 and the XP2 are effectively grain-free at a 15x blow-up, although the Delta 100 is slightly sharper.

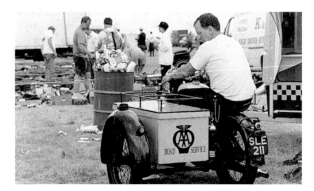

of quality; and a fifth might rate it at EI 400, accepting some loss of shadow detail and rather bigger grain as the price of the extra speed. An ISO 400 film would normally give better results than a 'pushed' ISO 100 film, but there are times when you just do not have any fast film in your camera bag. All of these ratings, from EI 50 to EI 400, are perfectly defensible, if they give the results you want: in photography, it is results rather than theory which matter.

Once you have accepted the potential for discrepancies, it becomes a question of establishing just how useful the films of different speeds can be, and what they can do for you. This normally centres around the finest attainable grain on the one hand, and the maximum speed on the other.

At any given time, there is a speed/grain balance which is so convenient for the vast majority of pictures that it becomes in effect the 'standard'. From the 1950s to the 1990s, the 'standard' speed for monochrome films was commonly quoted as ISO 100 or 125, but recent advances have meant in effect that the best ISO 400 films are fine grained enough for the vast majority of applications, thereby relegating anything slower to the realms of 'slow' and redefining 'fast' as 'significantly over ISO 400'. This is the system of definition that is used in this book.

Reciprocity failure

At shutter speeds of much less than $\frac{1}{1000}$ second, many films require an extra ½ stop. At more than one second, try 1 stop at 10 seconds, 2 stops at 100 seconds, and 3 or 4 stops at 1,000 seconds (a quarter of an hour, roughly). These are only rules of thumb, but if you do not have the manufacturer's information to hand, they are a good start.

LATITUDE

Latitude is the ability of a film to cope with over- or under-exposure, and is closely related to speed. 'Everyone knows' that monochrome films have more latitude than colour slide films, where a stop too much exposure can wash them out and a stop too little can make them murky – but there are nevertheless quite a lot of things that most people do not know. For optimum results, monochrome exposure is scarcely less critical than colour exposure.

Reference to the D/log E curve illustrates this well. As we have seen, for most purposes a negative has a maximum useful density range of around 4 stops, 1.2 log density units or 16:1. With normal development, however, this will record a range of subject brightness

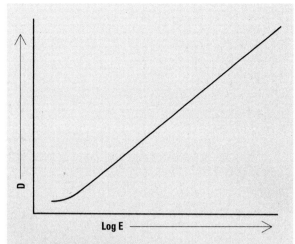

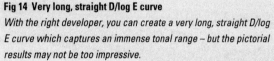

Fig 14 Very long, straight D/log E curve
With the right developer, you can create a very long, straight D/log E curve which captures an immense tonal range – but the pictorial results may not be too impressive.

of around 7 stops, 2.1 log density units or 128:1; and with extra exposure and reduced development this can be raised to around 10 stops, 3.0 log density units or 1,000:1, while still retaining a pictorially attractive image. Even longer ranges – as much as 1,000,000:1 – can be captured with special developer formulae, but the photographs are unlikely to have any pictorial merit whatsoever.

Again from the information in Chapter 2, we know that a print can just about hold a brightness range of 150:1, which equates to 7⅓ stops or 2.2 log units. This is quite adequate to hold many scenes, but if (for example) you want to hold a 10 stop (1,000:1, 3.0 log unit) subject on the print, either there must be some loss of shadow and/or highlight detail, or the tones must be compressed. Taking the 10 stop example, each stop on the original subject must be represented as about ¾ stop on the print (and by less than ½ stop on the film).

Even then, the tones will not be separated in exactly the same way as in the original subject: the brightest highlights will be compressed because they fall on the shoulder of the characteristic curve of the negative, and the darkest shadows will likewise be compressed because they fall on the toe. Transferring these tones to paper will 'clip' them still further, because the paper also has a shoulder and a toe. The idea of transferring long tonal ranges from subject to paper in a 1:1 relationship is an unattainable ideal, no matter what Zone System aficionados may believe.

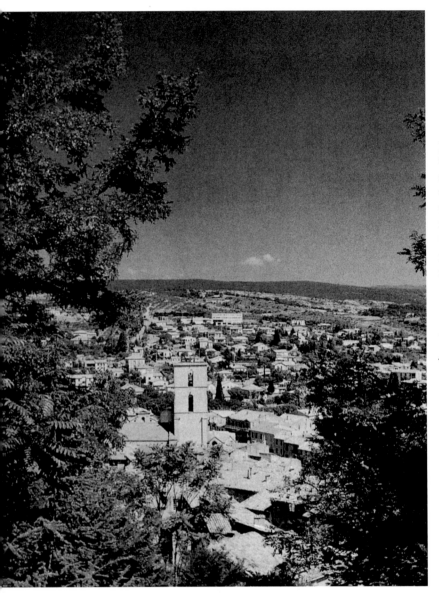

VIEW FROM THE FORTRESS, Forcalquier

A slight loss of sharpness is visible in the original print, because the image was formed with both visible light and near infra-red, and the lens was not stopped down quite far enough for depth of focus to take care of the discrepancy; this was shot on Ilford SFX 200 with a tri-cut red filter. Nikon F, 35mm f/2.8 PC-Nikkor. (FES)

▶ **TREES, Marshside, Kent**

Two film stocks, one print: the trees were shot on 6.5x9cm Ilford Ortho Plus, while the sky is from a 35mm negative on Ilford SFX 200. This is combination printing which is described on page 189. 'Baby' Linhof and Nikon F. (FES)

The above figures are based on glossy paper. Switch to a matte (or matt) paper, and the density range on it may easily fall as low as 20:1 (4⅓ stops, 1.3 log units) and will rarely exceed 32:1 (5 stops, 1.5 log units). The printed page will normally be in the range of 10:1 (3⅓ stops, 1.0 log unit) or less for really nasty newsprint to maybe 60:1, although 25:1 to 30:1 would normally be regarded as pretty good.

Mitigating factors

There are at least five factors which work in the opposite direction to what has just been said, and which have given rise to the belief that monochrome films do in fact have a very wide latitude.

First, there is the psychological factor. People notice highlights first: the eye is drawn straight to them. Some compression in the highlights is no bad thing, as it 'balances' what the eye would otherwise fail to notice in the mid-tones and shadows. Also, a great deal can be done with lighting: a rich, dense print under strong light will present a wider tonal range than is possible with any print under less brilliant lighting.

Second, most people are not even aware of what a first-class black and white print looks like. They are pleased with recording a subject brightness range of 32:1 or less (1.5 log units, 5 stops). In this case, the film should still have both shadow detail and highlight detail which are not recorded in the print. If the exposure is a stop out either way, it will not matter to them; over-exposure simply means that there is more shadow detail in the negative which is not used in the print, and under-exposure that there is more highlight detail which is not used. Losses in highlight detail because of over-exposure and in shadow detail from under-exposure are not noticed. To be sure, even ⅓-stop variations may be noticeable in prints made by a master printer, but there are not many master printers in the world.

From all of this, it is clear that when you are going for ultimate quality, monochrome film has very little latitude if you are photographing a subject with a tonal range of much more than 100:1 or maybe 200:1. Over-expose it, and you block up the shadow detail that you wanted to keep; under-expose it, and you burn out the highlights.

Third, there are different grades of printing paper. A 'flat' negative can be brought back to life with a hard grade of printing paper, while a contrasty negative can to some extent be redeemed with soft paper. As long as the print has a reasonably full tonal range, it will satisfy most people.

Fourth, some films automatically compress the tonal range quite significantly. Ilford's XP2 is the most remarkable of these, capturing a brightness range of around 1,000:1. The tonal range is compressed in the process, but it can easily be expanded again by using a harder grade of paper, typically grade 4 instead of grade 2 or 3. For effective latitude, XP2 is unbeatable in practical use.

Fifth, you do not always want to capture exactly the tonal range of the subject in a 1:1 fashion. You may well find you get better pictorial results by increasing differentiation in the mid-tones, and letting the brightest highlights or the darkest shadows (or both) go hang. Large areas of burned-out highlights are seldom attractive, but large areas of pure black can be very effective indeed; and if there are only small areas of bright highlights, you may not be too worried about highlight detail.

Of course, if the subject brightness range is much less than about 100:1, as it can be in the studio (or even on a foggy day, for that matter), then the film can capture more than is present in the subject, even on a 1:1 correspondence in the final print. Flat contrast ratios can be expanded by under-exposure and over-development, in exactly the opposite way to compressing contrast, but this is not a question of latitude and is covered on page 117.

◄ ▲ **PRESTON-NEXT-WINGHAM**

One of these two pictures (above) was shot on Ilford Type 55 P/N, unfiltered, the other (opposite) on Kodak High Speed Infra-Red with a red (Wratten 29) tri-cut filter. The way in which the IR film appears to see 'through' and 'into' IR-reflective foliage is abundantly clear. As well as the foliage, note the tonal differences in the house, lake and fence. Walker Titan 4x5in, 120mm f/8 Schneider Super Angulon. (FES)

Double-coated emulsions

The traditional way to get maximum latitude was to coat two emulsions, one atop the other. One was a slower, finer-grain emulsion and the other was faster and coarser grained. The idea was that at one extreme the fast film would get some sort of image even if the exposure was too low to affect the slow film, while at the other, the slow film would record highlight detail long after the fast film had blocked up solid. The obvious disadvantage is poor sharpness as a result of the thick emulsion sandwich, but these films were intended for en-prints from box cameras or for very modest degrees of enlargement.

And yet today the double-coated emulsion is again commonplace, and for much the same reason. With traditional emulsions, a wide range of different crystal sizes was present in fast emulsions, from large to small; in slower emulsions the crystals were smaller, but there was still a good range of sizes. It was this range of sizes which accounted, in large part, for film latitude. With modern monosize crystals however the range of sizes is much smaller, and latitude is accordingly reduced.

FOLK SINGER, Broadstairs Folk Week
With fast enough lenses, you can use quite modest film speeds even in very poor lighting. This was shot with a 35mm f/1.4 Summilux on a Leica, wide open, on Ilford XP2 film (ISO 400). It may not read in reproduction, but in the original print the sleeve of the singer's dark sweater is visible against the pitch-dark outdoor background. His face was metered with a Gossen Spot Master 2. (RWH)

The way around this is to coat a thin layer of fast emulsion on top of a thicker layer of slow emulsion – although both layers together may well be thinner than a single layer of the old thick-emulsion films. The fast emulsion takes care of the toe of the curve, but if it were all that was there, latitude would be low, contrast would be high (because all grains would develop at about the same exposure), and grain would be very coarse in the higher densities. The slow emulsion takes care of the mid-tones and the maximum black (D_{max}), while still retaining a much lower

graininess. Of course, if the slow emulsion were all that was there, you would once again get low latitude and high contrast.

In practice, all kinds of tricks can be played by mixing different proportions of the two emulsions, either literally or one atop the other. Not all emulsions mix well however – there can be problems with turbidity and even speed loss – so this is very much a 'black art', and it is not without reason that emulsion chemists often reckon that their craft owes as much to alchemy as to chemistry.

Speed and latitude
Other things being equal, a faster film of traditional single-emulsion type will normally exhibit more latitude than a slow one will. This is a consequence of the bigger spread of crystal sizes in the faster film, as mentioned above. On the D/log E curve, slow, low-latitude films demonstrate a steep straight-line portion with short toe and shoulder.

The net result is that if you over-expose a slow film, the highlights will burn out to clear white on the print (maximum black on the film). Under-expose it, and the shadows will 'block up' to featureless black (clear film). With a faster film the transition is rarely so abrupt, and you may be able to make a much more acceptable print.

Other things are not always equal, of course, and early examples of 'new technology' films exhibited less exposure latitude than older types such as Tri-X or the Ilford 'Plus' series. Today, the best 'new technology' films are as tolerant as traditional emulsions, although some still lag, and this is to a large extent achieved by coating with two dissimilar emulsions, as explained above.

SENSITISATION: ORDINARY, ORTHO AND PAN FILMS
Although speed and latitude are familiar concepts (even if they are not always fully understood), sensitisation is less well known. This is because almost all films today are 'panchromatic', meaning that they are sensitive to all colours of the visible spectrum. They are not, however, equally sensitive to all colours, and in order to understand this you have to know a little about sensitisation.

In the distant past, all films (or plates, in those days) were 'ordinary', or sensitive to blue light only. If they were exposed by light rich in blue and indeed ultra-violet rays, they were surprisingly fast: this is what our forbears meant when they referred to 'highly

actinic' light. If, on the other hand, they were exposed to light which was primarily yellow and red, they could be very slow indeed – even to the point of failing to register an image at all under red lighting, which is why safelights work.

Inevitably, an 'ordinary' plate gave a somewhat distorted impression of colours in a picture. The worst example might be a child with blue eyes and red lips: the iris of the eyes would wash out almost to nothing, leaving a pinpoint pupil, and the lips would read as black. Results in landscapes were better, but still not good: skies would normally register as a featureless tone because there was no differentiation between blue and white, and (for example) red brick would read almost as black.

In 1873, Vogel found that by adding dyes to the emulsion, the film could be made sensitive to green light as well as blue. Better still, the speed of the film increased at the same time, as the green sensitivity was in addition to the blue. The first commercial dye-sensitised plates were introduced in 1882 and were called 'isochromatic', meaning 'equal colours'. This was something of an exaggeration. Only two years later, considerably improved plates appeared using erythrosin, and these were called 'orthochromatic' (often shortened to 'ortho'), meaning 'right colours' – although in fact they were still sensitive only to blue and green. As these plates improved, they came to be called 'highly' or 'fully' orthochromatic – which was still an exaggeration.

In due course, dyes appeared which extended sensitivity into the red as well; the earliest useful one was pinocyanol. The first commercial plates with this were introduced in 1906 and were called 'panchromatic' for 'all colours' (often abbreviated to 'pan'). Since then there have been still further improvements – a number of new cyanine dyes were discovered after 1926 – and today almost all films are panchromatic. The extent to which they are sensitised to red varies widely, and the term 'extended-red pan' is applied to pan films with unusually high red sensitivity as well as to films which exhibit an almost infra-red sensitisation because of deliberate sensitisation for this purpose.

Apart from its speed, an extended-red pan film has one notable advantage and one notable drawback.

ROGER
Ortho film – this is Kodak Commercial Ortho – can be used for 'character' portraits of men, and for young women and children with flawless complexions, but it is not necessarily flattering to everyone.
De Vere 8x10, 433mm f/8 Ross, Thornton Pickard shutter. (FES)

The advantage is that it has the same speed to tungsten light as to daylight. Because tungsten light is richer in red than daylight, a plain pan film may be up to a ½ stop slower under artificial light, while an ortho film is commonly a full stop slower. The drawback of an extended-red film is that reds record lighter than the human eye perceives them, so complexions and even lips can appear unnaturally light. Perfectionists in portraiture may therefore use a very weak blue filter, or even go to ortho film in order to emphasise ruddy cheeks and cherry lips – although this is a strategem which works better with fresh-faced children and young women than with middle-aged men with drinkers' complexions.

Two more reasons why ortho films survived for so long are expense (ortho films were cheaper than pan) and the fact that an ortho film will give a sharper image than pan if the lens is poorly colour corrected. Such a lens may not bring the different colours to a common focus, but it will not matter too much because the red light will not record. A third reason, helpfully suggested by friends at Ilford, is that ortho films can be processed under a red safelight if you are afraid of the dark.

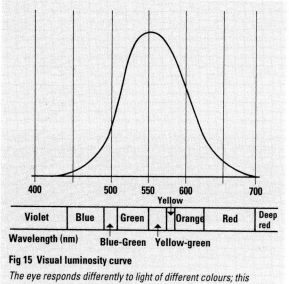

Fig 15 Visual luminosity curve
The eye responds differently to light of different colours; this diagram shows a typical curve for normal lighting conditions.

It is also worth adding that undyed Kodak T-grains are very nearly transparent to blue light, so blue sensitivity is much lower than might normally be expected. Some compensation is afforded by increased sensitivity to red via dye sensitisation, and examination of published wedge spectrograms will confirm this.

Wedge spectrograms
Colour sensitivity can be quantified with the help of wedge spectrograms, which are surprisingly easy to understand once you know what you are looking at.

The first thing to find out is what wavelengths of light correspond to which colours. The second thing you need to know is that the human eye is most sensitive to green light of about 550nm wavelength. Below about 490nm and above about 630nm, sensitivity is about one-quarter of that at the peak; after that sensitivity declines rapidly, although a bright enough flash is apparently visible at 750nm or more: this is why the distinction between 'deep red' and 'near infra-red' is not easy to make. The visual luminosity curve (Fig 15) gives a good idea of how the human eye responds to different colours, and of how those colours relate to wavelengths.

Strictly, this is the curve for normal, bright conditions (the 'photopic eye'). Under poor light the eye will adapt, and maximum visual sensitivity for the 'scotopic eye' is at about 515nm; the whole curve shifts to the left and becomes slightly more pointed. This is known as the Purkinje shift, and it explains

why safelights for pan materials are blue-green rather than yellow-green.

A wedge spectrogram gives the same sort of sensitivity curve for film, and is obtained in an ingeniously simple way. The diagrams make it clear. White light is split by a prism into the familiar rainbow. In practice, the spectrum extends beyond the blue and violet into ultra-violet (UV), and beyond the red into infra-red (IR); all film is sensitive to UV, and with the appropriate dyes it can also be made sensitive to IR.

This spectrum is projected onto the sensitised material through a graduated filter (the 'wedge'), which is darker at the top than at the bottom (Fig 16).

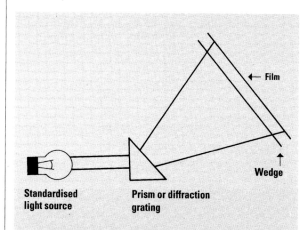

Fig 16 Wedge spectrometer
The principle is quite simple. A diffraction grating splits the light into a rainbow, in the same way as a prism does. In fact, we have drawn a prism to make it clearer. This rainbow is allowed to fall on the material under test, but through a wedge which is steadily denser from bottom to top. Where the film is particularly sensitive, the light penetrating the wedge affects it more.

Where the sensitised material is particularly sensitive, there are peaks, and where it is less sensitive, there are troughs (Fig 17). The X axis (left to right) is always wavelength, while the Y axis (up and down) does not need to be specified in units, as it is merely a matter of relative sensitivity. If it is twice as high at one point as at another, then it is twice as sensitive to light of one wavelength as it is to light of the other.

The spectrum will depend on the light source used, and a typical light source is International White Light SA, a tungsten lamp operating at 2,848°K. SB is Standard British Daylight, while SC and SD are American daylights. Its shape will also depend on how the light is split: compared with a diffraction grating,

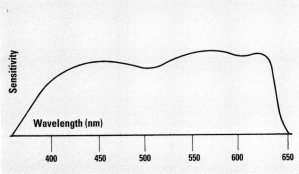

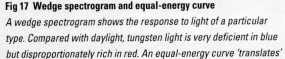

Fig 17 Wedge spectrogram and equal-energy curve
A wedge spectrogram shows the response to light of a particular type. Compared with daylight, tungsten light is very deficient in blue but disproportionately rich in red. An equal-energy curve 'translates' the tungsten curve into what it would resemble to a light source with equal energy in all wavelengths. This is for 400 Delta Professional film. (Courtesy Ilford Ltd)

a prism will compress the red end of the spectrum relative to the blue, so different manufacturers' wedge spectrograms may not be comparable – although any one manufacturer's spectrograms should be useful for comparing different films tested in the same way.

Three wedge spectrograms are shown, courtesy of Ilford. They are Ortho Plus, HP5 Plus and SFX 200. All are sensitive to UV light, peaking at around 450nm (deep blue), but after that you can see the dye sensitisation peaks with the troughs in between. The Ortho Plus dye peak is just after 550nm (yellow-green); the HP5 Plus dye peaks (panchromatic sensitisation) are at about 570nm (yellow-green) and 640nm (orange-red); and the SFX 200 dye peaks (extended-red sensitisation) are at about 600nm (orange) and 720nm (deep red/near infra-red).

If a film is sensitised only for infra-red, there will be a 'green gap' between the normal 'ordinary' sensitivity and the IR dye peak, which may be at anything from about 825nm to 1,050nm; Konica's '750 IR' exhibits the 'green gap' even though the IR peak is at only about 750nm, which is on the borderline between deep red and near IR. Not all IR materials exhibit the 'green gap', but it well illustrates how sensitising dyes can be used.

WEDGE SPECTROGRAMS
These spectrograms show the spectral response of three films: Ortho Plus, HP5 Plus (panchromatic) and SFX 200 (extended-red/near infra-red). The basic sensitivity of the silver halide is clearly visible, as are the peaks of the dye sensitisation, and you can see how the sensitivity dies away rapidly after the last dye peak. You can also see how a wedge spectrogram, as conventionally drawn, is open to interpretation. (Courtesy Ilford Ltd)

Infra-red and extended-red films
Not all films which are sold as 'infra-red' can fairly claim the name. True IR films are normally sensitised out to anything from 900nm to 1,100nm, and can be used with filters which are visually opaque. At the time of writing the only manufacturers offering IR films for general use were Konica (35mm and roll film, peaking at 750nm) and Kodak (35mm and 4×5in sheet film, sensitised beyond 900nm), although there was some hope that Fomos in Moscow might repackage some of their aerial films for 35mm amateur use: at least one of these goes out beyond 1,100nm, peaking at 1,050nm. Ilford's SFX 200 extended-red film (35mm only, sensitised to about 740nm) is similar in application and use to the Konica material, although it is not a true IR film.

The greater the IR sensitisation, the more dramatic the effect, although the films with the more modest

PAGES 58–59 MONO LAKE, California

Ilford's SFX 200 is not a true IR film, but it does have an extended sensitivity which goes into the near infra-red. With heavy red filtration (this is a tri-cut red) this permits some very dramatic effects, as with this near-black sky and water and very pale grasses. Nikon F, 35mm f/2.8 PC-Nikkor. (FES)

sensitisation are much easier to handle; for a start, extended-sensitisation film should be loaded into the camera in pitch darkness, and exposure determination is therefore considerably more difficult. With a film sensitised to 740nm or 750nm, a conventional tri-cut filter requires only about an 8× exposure increase compared with a straight meter reading, while a B+W 092 'deep dark red' requires at least 16× in daylight (less in artificial light).

Konica's 750 IR film (predictably) shows a sensitivity peak at 750nm, although it falls off rapidly

beyond this. It is a true IR film, but is not sensitised very far into the infra-red. Ilford's SFX 200 peaks at around 720nm and is sensitised out to 740nm, but its wedge spectrogram shows no 'infra-red gap' and reveals that it is in effect a panchromatic film with additional sensitisation into the near infra-red. This is why it is sold as 'special effects' film, not as 'infra-red'.

Films which are sensitised only into the very near infra-red are normally used with deep red filters (Wratten 29, red tri-cut). Those which are sensitised beyond 900nm can be used with deep red or even 'black' filters, which are so deep red as to be almost visually opaque. Without filtration, IR films give results similar to extended-red-sensitivity films.

With a filter such as a B+W 093, where transmission begins at 740nm and is no more than 2 or 3 per cent at 750nm, the Ilford film would record nothing at all, and the Konica would record very little. With something like an 092 (beginning at 650nm, 80 per cent at 700nm, 95 per cent by 750nm), both would work much better – although if you used just a yellow filter you would see far more effect with the Konica than with the Ilford, because of the 'infra-red gap'.

With IR films, the point of focus of IR rays may be slightly different from that of visible rays. Some lenses have IR focusing marks, while with others the only possibility is experiment; you need to wind out the lens a fraction of a turn. If you are using visible rays as well as IR, as you will be with conventional red filters, you may find it preferable to make no focus adjustment but to stop down to f/8 or below in order to cover up any errors in focusing and to mitigate the effects of chromatic aberration.

A problem often mentioned in older books, but which we have yet to encounter, is that some plastics and some leather bellows were apparently not fully opaque to IR, which led to fogging. A more pressing problem today arises with cameras which use IR LED sensors to count sprocket holes. These can fog IR films to the extent that they are useless – and there are some top-notch cameras which do it. Check your owner's manual, or just look

RUINS, Knossos

Infra-red films often exhibit considerable halation, which gives a 'dripping with light' effect, as can be seen in this Konica shot of Minoan ruins in Crete. Nikon F, 35mm f/2.8 PC-Nikkor. (FES)

ROBINSON CRUSOE'S WATCH

This is an example of our 'false lith' technique. The original Ilford Ortho Plus negative was rated at EI 40 to flash (manufacturer's ISO 80) and developed for two minutes in Tetenal lith developer. As may be seen from the conventional print, which is on grade 1, this gave a contrasty but not quite lith picture. Printing it on Sterling Lith paper

(processed in Fotospeed Lith Developer) dropped out the middle greys entirely. For a full lith effect, dropping out the remnants of half-tones in the shell, the answer would have been an interpositive and internegative on true lith film or on similarly processed Ortho Plus. Gandolfi Variant, 210mm f/5.6 Schneider Symmar. (RWH)

inside the camera back, to see if this is a problem.

The effects obtainable with any IR film are always unpredictable, but there is often a sort of liquidity to the light which can be quite magical, and many practitioners of hand-colouring also find that infra-red films are well suited to their craft.

The belief that IR films somehow record the warmth of the body is flatly wrong, as the 250°C or so – say 500°F – which is the practical starting point for photography with fast IR film would be a severe fever by anyone's standard.

OTHER SPECIALIST FILMS

Lith and line films are very high-contrast materials designed for graphic arts use. Their main purpose is in typesetting, where all you want is a black/white image with no shades of grey. They are processed in high-activity developers (see page 113) and when used to shoot continuous-tone subjects give a very short grey scale between a very dense black D_{max} and a clear film D_{min}.

Although lith and line films can be used in camera to shoot originals, this is not generally a very good idea as latitude is negligible and you may well miss the exposure altogether. The more usual approach is to make an interpositive from a conventional negative (either by projection or by contact), then contact print that onto another sheet of lith film to make an internegative. The two extra generations (interpos and interneg) also help to 'drop out' intermediate greys, giving only pure black and pure white tones.

Lith and line films are normally used in sheet form, although the same emulsion may also be coated in 35mm. Most are 'ordinary' (blue-sensitive), but ortho films are also common.

Another possibility is to shoot on Ilford Ortho and process it in a very high-contrast developer, either a lith formulation or Kodak D19. If you then print this on lith paper (see page 144) you will have something very close to a true lith effect – with the right subject, it can be indistinguishable – but without the hassle of internegs and interpositives. This is what we do.

Finally, 'fine-grain positive' is a slow emulsion, akin to a bromide paper emulsion, which is used to make either contact or enlarged internegatives and inter-positives (see page 108). Despite its name, it is not particularly fine grained.

FILM CHOICE AND FORMAT

Film choice is governed by at least seven objective considerations, and two that are subjective. The subjective considerations are easiest to deal with first.

To begin with, there is habit – and to this day, this still tends to go along national lines, so British photographers use Ilford, and American photographers use Kodak. This is foolish in the extreme, because both companies offer films for which there is no equivalent in the other's line-up, and there is always the possibility that an unfamiliar film – one you haven't tried – may deliver just the 'look' that you want in a particular situation.

'Look' is the second subjective consideration, and it explains why there are several 'love/hate' films on the market: Kodak T-Max 100 and Technical Pan, for example, or Ilford Pan F Plus. Those who like them, love them: they find that they can get superb results which are not obtainable in any other way. Those who dislike them have not been able to get the look they want. Neither camp is 'right' or 'wrong', and to debate this point is about as meaningful as arguing about whether it is 'right' or 'wrong' to like strawberries.

Quite apart from the love/hate films, there are also numerous films from lesser-known manufacturers which provide their own 'look'. For example, we are particularly fond of Forte cut films in 6.5×9cm size, even where objectively we might do better with (say) Ilford 100 Delta Professional.

Moving on to the objective considerations, the first and most basic is availability. Much as some may pine for 4×5in Royal-X Pan at 1250 ASA, there is no wide demand for ultra-speed films in large formats, so they are no longer made. The range of films is probably widest in 35mm, followed by 4×5in and then 120; in some of the more unusual sheet film sizes, or in 70mm, the choice may be very limited indeed.

The second objective consideration is suitability for a particular job. For instance, using Ilford Pan F Plus for available light reportage would be somewhat masochistic; equally, you would not normally want a low-contrast film for microfilming newspapers. Often, suitability is intimately intertwined with availability: the example of 4×5in Royal-X Pan has already been quoted, and Pan F Plus is not coated in 4×5in because at that size it gives no significant sharpness advantage.

The third consideration is grain. The larger the format, the less important this is.

The fourth is resolution. Again, this is more important with 35mm and sub-miniature formats than with

FLOWER
Most people would not dream of using Kodak TMZ rated at EI 12,500 for a flower – but Frances liked the look of the film, and so decided to try it. As can be seen, the gradation is surprisingly subtle, over a limited tonal range. Nikon F, 90mm f/2.5 Vivitar Series 1 Macro.

▶ **STREET, Rhodes Old Town**
With large formats – this is from a 4x5in Polaroid Type 55 P/N negative – resolution and grain are secondary considerations, and you can give slightly more development for a higher D_{max} to get a longer, subtler tonal range. Toho 4x5, 120mm f/6.8 Schneider Angulon. (RWH)

roll film, and by the time you get to 4×5in film it is barely a factor at all.

Fifth comes ease of processing. Some films are much fussier than others to process: for instance, 'old technology' films like Kodak Tri-X can be processed in virtually anything and will give you a printable image, while Technical Pan from the same company is notoriously demanding.

The sixth consideration is price. Slower films are normally cheaper than faster ones, and 'old technology' films are normally cheaper than 'new technology'. Even if a particular film is slightly inferior for a given application, it may be more than adequate for record shots or for modest degrees of enlargement.

Finally – and it has to be admitted that this is part objective, part subjective – there is the tonality of the film. The objective part can be represented adequately by the D/log E curve, which shows how the film handles shadows, mid-tones and highlights, as well as what the contrast is like; but the subjective part goes back to the 'look' of the film. Many people believe that the old-fashioned thick emulsions such as Ilford FP3 gave a tonality which cannot be equalled with modern thin-emulsion films, and to some extent they are right; but equally, the tonality of the best modern emulsions such as Ilford 100 Delta Professional can be pretty miraculous.

Because of all of the above, it is probably easiest to begin by looking at film choice for large formats, where grain and resolving power are substantially irrelevant, and then to look at the ever more rigorous demands of the smaller formats.

CUT FILM

In the larger cut-film formats – bigger than 4×5in – the principal factors governing film choice are likely to be habit, 'look' and price. Some people use Central European films because they are cheaper than Ilford, Kodak or Agfa, and the results can be very good indeed: you may even find that you prefer their 'look'. In the less usual sizes, such as whole-plate (6½×8½in), availability may also be a factor.

At 4×5in, and to a lesser extent at 9×12cm, the choice is tremendous: all speeds up to ISO 400, infra-red (Kodak), transparency (Agfa Scala), high contrast, general-application orthochromatic (Ilford Ortho Plus) and so on... In fact about the only films you cannot get are those faster than ISO 400, because there is so little demand for them: if you want speed, Ilford HP5 Plus can be pushed to EI 1000 or even 1600 with little or no loss of shadow detail. Again, habit and 'look' will be the main considerations for most photographers in deciding what to buy, with price as a possible factor. At quarter-plate (3¼×4¼in), technical considerations are much the same as for 4×5in, but availability is much more of a question. Well into the 1990s you could even buy 4×5in plates from some manufacturers, although usually at a handsome premium as compared with cut film: for example, Kodak's T-Max 100 cost about six times as much per exposure.

For the small cut-film sizes of 6.5×9cm, 2¼×3¼in and 2½×3½in, availability is a major concern, and you may be constrained as to which films are available by precisely which format you choose. Also, because you are now looking at the same sort of size as a big roll-film negative, grain and resolution can start to be an issue with big (16×20in/40×50cm) enlargements. Fortunately, at the time of writing Ilford 100 Delta Professional was available in 6.5×9cm. Of course, the external dimensions of standardised cut-film holders are the same for all three of these 'baby' sizes.

ROLL FILM

As regards the most popular 120 size, the range of emulsions is similar to that for 4×5in, although

without the option of ultra-high-contrast lith and line films. Also, the only infra-red film readily available at the time of writing was Konica (see page 57). Foma T800, a true ISO 800 roll film, was the outright winner for speed, but a more usual (and often more convenient) route was again to push something like Ilford HP5 Plus.

At 6×9cm and 6×7cm, pretty much any film will give good 16×20in (40×50cm) enlargements and excellent 11×14in or even 30×40cm blow-ups; but when you come down to 645 or cropped 6×6, grain and resolution do enter into it and you will do better to use ISO 125 or slower films or, if you need the speed, 'new technology' ISO 400 films, including Ilford XP2. Also, unless you need the speed, you

◀ ▶ **BRIDGE, Marshside, Kent**

The kind of camera you are using and the focal lengths you have available will inevitably affect the way you compose your pictures – quite apart from the film's own 'look' and the photographer's eye. Frances shot this bridge on Ilford XP2 with a Nikon F and a 35mm f/2.8 PC-Nikkor (right), and Roger shot it on Fortepan 200 6.5x9cm with a 'baby' Linhof Technika IV and a 105mm f/3.5 Schneider Xenar (left).

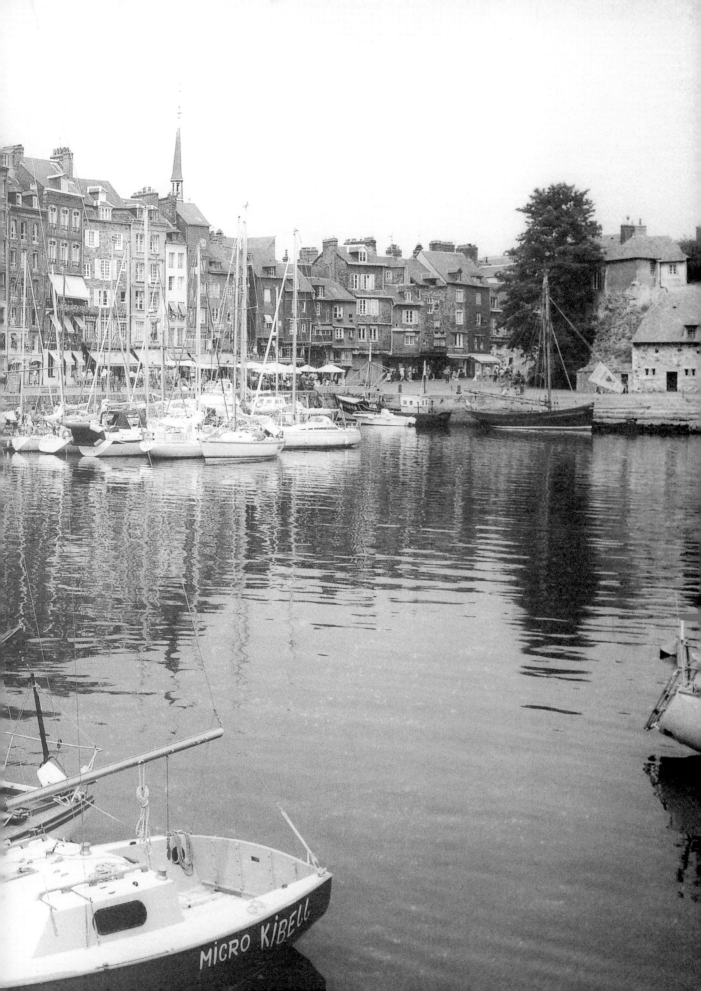

PREVIOUS PAGES 66–7 **HONFLEUR HARBOUR, Normandy**
The 56×72mm Linhof '6×7' format uses selected Linhof lenses – this
is a Schneider Angulon 65mm f/6.8 – and precision engineering for
maximum sharpness. Combine this with Ilford's wonderful 100 Delta
Professional and you have the potential for grain-free 16×20in
(40×50cm) enlargements which compare favourably with 4×5in. 'Baby'
Technika IV. (RWH)

TOHO FC-45A CAMERA
Contrary to what many people believe, the main advantage of larger
formats does not lie in extra resolution: rather, it is in the better
gradation, the increased ease of focusing on a bigger ground glass,
and the availability of camera movements. This camera, with the
120mm f/6.8 Angulon (normally used at f/22) was used to take many
of the 4x5in pictures in this book.

might as well take advantage of the modest cost
savings of slower films.

 With other roll-film formats such as 220, 127 and
70mm, you really have to take what you can get.

35MM

The very widest range of films is available for 35mm,
including three kinds of infra-red/extended-red, the
fastest general-application films available, ultra-slow
films, and even high-contrast lith and line films. By
the time you get down to this size, however, grain and
resolution really do start to be of major importance.

 Even so, 'new technology' ISO 400 films and Ilford
XP2 will deliver truly remarkable quality, and may be
regarded as the best available compromise between
speed and grain for many applications. If you want to
make really big enlargements, however, then ISO 100

RAZOR WIRE
It was pure chance that Frances had Tri-X – a film she almost never
uses – in her camera, but its grain and gradation seemed perfectly
suited to this study of shredded plastic sheeting trapped on the razor
wire surrounding a car park in New York City. Nikon F, 90mm f/2.5
Vivitar Series 1 Macro.

▶ **PORTRAIT OF ROGER**
Even with 6x6cm roll film, quite modest lenses may prove adequate.
This was shot on Ilford 100 Delta Professional with a Russian Lyubitel
twin-lens reflex with a three-glass lens. In the original print, the texture
of the tightly woven artist's smock is (surprisingly enough) perfectly
visible. (FES)

'new technology' films are better, along with slow (ISO 50 and below) 'old technology' films.

Nevertheless, there are plenty of good reasons for using other films. One is price: there are some bargains around, especially from Central Europe. Another is ease of processing: some films are far more forgiving than others. Yet a third is availability: Ilford HP5 Plus, pushed to EI 3200, may not be quite as good as Kodak TMZ at the same speed, but it is generally more widely available. A fourth is sheer, raw speed: there are times when everything is subservient to this, and Kodak TMZ can be pushed to EI 25,000. And, of course, there is the 'look'. For example, some people just prefer Ilford FP4 Plus to Ilford 100 Delta Professional, while others swear by the tonality of Foma films or the grittiness of Tri-X.

BLIND-SIDE BREAK

With pushed film used for sporting events, you can often get more drama by pumping up the contrast in printing. This is an enlargement from about one-third of a negative on Kodak TMZ rated at EI 3200, printed on grade 4½ paper. Nikon F, 300mm f/2.8 Tamron. (RWH)

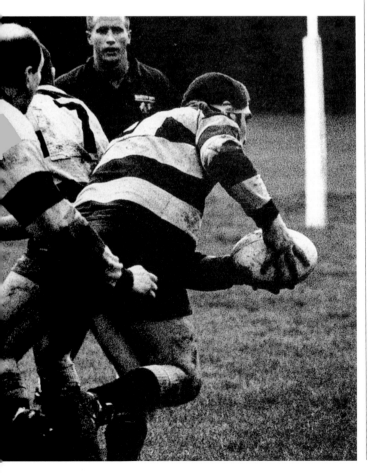

▶ BRUGGE

Used carefully, on a tripod, with the lens at its optimum aperture (typically f/8 or so) and on the right film (this is Ilford XP2), 35mm can deliver remarkable edge-to-edge sharpness on an 8x10in print. Nikon F, 35mm f/2.8 PC-Nikkor. (FES)

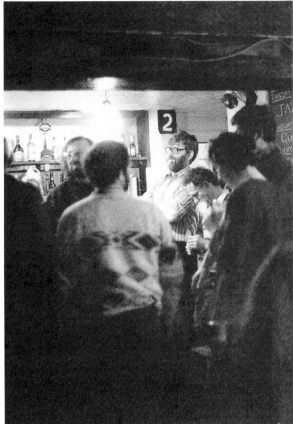

FOLK NIGHT AT THE GATE, Marshside, Kent

With ultra-fast lenses, such as the 35mm f/1.4 Summilux used for this picture, you can often use slower film than you would need with modern, slow zooms: this was shot on 400 Delta Professional pushed to EI 1000. On a reflex, faster lenses are easier to focus than slower ones, but this was shot with an M4-P Leica. (RWH)

SUB-MINIATURE FORMATS

For these tiny negatives you have to use slow, fine-grained films unless you want impressionistic, grainy pictures – although these can be very successful too. Camera manufacturers normally offer a very limited range of films, but a number of specialist suppliers can provide you with almost anything in cassettes for sub-miniature cameras, or you can slit your own. We no longer shoot sub-miniature film, but if we did we would probably use Ilford 100 Delta Professional and

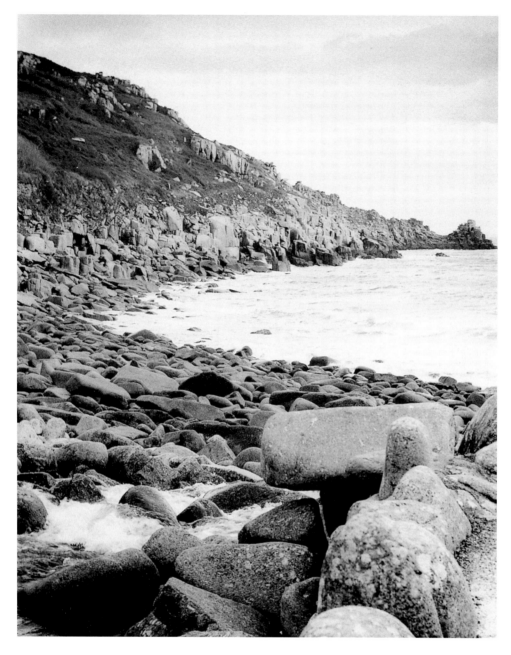

▶ **TREE AND ROCKS, Rhodes**
Polaroid Type 55 P/N is one of our favourite films in 4x5in. Despite being quite a high-contrast material, it can capture an enormous tonal range. Dodging, as under the large rock just right of centre, may well be required. Toho FC-45A, 120mm f/6.8 Angulon. (RWH)

LAMORNA COVE
Going for a larger format may improve grain and resolution, but it can also bring depth-of-field problems: depth of field depends solely on the size of the image on the film, so bigger formats mean less depth of field. 'Baby' Linhof Technika IV, 65mm f/6.8 Schneider Angulon, Forte 100. (RWH)

400 Delta Professional. If you can make it work, Kodak Technical Pan is reputedly very good, and Agfa APX 25 and Ilford Pan F Plus should work well.

POLAROID FILMS

These are often ignored, or treated as if they are not 'real' films, but they have a lot going for them. There is a very wide variety, in quarter-plate, 4×5in, 8×10in and 35mm form. There is no point in going into them in depth, because the precise line-up changes quite often and the names even more frequently, but

it is worth mentioning that with resolution in excess of 20 lp/mm (line pairs per millimetre) and sometimes as high as 25 lp/mm, origination from Polaroid print materials is perfectly feasible, and whole-page enlargements are quite realistic. The negatives from the pos/neg materials offer significantly higher resolution than the print materials, thereby permitting big, sharp enlargements.

As well as general-application black and white instant-print materials, Polaroid also offers a wide range of ultra-fast films (ISO 3000 to ISO 20,000),

some high-contrast films (although not as high con-
trast as lith and line), and a wonderful sepia material.

As for the 35mm 'instant process' films, the
standard Polapan slide film offers a superb tonality
and gradation which has been widely employed by
advertising photographers, but owing to the extreme
fragility of the emulsion it is almost essential to
duplicate the image onto conventional film before
allowing it into the hands of a printer or separation
house. A higher-contrast material (Polagraph)
has also found some use in creative photo-
graphy, and PolaBlue is an unusual blue and
white monochrome film of negligible latitude
and very low speed (ISO 8) which some
photographers have put to creative use.

HEADLINER

*In the days when we still used sub-miniatures we bought this
Headliner slitter, which allows 35mm to be sliced down to
16mm and 9.5mm. We have never
developed 9.5mm ourselves, but
16mm is no problem in an old
Paterson Universal tank.*

EXPOSURE AND METERING

There is no such thing as correct exposure, except perhaps in the context of an ISO testing procedure. There is however such a thing as a perfect exposure. A perfect exposure is one which manages to express exactly the mood which you wished to express – and it may be some distance from what most exposure meters or even an ISO test would have you believe.

Some of the circumstances requiring departures from 'correct' exposure are almost clichés: the over-exposed ballerina, the dark, depressive portrait. Others are more complex, especially when there is a long tonal range to deal with.

As discussed on page 32, the luminance range of a print may be anything from about 20:1 to 150:1, which may or may not correspond to the luminance range of the subject. Quite apart from the question of brightness range, though, is the question of a fixed point to which that range may be tied.

It is perfectly possible to take a picture in which the reflectivity of the final print approximates very closely to the reflectivity of the original subject. In real life, for example, Caucasian skin reflects about 25 per cent of the light falling on it. The negative and print can be made so that the skin in the photograph also reflects 25 per cent of the light falling on it. With a skin tone, this is generally a good starting point.

The potential for moving the fixed point can, however, be illustrated rather neatly by assuming that your Caucasian subject is standing in the shade, in front of a sunlit, whitewashed wall. If the skin tone is chosen as the fixed point, with reflectivity roughly equal to that of the original subject's skin, then the wall will be a solid white. But if you want texture in

RHODES OLD TOWN
Compare this with the picture of the lights in New York (opposite). The street scene is well lit, but the shop window is over-exposed almost to the point of being burned out. Leica M2, 35mm f/1.4 Summilux, Ilford XP2. (RWH)

the wall, you are going to have to give less exposure – and this will translate into both the wall and the skin being rather darker in the print than they were in the original subject. In addition, you may choose to increase exposure and reduce development, so as to compress the tonal range; but this is another matter.

It may seem like a near-miracle that exposure meters work successfully at all, but in practice two features act in their favour. The first is film latitude, especially when it comes to colour print films: meters do not have to be particularly accurate. The second, which is rather more surprising, is the remarkably constant average reflectivity of an overall scene, which generally runs from about 12 per cent to 25 per cent. This was originally determined empirically, and it has stood the test of time.

This may sound like a wide range, but it is only 1 stop. Often, it is asserted that average reflectivity is 18 per cent, as formalised with the well-known 18 per cent grey card, but this is not true: 18 per cent is merely a visual mid-tone. The standard reflectivity to which reflected-light meters (including in-camera meters) are calibrated is 12.5 per cent, though some manufacturers apparently introduce variations to this

NEW YORK CITY

If there are light sources in a picture, the brightness range will be beyond the recording ability of any film. Paradoxically, this means that the range of acceptable exposures is often very wide: you have the choice of capturing the light and letting the rest go dark (as here), or capturing the street scene and letting the lights burn out. Nikon F, 15mm f/2.8 Sigma fish-eye, Ilford HP5 Plus rated at EI 800. (FES)

standard which they think give better results.

Also, most photographers have direct experience of subjects outside this reflectivity range. The most usual example is snow, which can reflect 90 per cent of the light falling on it. A 'straight' meter reading will therefore invariably lead to under-exposure, as the meter is based on the assumption that the subject reflects something around 12.5 per cent of the light falling on it, and therefore gives a reading which leads to a print that reflects 12.5 per cent of the light falling on it. Follow the meter, and you will have grey snow. Another common example is photographing a domestic cat with dark fur, which can reflect as little as five per cent of the light falling on it. Take your reading off the cat, and the result will be over-exposure and a washed-out moggie.

PERFECT EXPOSURES AND PREVISUALISATION

Sticking with the examples given above, we have all seen unacceptable exposures, and we all have a pretty clear idea of what might constitute a 'perfect' exposure. The picture of the person in front of the whitewashed wall should have a tremendous tonal range, from the bright (but still textured) white of the wall to the black of the pupils of the eyes; the snow scene should capture the crispness of the snow, with just enough texture to stop it being a blinding white; and the cat's fur should be so perfectly delineated that you could almost feel the softness.

What we have called 'a pretty clear idea' is what Ansel Adams called 'previsualisation', and the perfectionist will be able to manipulate the photographic process at every stage in order to get a print which equates very closely to this previsualisation. This may involve very careful metering (which is dealt with on page 79), specialised development (see Chapter 8) and, of course, skilled printing. There are, however, a couple of 'quick and dirty' ways to get far better exposures than you would be able to with a simple reflected light reading.

One of these is modern through-lens metering. Whether it is called Matrix, Multi-Segment, Multi-Sector, Intelligent or Contrast-Light Compensated, it generally uses more than one metering sensor to measure the brightness range of the subject; to form an estimate of what parts of that brightness range are most important, often based on the position of different areas of brightness in the field of view; and to set an exposure based on this information.

Such meters are astonishingly good, but even so, they are far from perfect. Also, many cameras do not have this sort of meter: this includes all large-format, most medium-format, and many 35mm cameras,

INVERCONE AND EXPODISC

The Invercone incident light attachment on the Weston Meter on the right is probably the best integrating attachment ever sold for a meter. The ExpoDisc on the left allows you to use a conventional through-lens meter as an incident light meter, and has the advantage of doubling as a lens-cap.

especially older models. The alternative 'quick-and-dirty' route is therefore incident light metering.

INCIDENT LIGHT METERING

Incident light metering, also known as the 'artificial highlight' method, is exactly what its name suggests. Instead of measuring the light reflected from the subject ('reflected light reading'), you read the light falling on the subject. This removes any consideration of how reflective the subject may be and, better still, it means that any corrections you have to make are so simple as to be almost intuitive.

With the snow scene, for example, the reflectivity of the snow will have far less influence on the exposure, which will probably be a couple of stops nearer the optimum. What is more, corrections require no great thought. If you want a little more texture in the snow, you just give a little less exposure (maybe 1 stop) so that the snow reads darker. The same sort of approach can be used with the cat, but in the opposite direction: if you want the fur a little lighter, so that there is more detail in it, you just give a little more exposure – anything from 1 to 2 stops.

Compare this with a reflected light reading, where it is necessary to give even more exposure than the already high reading indicated by the meter for the snow scene, or even less exposure than the already low reading given for the cat. It is no wonder that so many photographers actually compensate in the wrong direction!

Drawbacks

Admittedly, the incident light system has its drawbacks. First, you need a meter which can take incident light readings, although almost all hand-held meters can do this and the Wallace ExpoDisc converts

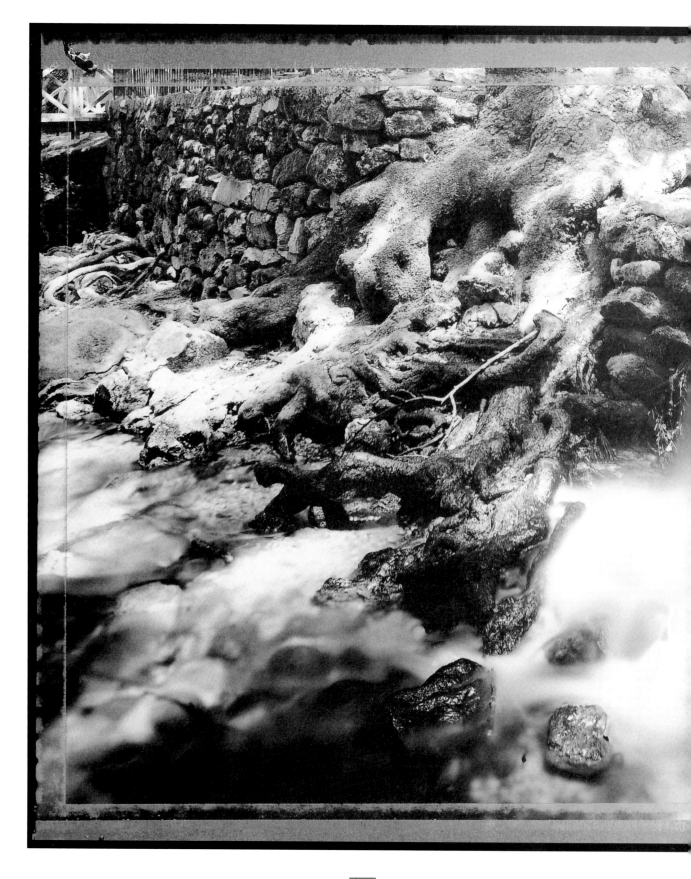

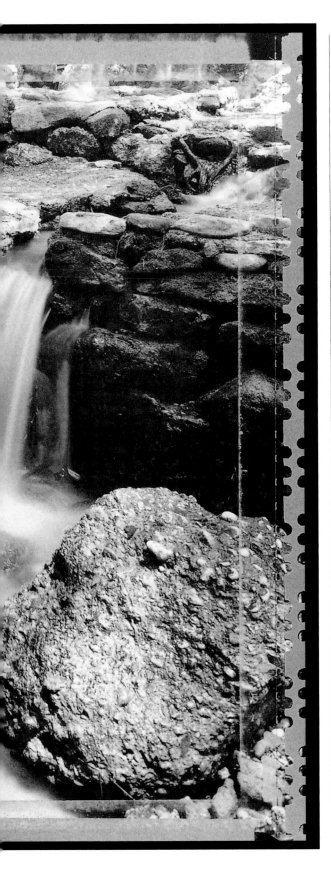

cameras with through-lens meters into incident light meters. Second, you need to be able to measure the light falling on the subject, which can be difficult if the subject is (say) a tiger – most people would not want to walk over and stand beside it to take an incident light reading. Fortunately, in most cases you can take an 'equivalent light reading': as long as the light falling on the photographer is the same as the light falling on the tiger, whether it be sunlight or shade, you can read the light where you are rather than where the tiger is. There are, however, some cases when this is not possible – as in theatre photography when you cannot check the stage lighting in advance – in these instances you will have to rely on reflected light readings.

Duplex readings

When you are in doubt, a useful trick is to take both a reflected light reading and an incident light reading, and split the difference between the two. Taking the incident light reading as the starting point, the second reading will encourage you to give a little more exposure to dark subjects, and a little less exposure to light subjects – which is precisely the same direction as the 'rule of thumb' modifications canvassed earlier.

SELECTIVE LIGHT METERING

Where incident light metering is not practicable, or where you want the most accurate and comprehensive metering information you can get, the best approach is selective light metering. This is a bit like the multi-segment method adopted by the cleverer in-camera meters, except that you work out the correct exposure yourself, bearing in mind the scene in front of you, instead of relying on some 'average' program. It is more difficult than relying on a simple meter reading, but it is also incredibly versatile.

The first thing you need is a meter capable of reading from a limited area. A true spot meter is the purist's choice, with its metering angle of 1°, but for practical purposes considerably wider metering angles are often acceptable: the 5° of a Sekonic L-408, the 7.5° of a Gossen TELE attachment, and (if you are

WATERFALL, Epta Piges, Rhodes
This is a classic example of dappled sunlight. You can see how the brightest areas are burned out, but fortunately they are fairly small. The alternative would have been to lose all detail in the rocks, or to increase exposure and cut development, which would have led to a flat, dull print. Toho 4x5, 120mm f/6.8 Schneider Angulon, Polaroid Type 55 P/N film. (RWH)

SPOT METER AND LUNA-PRO F

For general application, the Luna-Pro F is far more useful than the spot meter: cheaper, easier to use, and easier to carry. The Spot-Master 2 does however offer the ultimate in metering control – once you have figured out how to use it.

SEMI-SPOT ATTACHMENT

This clip-on attachment for Luna-Pro/Luna-Six meters is not a true spot meter, but it does allow 7.5° readings which, surprisingly, are often quite adequate for limited-area metering.

able to get close enough), even the 30° which most non-selenium meters deliver, though you need to be careful not to shade the subject with your body or the meter. Selenium-cell meters, with their big photogenerative cells, are likely to have too wide a metering angle to be very versatile for use in selective metering.

The second thing you need is a working (if simplified) knowledge of Ansel Adams' Zone System. This assigns Zones to the tonal values of the subject and the print; the original nine-Zone scale (probably more useful to the novice than the later eleven-Zone scale) refers to the print.

Zone I	The maximum black of which the paper is capable.
Zone II	The first tone distinguishable from black.
Zone III	The darkest tones showing shadow detail and texture.
Zone IV	Dark mid-tones.
Zone V	The mid-tone: 18 per cent grey by definition.
Zone VI	Light mid-tones.
Zone VII	The lightest tones showing highlight detail and texture.
Zone VIII	The lightest tone distinguishable from pure white.
Zone IX	Pure, paper-base white.

The Zones are all symmetrical about Zone V. Zone I is anything more than 3 stops darker than the mid-tone, and Zone IX is anything more than 3 stops lighter. Zone II is 3 stops darker, and Zone VIII 3 stops lighter. Zone III is 2 stops darker, Zone VII 2 stops lighter. Zone IV is 1 stop darker (the 'dark mid-tone') while Zone VI is 1 stop lighter (the 'light mid-tone').

Once again, it is important to emphasise that the

subject tones can be manipulated (either on film, or during printing) so that they do not necessarily correspond 1:1 with the print tones, and it is worth adding that sometimes you do not want a print with a full tonal range, although even a high-key picture consisting mainly of Zones VI and lighter will usually have tiny areas of Zones I or II, and a dark, low-key picture will look very murky indeed if there are no areas of at least Zone VII.

▲ ▶ GAS PUMP, Selma, Alabama

The various Zones are readily visible here, from Zone I (more than 3 stops darker than the mid-tone), to Zone IX (more than 3 stops lighter than the mid-tone). The broken plywood on the front was assigned to Zone V (the mid-tone) and the image was shot on XP2, which compresses the tonal range significantly. Final print Zones were determined by choice of paper grade. Nikon F, 35mm f/2.8 PC-Nikkor. (FES)

POOL TABLE AT THE ST CHARLES, Columbia
In very low light levels like this, it is as well to take incident light readings at a number of locations before shooting the picture. You also need to open up appreciably to make the light-painted walls seem reasonably pale. With a reflected light reading, you might need to open up 3 stops or so, unless the reflection in the mirror greatly affected your reading. Nikon F, 17mm f/3.5 Tamron SP, Ilford XP1. (RWH)

asymmetric scale. We prefer to use the older nine-Zone scale, with the extra Zones as a slight safety margin. Modern materials then mean that you can frequently 'push your luck' with the nine-Zone scale, and get shadow detail extending into Zone II and highlight detail extending into Zone VIII, so it is not a good idea to get too dogmatic about things.

ASSIGNING TONAL VALUES

A major problem for any newcomer to the Zone System lies in recognising what is a mid-tone, what is a dark mid-tone, and so forth; the truth is that it doesn't quite work this way. The easiest approach, which you may well modify as you gain experience, is as follows.

First, you select your key tone. Grass, for example, is a classic mid-tone. So, surprisingly enough, is a deep blue sky. Caucasian skin is generally about 1 to 1½ stops lighter than a mid-tone. But you do not have to begin with a mid-tone. To return to our white-washed wall, for example, you could meter that; if you wanted texture in it, you would have to expose it as Zone VII, that is, giving 2 stops more exposure than the meter indicated for the wall (Zone VII is 2 stops lighter than the Zone V mid-tone).

You can measure any tone in the picture to see if it fits onto the Zone scale as above. Suppose you had begun with grass (Zone V). You then meter the darkest area in which you want shadow detail (Zone III). If your second reading is exactly 2 stops darker than your first, then you are in clover. You might then decide to take a third reading for highlight detail (Zone VII). Again, if the reading is exactly 2 stops lighter, you have no problems: you expose the picture for the mid-tone, process it normally, and it should print perfectly on Grade 2 or Grade 3 paper. We shall come back in a moment to what happens if this range is exceeded.

Using an 18 per cent grey card

If you have difficulty in deciding exactly what corresponds to an 18 per cent mid-tone, an easy solution is to carry an 18 per cent grey card around with you. It

The eleven-Zone scale, adopted by Ansel Adams in later years, is as follows:

Zone 0	The maximum black of which the paper is capable.
Zone I	The first tone distinguishable from black.
Zone II	The darkest tone with a suggestion of texture.
Zone III	The darkest areas with clear texture.
Zone IV	Dark mid-tones.
Zone V	The mid-tone: 18 per cent grey by definition.
Zone VI	Light mid-tones.
Zone VII	The lightest areas with clear texture.
Zone VIII	The lightest tones with a suggestion of texture.
Zone IX	The lightest tone distinguishable from pure white.
Zone X	Pure, paper-base white.

Ansel Adams himself pointed out that with small-format negatives printed with a condenser enlarger, Zone IX may print as a pure white indistinguishable from Zone X (*The Negative*, page 60 – see Bibliography), which effectively gives a ten-Zone

can be hard to separate what might be called the 'inherent' tone of something – a Japanese male skin tone is a good equivalent to an 18 per cent grey, for example, according to one (Japanese) meter manufacturer – from how brightly it is lit: the example of one man in the sun and another in the shade immediately springs to mind.

If you have an 18 per cent grey card with you, though, you can simply offer it up and see which tone it looks most like. This will teach you more about midtones, faster, than any other trick. You do not need a big card: something the size of a credit card, or even smaller, is fine.

Learning about tonal values using Polaroids

The best way to demonstrate the interrelationship of tones is with Polaroid black and white films. At a stroke, they cut out almost all the variables inherent

VAJRASATTVA

The grey card by the right knee of Vajrasattva (in Tibetan, rDorje sems.dpa) shows that the whole wood-carving is very close to an 18 per cent grey, but that the area above the head and to camera right is probably best to meter. This Polaroid test also indicates that a hard grade of paper will be desirable for expanding the tonal range – or that increased development and curtailed exposure of the negative are called for. Linhof Technikardan, 210mm f/506 Schneider Symmar, Polapan 100. (RWH)

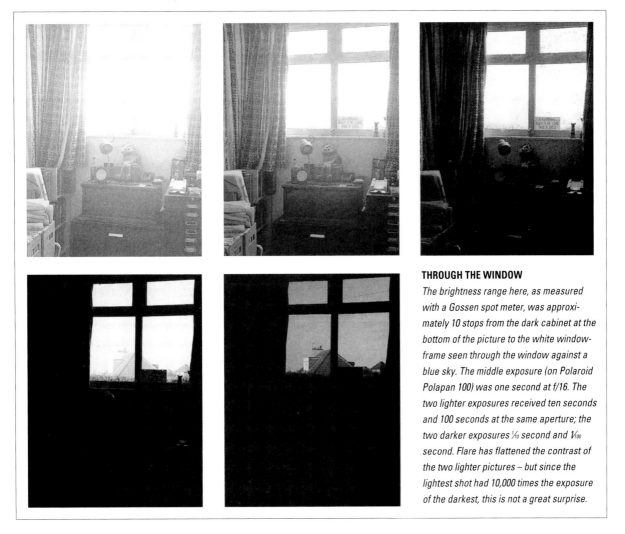

THROUGH THE WINDOW

The brightness range here, as measured with a Gossen spot meter, was approximately 10 stops from the dark cabinet at the bottom of the picture to the white window-frame seen through the window against a blue sky. The middle exposure (on Polaroid Polapan 100) was one second at f/16. The two lighter exposures received ten seconds and 100 seconds at the same aperture; the two darker exposures 1/10 second and 1/100 second. Flare has flattened the contrast of the two lighter pictures – but since the lightest shot had 10,000 times the exposure of the darkest, this is not a great surprise.

HALLOWEEN, New York City

Often, you will get better exposures than automation could offer if you take a meter reading and then set a general, average exposure on your camera and lens. Use this for grab shots, modifying it if you have time. An automatic camera would have given too much weight to the brightly lit McDonald's behind these two ghoulish revellers, and flash would have destroyed the mood completely. Leica M2, 35mm f/1.4 Summilux, Kodak TMZ at EI 12,500. (RWH)

▶ **BALANCED ROCK, Rhodes**

The blue sky above this improbably up-ended rock in Rhodes has been turned almost black with a 4x orange filter, but for metering (without filtration) it provides a very reliable mid-tone (Zone V). Toho FC45A, 120mm f/6.8 Schneider Angulon, Polaroid Type 55 P/N film. (RWH)

Not only do you learn where values 'fall' (in Zone parlance): you also learn about 'assigning' them. Something looks too light? Give a stop less exposure, reassigning Zone V to Zone IV or Zone VI to Zone V. With a conventional neg/pos process, you can 'fudge' this at the printing stage, quite possibly without realising it; with a Polaroid, it is there in front of you.

Finally, if you want to learn to use a spot meter, Polaroids will enable you to confirm your readings quickly and easily. To ascertain tonal values, first look through a PV (pan vision) olive-green filter – this will teach you a lot in itself – and meter what you believe to be Zone V, Zone IV, Zone VI and so forth. You may be surprised at how badly you guess at first. When you are satisfied with your meter reading(s), take a Polaroid picture. You will learn more about tonal relationships from a couple of packs of Polaroid monochrome film than you could in any other way.

WHEN THE SUBJECT DOESN'T FIT

You have taken your readings, and your proposed Zone III (darkest shadows with detail) and Zone VII (brightest highlights with detail) are more than 4 stops apart. What do you do?

To begin with, if Zones III and VII are only about 5 stops apart, or if your overall range is 8 or 8½ stops, you can generally ignore the problem. As already mentioned, many modern materials allow shadow detail to extend into Zone II and highlight detail into Zone VIII.

If Zones III and VII are 6 or 7 stops apart, or if your overall tonal range is 9 stops or more, you may have a problem. The easiest choice is to decide which you are willing to sacrifice: some highlight detail or

in a two-stage negative/positive process where negative exposure and development, and print exposure and development (and contrast selection!), can be varied independently. They also enable you to examine a print while the exposure is fresh in your memory, instead of being at least a few hours ago.

The approach is simple. All you need is a camera or back capable of taking a Polaroid black and white film. You meter your subject; make any adjustments to the meter reading which you think fit; and then shoot and process the picture. Then, look at what you wanted to be a mid-tone (Zone V); compare it with an 18 per cent grey card (see above); and see if they match. Look at the other Zones, too: at least Zones III to VII should pretty much meet the descriptions on page 80, although the very light and very dark tones may not differentiate so well.

some shadow detail, or a little of both. Most of the time, this is perfectly acceptable and will still give you negatives which would be the envy of the vast majority of photographers.

Suppose, however, that you really want to hold detail in both highlights and shadows. You will then have to compress the tonal range of the subject onto a shorter tonal range on the film. You can do this by choosing a low-contrast material, or you can start playing around with development as described in Chapter 8: increased exposure and reduced development will compress the tonal range, which is why the Zone System works best with single sheets of cut film. Anyone who was sufficiently determined could carry an extra roll-film back (or a spare 35mm body) loaded with film destined for curtailed development (see page 117), but few would bother.

Now take the opposite problem. What if the subject has a very narrow tonal range? To be sure, you could under-expose and over-develop, but most of the time you can obtain substantially the same effect in printing by using a harder grade of paper. With a short tonal range, after all, you have everything that you need on the film; only when the tonal range is longer than you can capture on the film do you need to compress it. Some Zone System *aficionados* will become apoplectic at such a suggestion, but don't knock it until you have tried it. If it does not work for you, then start exploring extended development.

▶ **FREELANCE DREAMS, 1936**

In the studio, where lighting is under control, flat-receptor incident light readings and Polaroid tests make everything easy. This formed the basis of an article for Shutterbug *magazine, showing how the lighting and indeed the precise composition of a still life evolves through a series of Polaroids.* Gandolfi Variant Level 3, 210mm f/5.6 Schneider Symmar, Ilford 400 Delta Professional. (RWH)

The constant-contrast theory

Although the Zone System normally calls for extended or contracted development to match the film density to the subject luminance range, it is all too easy to get carried away by it. Kodak research as far back as the 1940s suggested that if the density range of the negative is greater or less than 'normal' because of variations in subject luminance, no change in paper grade is called for, while if the variation in density range is the result of changes in development time, changes in paper grade may be required.

Basically we want a print to look like the subject – a foggy day to look foggy, with a restricted range of greys; and on a bright, sunny day we actually see a brighter, contrastier scene. If we try to expand the tonal range of the negative shot on the foggy day by increasing development, or to contract the tonal range on the sunny day by reducing development, we will end up with a picture which looks more or less unnatural.

One answer to this is that nothing in photography is 'natural' – it is a process which relies, by its very

THE CONSTANT-CONTRAST THEORY

This is a snapshot made with a Pentax compact camera on Ilford XP2. It well illustrates, though, the way in which the contrast of a picture should reflect our expectations of the contrast of the subject. The hair is jet black, but only a few tiny patches of anything lighter than Zone VI or Zone VI+½ can be seen, on the lips and on the highlights of the buckle. The tonal range in the flesh tones could be expanded – but would it look more natural? (FES)

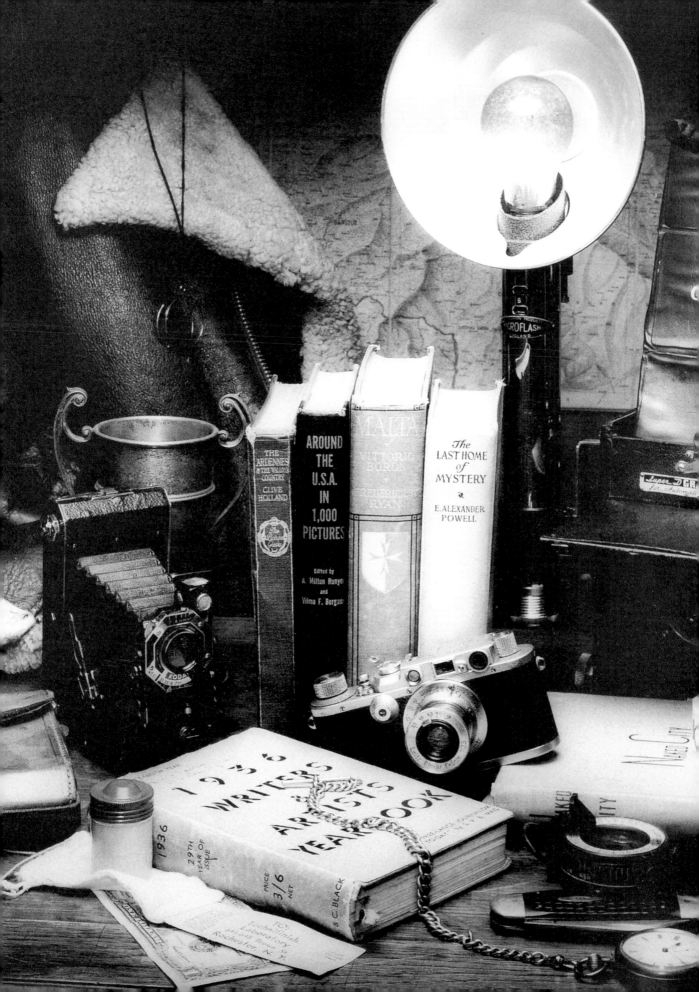

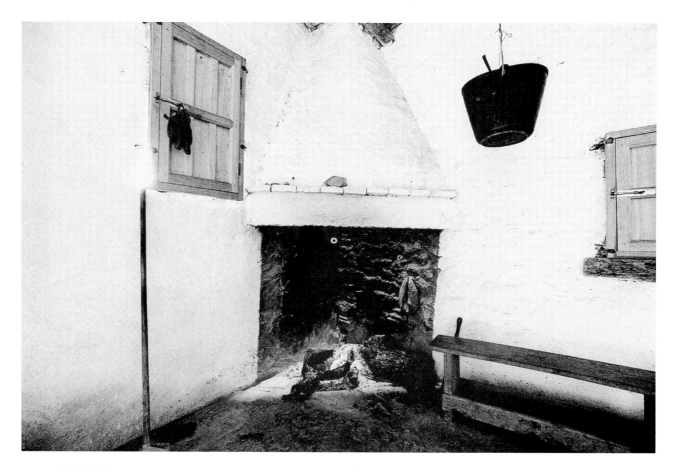

INTERIOR, Portugal

This is the attendant's shelter in a cottage at an abandoned castle and village on the Spanish border. Ilford XP2 and Ilford Multigrade IV paper allow texture to be retained in the whitewashed walls (Zone VII) and in all but the darkest parts of the soot-encrusted fireplace (Zones I/II/III). The light leaking through the shutter is Zone IX. Nikon F, 14mm f/3.5 Sigma. (RWH)

nature, on manipulation and psychology as well as physics; but another answer is that the Zone System can be (and frequently is) extrapolated to curious lengths.

CONTINUOUS AND FLASH METERING, AND STUDIO LIGHTING

All of what has been said so far was written principally with continuous light sources in mind: daylight, tungsten, HMI, even candlelight.

In theory, exactly the same approach can be applied to flash metering – except that by definition, flash is to a considerable extent under the photographer's control, so incident light metering close to the subject is the normal approach. We are talking of course about studio flash: on-camera flash is normally taken care of through automation and film latitude.

For maximum control, some flash meters use flat diffuser plates instead of diffuser domes. This allows the photographer to read the flash from a particular head, to see what contribution it makes to a given area of the subject. The same technique used to be the norm with tungsten lighting, which was why the old Norwood meter (later taken over in essence by Sekonic) was furnished with a remarkable variety of domes, plates and 'tea strainers', or perforated cell-covers. Today, this technique has been replaced by spot metering, where the utmost precision is required, or by straightforward incident light metering (supplemented by Polaroids) the rest of the time.

An important factor to consider in flash metering is the relationship of flash to continuous lighting. Obviously, flash exposures are governed solely by aperture, while ambient light readings are governed by both aperture and shutter speed. The best meters show two readings simultaneously, one for flash-plus-ambient and one for ambient alone – and the shutter speed for flash-plus-ambient can be varied.

Inevitably, the flash-plus-ambient reading at any given shutter speed must be more than the ambient-only reading, which might seem to be a problem with fill-flash, but the answer here is to crank the flash-plus-ambient shutter speed to the maximum (with the Gossens, for example, $\frac{1}{1000}$ second); take a reading; and then take an ambient-light reading at a slower shutter speed, such as $\frac{1}{30}$ or $\frac{1}{60}$ second.

With a lesser meter, the flash-plus-ambient reading will normally be given for a single shutter speed equivalent, normally $\frac{1}{60}$ second, although it may be longer or (rarely) shorter. In this case, you must take a separate non-flash reading at whatever shutter speed you plan to use. This will give you an indication of the value of the flash, but obviously some mental gymnastics are required.

Suppose, for example, the flash-plus-ambient reading is f/11. A second reading, of ambient light only, gives $\frac{1}{250}$ at f/8, so you know that the flash is effectively adding a stop to the ambient light. If you want the ambient light to record a stop lighter than the flash – which would still be a strong fill – you need to reduce the aperture by 2 stops from the ambient light reading (to f/16) and to change the shutter speed to $\frac{1}{60}$.

◀ MARTIN LUTHER KING MEMORIAL

Sometimes, you just have to grab what you can get. Roger was setting up a 4×5in camera to photograph the Brown Chapel AME church in Selma, Alabama when Frances spotted these girls on the sidewalk, grabbed a 35mm camera and shot. She has a better exposure, but without the girls, who never came back. Ilford XP2 is remarkably forgiving in such circumstances. Nikon F, 35mm f/2.8 PC-Nikkor.

▲ FAMILY ALBUM SHOT: GROẞMAMA

This is Frances' great-grandmother, probably with Frances' older brother, taken in the 1940s. A copy negative on XP2, taken from the original in the family album, allowed copies to be made for Frances' brother, sister, nieces and nephews. XP2 is ideal for this sort of continuous-tone copying.

This still gives you a correct ambient light reading (⅟₆₀ at f/16 equates to ⅟₂₅₀ at f/8) and it reduces the effect of the flash to a fill, 1 stop down.

Generally, if you are mixing flash and ambient light in the studio, you will use quite long ambient-light exposures (typically ⅛ second and longer). In this case, the contribution made by ambient light during the flash is trivial compared with the contribution made during the extended exposure.

COPYING

Incident light metering is easily the best option for copying. A flat-plate diffuser is theoretically best for checking evenness of illumination, but in practice a domed diffuser seems to work just as well. What you do need, though, is a meter which can be laid flat on the copy-table with the diffuser upwards: trying to use a meter which has a dome on one end, concentric with the long axis of the meter, can be very difficult indeed. A spot meter would work, but there seems little to be gained.

It is also quite usual to over-expose slightly when copying, so that the shadow values are lifted off the toe of the characteristic curve and recorded in a linear relationship: tonal compression of shadow values is something you rarely want when you are copying.

TRANSILLUMINATED SUBJECTS

Few people today photograph stained glass in black and white (although the results can be beautiful), so the main occasion when most people need to read a transilluminated subject is when making a black and white negative of a slide – a 'mono conversion'.

Meter through the transparency or other transilluminated subject, and treat the reading in exactly the same way as you would any other reflected light reading. If the overall density of the transparency is average, use the reading as given. If the transparency is lighter than average, and you want your copy to reflect that, then give a little more exposure; if it is darker than average, then cut the exposure a little. The maximum correction should be no more than 1 stop either way.

STAINED-GLASS WINDOW
As mentioned in the text, few people shoot stained glass in monochrome, but the effects can be rather charming. This Tiffany window is in a church in Vicksburg, Mississippi. Linhof Super Technica IV 6x9, 180mm f/5. 5 Tele-Arton, Ilford XP2. (FES)

Sunsets can be metered in the same way: just point the meter at the sunset. If the sun is inside the field of view of the meter and is bright and strong, you should however increase the indicated exposure by at least 1 stop. Normally, strong red or orange filtration will make the most of a sunset in monochrome – but remember to allow for the filter factor.

METER TYPES

Exactly what sort of meter you find most agreeable is very much a matter of personal choice. We prefer relatively simple meters without too many options and

programs, and it is certainly easy to spend more than you need to on a meter. On the other hand, modern meters are (or can be) more versatile.

A traditional swing-needle meter like the old Lunasix/Luna-Pro is easy to use and to understand, but the scale is necessarily compressed. This reduces accuracy (although not usually by very much) and as you get older you may also find that it gets harder and harder to read. A null meter like the Lunasix F/Luna-Pro F allows for a larger, clearer readout but still involves small numbers on the readout dial. Digital meters like the Variosix F, and its successor the F2, are the easiest to read, and once you have got used to them they are probably the easiest to use, too; but they do take some getting used to after the old revolving exposure calculators, where you could read all the possible combinations of shutter speed and aperture simultaneously.

Some 'system' meters allow you to fit attachments for narrow-angle metering, microscopy, enlarging and even flash. We have both narrow-angle and enlarging attachments for the Lunasixes and they are useful, but they will not be decisive factors in influencing meter choice for most people.

True spot meters are very expensive and are not for the inexperienced. Even experienced photographers can take a while to learn how to use them. When you are ready for a spot meter, you will know. Some have Zone scales built in, while others are adapted by third parties, although if you are familiar with the Zone System it is often easier to meter the various tones conventionally, retaining the equivalent Zone values in your head.

Selenium-cell meters are battery-independent and the best of them are very accurate indeed – for years, we used Weston Masters – but the cells can die of old

TWO GOSSEN METERS
The 3 stop scale on either side of the null point on the Luna-Pro F allows for easy Zone readings. On the minus ('under') side, –1 corresponds to Zone IV, –2 to Zone III, and –3 to Zone II; on the plus ('over') side, +1 corresponds to Zone VI, +2 to Zone VII, and +3 to Zone VIII. With the Sixtomat Digital, the bar chart along the bottom can be used in a similar way.

▶ **ARMORIAL BEARINGS, Mertóla castle**
Noonday sun – this was actually shot at about 1.30pm, in January in Portugal – is very harsh and contrasty. Careful metering is essential; you may also wish to bracket, giving one exposure 2 stops over and one exposure 2 stops under the metered exposure. Tighter brackets are rarely necessary with monochrome. Nikon F, 90mm f/2.5 Vivitar Series 1 Macro, Ilford XP2. (FES)

age, and the essentially pre-war technology of these meters also means that they are expensive to make well: for the price of a good selenium-cell meter you can now buy a solid-state digital meter which is more reliable and which reads down to much lower light levels.

Spectral sensitivity and response speed
Meter cells vary in their sensitivity to light of different colours, and also in their speed of response. The old selenium cells were commendably quick to respond and their response curves matched those of film quite well, and the same is also true of most modern photoconductive cells, but the cadmium sulphide (CdS) cells which were popular for so many years can give odd responses to coloured light.

A lot can be done with filtration, although many meters apparently exhibit an undue sensitivity to red light, and besides, you are not dealing with pure physics here; you are dealing with the psychology of perception. Green and grey 'mid-tones' should pretty much match the meter, and oranges are close enough, but blues and reds may need a little less exposure than a meter indicates; deep blues, violets and purples may need quite a lot less; and yellows may need somewhat more.

To return to CdS cells, they are also notoriously slow: hold the button down on a CdS meter and the needle may well swing rapidly to an initial reading but then continue to creep towards its final reading for anything from ten seconds upwards.

One more thing to take into consideration is that meters which are equipped with belt-pouches are far more convenient to carry than those which come with traditional cases: an odd little point, but one which we can certainly confirm from experience. The pouches supplied by the manufacturers are not always the most convenient; we have had leather pouches made specially, to allow our Gossens to be carried vertically rather than horizontally.

FILTERS AND FILTRATION

The effects of filtration need little explanation. Once you understand the concept of complementary colours, it is easy to see how a filter lightens its own colour and darkens its complementary colour; thus, a red filter will lighten 'foxing' on an old book, but darken the blue of the sky. A white sky defies filtration, but a 'bruised' winter sky can often be emphasised with fairly strong filtration because there are shades of purple in the clouds; a wide range of filters will work, including the usual 'sky' filters (yellow, orange and red) but also including green, which is the complementary colour to purple (or at least to magenta).

Admirers of Ansel Adams's work are sometimes surprised when they first learn how often he used fairly heavy filtration – deep yellow, orange and red, and sometimes green – in his landscapes. Another surprise lies in stock at high altitudes, where a weak filter or even a UV filter can darken skies significantly: at less than 2,000m (around 6,000ft) in the Himalayas, we have seen significant darkening on XP2 with a UV filter. Because the response of films is not the same as the response of the human eye (see page 56), it is not always possible to get a full idea of how a filter will affect a given film in a given situation, merely by looking through the filter.

Something else which is not immediately obvious is why 'sky' filters often increase contrast in landscapes, quite apart from their effect on the sky. There are two reasons for this. One is because haze is blue; 'scatter'

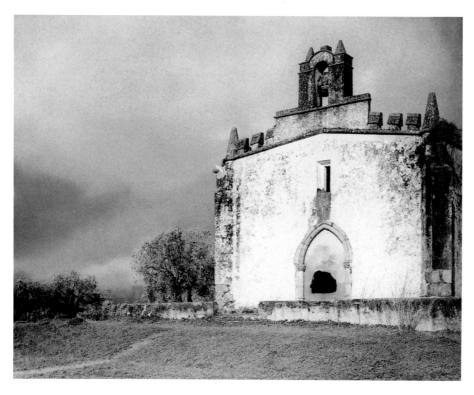

ABANDONED CHAPEL, Portugal
It is often said that 'sky' filtration will have no effect on cloudy skies, but this is not strictly true. Often, a lowering, bruised-looking sky will have wide variations of blue in the clouds, and orange filtration (as here) can have considerable effect. Nikon F, 35mm f/2.8 PC-Nikkor.(FES)

▶ **EPTA PIGES (SEVEN SPRINGS), Rhodes**
Despite the dappled sunlight, which brings contrast problems of its own, Roger used a 2× yellow filter to increase the contrast in this landscape: a green filter would have been even better, but he did not have one with him. Toho 4x5, 120mm f/6.8 Schneider Angulon, Polaroid Type 55 P/N film.

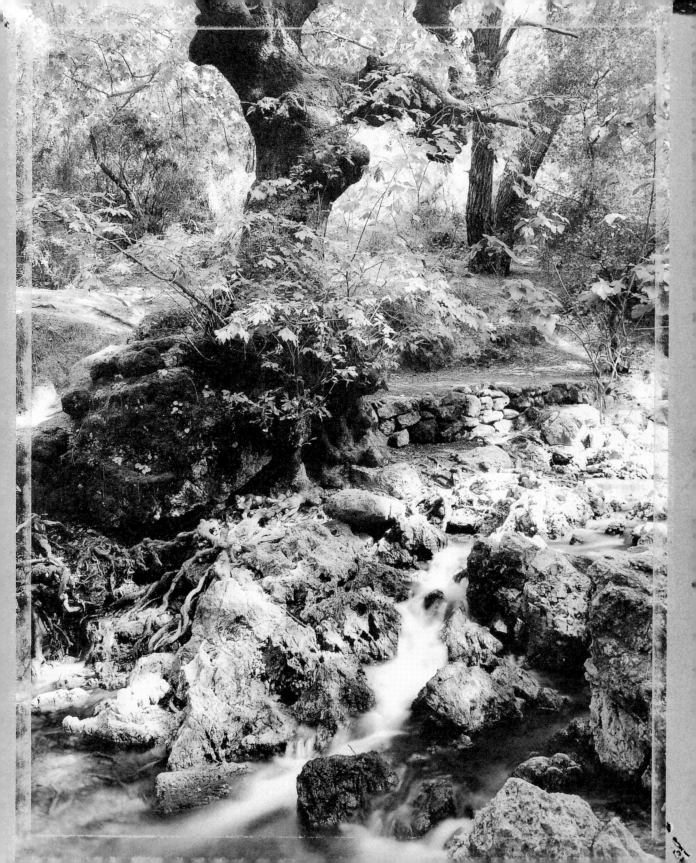

PAGES 96–7 **SNOW SCENE, northern California**

An unexpected use for deep red filtration and infra-red film is to lighten foliage and darken blue shadows in a snow scene. The net result is that while overall contrast is high, gradation can be remarkably subtle.
Nikon F, 35mm f/2.8 PC-Nikkor, Ilford SFX 200. (FES)

illumination therefore flattens contrast where there is haze between the camera and the subject, and it is a matter of common experience how 'sky' filters cut through haze. The other reason is because shadow areas are (by definition) lit by relatively blue skylight rather than by relatively warm sunlight. The usual 'sky' filters will darken both the blue of the sky and the blue of the shadow areas. A green filter will have

less effect on the sky, but it will still be detectable; while if there is foliage in the shot, this filter will lighten it, thereby often negating the effects of the darkening of the shadows.

Green filters may be less used than they could be, but a still more unusual approach in monochrome is a very weak blue filter to counter the excess red sensitivity of some panchromatic films, which leave complexions and lips looking washed-out, especially under tungsten light; some photographers still use ortho films for portraiture for this very reason, although this can result in over-correction. The results are not too bad for those with very good complexions, or for 'character' portraits of men with weatherbeaten faces,

SCHLOß, Bavaria

If the tonal range of the film is too great, the sky may read as 'bald' (below) unless it is burned in during printing. A weak yellow filter helped to bring out what little detail there was in the sky, and burning it in a little allowed the use of more contrast for more impact (left). Nikon F, 35mm f/2.8 PC-Nikon. (FES)

but they can also be merciless in showing up broken veins, flushed faces and 'drinkers' noses'.

POLARISERS AND ND FILTERS

Polarisers are of limited use in monochrome, apart from their obvious function in removing reflections, because you can often achieve a better effect by using the 'colour triangle'. If you are trying to show up grain in a reddish wood, for example, you would do well to consider which would give better results: a red filter to lighten the red parts, or a polariser to reduce reflections. Of course, you might decide to use both.

Neutral density (ND) filters have three main uses. One is with fixed-aperture mirror lenses, when the light is so bright that the camera's minimum shutter speed is insufficiently brief. The second is when you want to reduce depth of field, and even at the camera's minimum shutter speed the aperture is still inconveniently small. This is sometimes useful in portraiture. The third is when you want extra-long shutter speeds, for instance if you want to create a 'cotton candy' effect with flowing water. In the first two cases it is often better to switch to a slower film if at all possible, as the image will be easier to focus and to compose, but if you have to use an ND filter it will normally be fairly weak: 4× (ND 0.6, 2 stops) or 8× (ND 0.9, 3 stops). For 'cotton candy' you may want stronger filters, and you can get strengths of up to 1,000,000× (ND 6.0, 20 stops), although 1000× (ND 3.0, 10 stops) is as far as most people will want to go. Remember, too, that with heavy ND filtration and long exposures you may get into reciprocity failure, which can require doubling, tripling or quadrupling of the exposure in its own right.

SOFT-FOCUS SCREENS, FOG SCREENS AND CLOSE-UP LENSES

These are not strictly filters, but are closely related. A soft-focus image is not the same as an out-of-focus image. An out-of-focus image represents a point as a diffuse blob of substantially even intensity, while a true soft-focus image represents it as a point with a halo around it. A purpose-made soft-focus lens leaves spherical aberration under-corrected in order to provide the 'halo'. The effects obtainable with a soft-focus screen can range from something very like this, to something which is more akin to the results created by a fog filter.

All soft-focus effects work better on larger formats, and soft focus on 35mm never has the same quality as soft focus on roll film or (better still) cut film. Without

STORAGE POTS, Knossos, Crete

A red tri-cut filter (Wratten 29 equivalent) has turned the sky black in this infra-red shot of the millenia-old ruins of the Minoan capital. Frances chose Konica IR so that the strangeness of the tonality would in effect match the eeriness of the ruins. Nikon F, 90mm f/2.5 Vivitar Series 1 Macro.

a true soft-focus lens, the best soft-focus results are probably obtained with Softars (which are very expensive) or with Pro-4 screens, which use holes drilled in a slightly (but deliberately) 'imperfect' clear screen; these are a lot cheaper, and probably represent the best value for money. Another way to get quite good soft focus is to use a cheap, old zoom lens, preferably with a teleconverter.

Whatever method you use, the effect will vary with

No filter

Blue filter

Red filter

Green filter

STILL LIFE

The colours of the fruit are familiar enough: yellow banana, red and green apples, purple plum, orange, lemon-yellow, apricot. The fuchsias are red and purple; the artichoke flowers are green and violet; and the vase is cyan. The three 'tri-cut' filters for red, green and blue show tremendous differences: for example, through a blue filter, the orange is black and the vase is very pale, while through a red filter, the vase is black and the orange and the lemon are almost the same tone. Tone changes are not wholly predictable with strong filtration, as most people are not used to analysing colours accurately.

aperture, and soft focus introduced at the taking stage is quite different from soft focus introduced at the enlarging stage, unless you are using a pos/pos printing process. At the taking stage, the highlights diffuse into the shadows, giving a light and airy mood; at the enlarging stage, the shadows will diffuse into the highlights and the effect is altogether more sombre.

A fog filter does exactly what its name suggests: it creates the impression of a fog or mist. Despite the ingenuity of filter manufacturers in illustrating the use of these in their catalogues, they are very hard to use and there are few photographers who ever get good pictures with them.

Finally, a close-up or dioptre lens (so called because the strength is measured in dioptres) will inevitably degrade the performance of a lens quite significantly, because a lens is designed (and corrected) as a unit, so unless the close-up lens is designed in from the start (as it could be with some medical lenses, for instance), the correction must be affected. The best close-up lenses are cemented doublets, but these are growing steadily rarer as people become more and more willing to pay for purpose-designed macro lenses.

FILTER CONSTRUCTION

Any filter will degrade image quality, unless the lens is specifically designed to be used with a filter in the light path, as are many catadioptric (mirror) lenses. In those cases, the image quality will suffer if a filter is not used.

The degradation may however vary from the significant to the trivial – and the larger the format, the less important the degradation becomes. A filter which is unacceptable on 35mm may be adequate on roll film and perfectly fine on cut film, simply because the imperfections introduced by the filter will be magnified less. The basic reasons why filters degrade quality are refraction and reflection.

The first question which most people ask is whether a filter is multi-coated or not. This is only of much importance under adverse conditions (especially with light sources in the picture), when it is as well to have the best coating you can get – preferably multi-coating – or to use a gel filter (see below). Under really adverse conditions, such as shooting straight into the sun, use no filter unless you really have to.

Refraction degrades image quality in two ways: via the thickness of the filter, and via departures from plane parallelism.

Although a ray on the optical axis is not refracted, a ray which comes in obliquely must be; and the wider the angle of the lens, the more obliquely some rays must enter it. Fig 18 illustrates what happens. At an interface between two optical media of different refractive indices, the ray is bent, and the different colours are bent differentially, in the familiar way in which a prism splits light into a rainbow. The effect is not great, but neither is it negligible. The thinner the filter (and the closer its refractive index is to that of air), the less effect off-axis refraction will have.

As for plane parallelism, this is at least as important as coating, because filters where the surfaces are not plane parallel can significantly degrade image quality even under ideal conditions. The very worst are cheap plastic or 'optical resin' filters, which are so far from flat that you can actually see ripples in the surface if you hold them up and look through them obliquely. Even these may be acceptable with the larger roll-film formats or with cut film, but they should not be used with 35mm. The better plastic filters will not exhibit these problems.

Most glass filters are of more than adequate quality. Lack of plane parallelism between surfaces may degrade image quality slightly, but none of this should matter beyond 35mm, where it is a good idea always to buy the best filters you possibly can. Dyed-in-the-mass filters (where the glass itself is actually

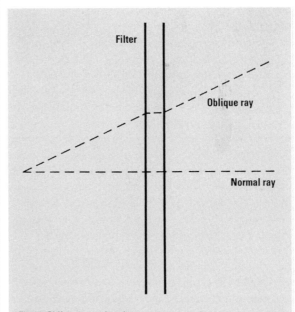

Fig 18 Oblique ray refraction

A 'normal' ray (striking the glass at right-angles) is not refracted, but an oblique ray is. This is why the deleterious effects of filters are most noticeable with wide-angle lenses.

FILTERS

The glass in the Linhof red (rot) filter is secured with a circular spring clip, just visible in the picture, while the Hoya UV filter uses a threaded retaining ring. The spanner slot can be seen just below the corner of the filter frame which holds the red tri-cut Wratten gelatine filter; you have to cut the corners off the 75mm (3in) filter so as to make it fit in the frame.

coloured) are generally safer than 'sandwich' filters (where the filter is held between two sheets of glass), but, with the exception of polarising filters, 'sandwich' or 'cemented' filters are rare nowadays.

The best glass filters are mostly held in threaded mounts with threaded retaining rings, although Linhof prefer spring clips. The advantage of either system is that it places the glass under minimal strain: cheaper 'spun in' mounts can strain the glass, leading to slight but sometimes detectable image degradation.

Gelatine filters or 'gels' (pronounced 'jells'), and their increasingly common relatives made of thin acetate sheeting, have the least effect on image quality. Another advantage is that you can get a tremendous range of colours. They are, however, surprisingly expensive – significantly more than cheap but adequate glass filters – and are very easily marked: a fingerprint on a gel effectively writes it off. They are best confined to the studio, and the majority of photographers use them only with colour films in any case, where exotic colours or fine gradations of colour correction are required.

The best filter manufacturers, such as B+W, publish transmission curves for their filters which can be read in much the same way as film sensitivity curves.

In theory, you could superimpose a filter absorption curve on a wedge spectrogram (see page 56) to see what wavelengths would record in which way, but this is rather too much like hard work for most people; normally, you can get an adequate idea (despite what was said above) by visual examination. You do, however, need to think a bit harder when you are dealing with infra-red.

INFRA-RED FILTERS

If you expose infra-red film without a filter, the results will typically look like a rather soft, grainy picture on ordinary film. To make the IR effect clear, you need to exclude colours other than red. Exactly which filter you choose will depend upon the film in use and the effect you want.

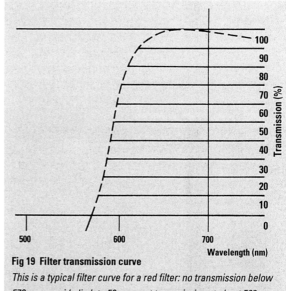

Fig 19 Filter transmission curve

This is a typical filter curve for a red filter: no transmission below 570nm, a rapid climb to 50 per cent transmission at about 590nm, a slight levelling off after about 70 per cent transmission at 600nm, and close to 100 per cent transmission at 650nm.

The densest IR filters in normal use are visually almost black, although you can see the sun through them. They exhibit negligible transmission below about 790nm, which means that they can only be used with films and plates sensitised to true IR radiation; with extended-red or near-IR films (see page 57), they may have a filter factor of 20× or more.

With extended-red and near-IR films, a much better bet is a very deep red filter with 50 per cent transmission at something like 650nm, although even a relatively mild filter with an overall 4× filter

factor and 50 per cent transmission at 600nm can still deliver quite significant IR effects.

BUYING AND USING FILTERS

If you have no great experience with 'sky' filters, then a good starting point with most modern films is a yellow-orange with a 4× exposure factor (2 stops). Try it for a while. If you find that you want a more dramatic effect, then buy a medium red (4× to 6×, 2 to 3 stops); or if it is too strong, you should go to a modest yellow (2×, 1 stop) instead.

Even if you are familiar with 'sky' filters, you may find that a green filter for landscapes, or a weak blue filter for portraits, can be useful; ND filters are more useful with 35mm than with larger formats, which can often be stopped down further.

Opinions vary as to whether you should attempt to focus with strong filters in place, or whether you should focus without them and then add the filter. Unless you know that your lens is very well colour corrected, the former is almost certainly a better idea with strong red or yellow filters. To get an idea of the colour correction of your lens, check how far the IR focusing mark (see page 60) is from the normal focusing mark. Whenever possible, you should shoot at a sufficiently small aperture for depth of focus to take care of the discrepancy.

▼ **LANDSCAPE, Crete**
Strong red filtration can be very effective with many films, especially if they have extended-red sensitivity as the faster panchromatic films often do. This was shot on XP2 with a 7× red filter, which cuts through haze very effectively indeed. Nikon F, 35mm f/2.8 PC-Nikkor. (FES)

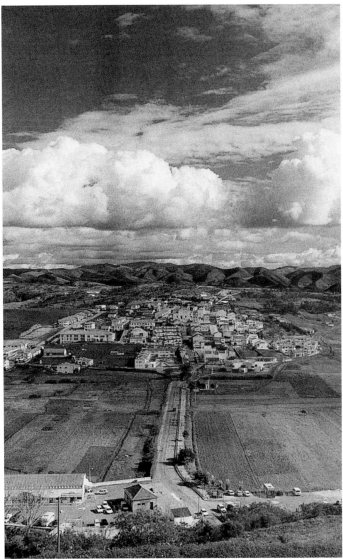

ALJEZUR
The haze-cutting effect of a deep red filter can be impressive. Without the filter – a Wratten 29, tri-cut red – the details of the houses in this southern Portuguese village are hazy, and the distant hills have no modelling whatsoever. Nikon F, 90mm f/2.5 Vivitar Series 1 Macro. (FES)

FILM DEVELOPMENT

The silver halides in a photographic emulsion are sufficiently unstable that the energy in light is enough to cause them to split into metallic silver and the halide in question. If an emulsion is exposed to light for long enough, it will darken visibly; and the brighter the light, or the longer the exposure, the more it will darken.

The very first silver-based photographic processes did not use developers: they just gave very long exposures, until the exposed parts were dark enough to register an image.

Long before the darkening becomes visible, however, enough molecules have been split for there to be a 'latent image' on the film. As few as ten or fifteen atoms can be sufficient to act as a catalyst which, in the presence of the right developing agent, converts the whole grain to metallic silver – or, in the case of 'new technology' films, into a set of image points which can be developed separately. A grain which has not been affected by light will be converted to silver much more slowly than one which has, so the developer converts the latent image to a visible image; the slow conversion of unexposed grains is what causes 'fog' – a general increase in density. Some contaminants, such as tin salts or sulphides, will also contribute to fog.

Chemically, developing agents are reducers. That is, they 'reduce' silver salts to metallic silver. For those who have forgotten their chemistry, the opposite is an oxidising agent; that is, something which converts metallic silver into a more complex substance.

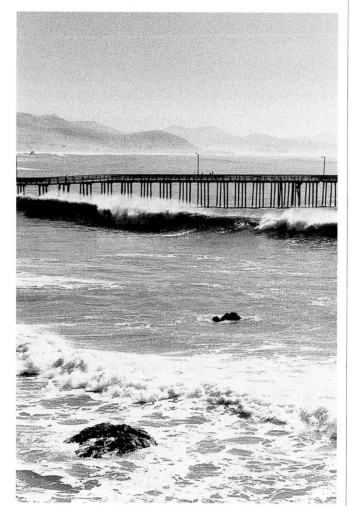

▶ **KITE FLYER, Reculver**

Compare this with the picture of the pier taken from Pacific Coast Highway. This was one of our first pictures taken with what was then Ilford SP 815T, a specialist traffic-control film which later metamorphosed into SFX 200. Slightly more inherent contrast would be welcome, which is why we upped the developing time. Nikon F, 14mm f/3.5 Sigma. (FES)

PIER, Pacific Coast Highway

There are several ways to increase contrast. Heavy red filtration is one of them: this was shot on Ilford SFX 200 extended-red film with a tri-cut (Wratten 29 equivalent) filter. But it was also processed for 15 per cent longer than normal, because even with the filtration, it was still a very hazy day. Nikon F, 90mm f/2.5 Vivitar Series 1 Macro. (FES)

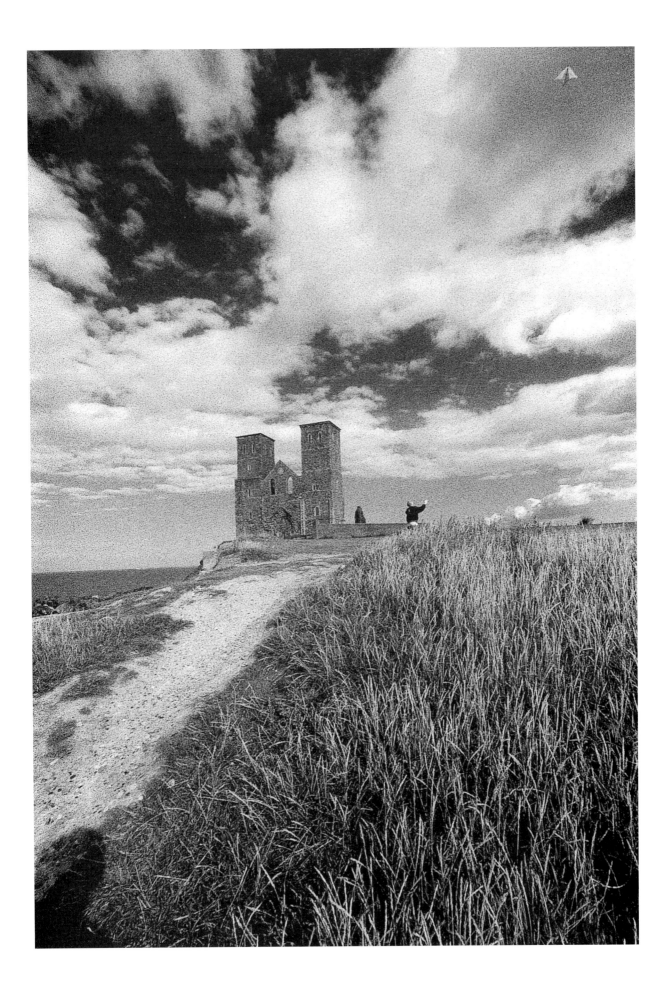

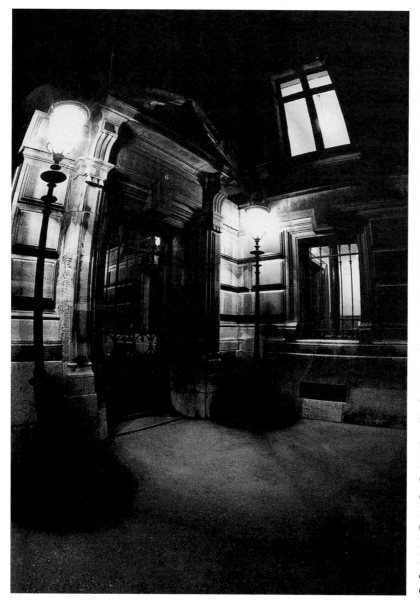

BACK DOOR, Paris Opéra

Ilford XP2 has often been ignored by enthusiasts, because you cannot influence it during development: you just run it through your nearest friendly (and clean) C41 line. On the other hand, as many of the pictures in this book show, you do not need to do anything to it, because you get reliable, easy-to-print negatives every time. Nikon F, 15mm f/2.8 Sigma fish-eye. (FES)

Background fog, aerial fog and dichroic fog

Background fog, resulting from development of unexposed grains, has already been mentioned. Aerial fog is caused by oxidation during development – the old 'see-saw' method of developing films often caused this

– and appears to be caused by an unstable oxidation product of hydroquinone; there are various chemical methods of controlling it. Dichroic fog (so called because it is one colour by transmitted light and another by reflected light) is normally caused by very prolonged development or by the choice of a totally inappropriate developer.

Popular developer ingredients

Over a dozen reducing agents have found widespread use in developers, although three are overwhelmingly the most important today. These are metol, Phenidone and hydroquinone. In what follows, the chemical names and notations are given wherever relevant, not because you normally need to know them – you don't – but because trade names and even popular names change, whereas formulae do not. Only if someone tells you, or if you have the formula in front of you, can you tell (for example) that hydroquinone and Quinol are the same thing.

Metol is 1-hydroxy-4-methylamino benzene sulphate, otherwise known as monomethyl p-aminophenol sulphate, $OHC_6H_4NHCH_3$. H_2SO_4. It was discovered by Bogisch and introduced by Hauff in 1891; it has been sold as Elon, Genol, Photol, Pertol, Pictol, Planetol, Rhodol and more. Phenidone is an Ilford proprietary developer; the compound is 1-phenyl-3-pyrazolidone, $C_6H_5N(CH_3)_2NHCO$, discovered in the late nineteenth century but first applied as a developing agent (by Kendall) in 1940. Hydroquinone, the developing properties of which were discovered by Abney in 1880, is p-dihydroxybenzene, $C_6H_4(OH)_2$, also known as Quinol. None of this matters very much to the photographer. What is more important is how they behave.

Metol gives very low contrast, but low fog. In other words, it is very good at distinguishing between exposed and unexposed grains; it develops very few unexposed grains, so fog is low. It keeps very well in a weakly alkaline solution, and quite well in a more strongly alkaline solution.

Phenidone behaves in much the same way as metol,

but can be used at much lower concentrations. A major attraction is that it is much less likely to cause an allergic reaction than metol. It is however rapidly oxidised in solution, and many modern developers use Phenidone derivatives for this reason.

Hydroquinone gives a much more contrasty image, especially in a strongly alkaline environment, but it also causes more fog and does not keep as well as either metol or Phenidone.

It is usual to make either a metol-hydroquinone (MQ) or a Phenidone-hydroquinone (PQ) developer, which shares some of the characteristics of both. In fact, 'superadditivity' means that such developers are better than those developers which are made up with one or the other.

Most developers are made up with a preservative: typically sodium sulphite, although potassium metabisulphite may also be used. The preservative prevents the developing agents being oxidised, although the chemistry of this is more complex than is immediately apparent.

The alkali which is used as a preservative and accelerator in most developers is sodium carbonate (Na_2CO_3), and the concentration of this salt greatly affects the energy of the developer. For maximum energy, caustic alkalis (typically sodium hydroxide, NaOH) are used, while for fine-grain, low-energy developers borax (sodium tetraborate, $Na_2B_4O_7$. $10H_2O$) may be used.

After the developing agents, the preservative and the alkali, the fifth ingredient that is normally found is a restrainer, which reduces fog levels. This may be omitted in some low-energy, fine-grain developers. The most usual restrainer is potassium bromide (KBr), although benzotriazole ($C_6H_5N_3$) is also widely used.

In order to maintain the alkalinity of the developer during its working life, it may also be 'buffered'. This is achieved by adding relatively large quantities of a weak acid and of an alkaline salt of that acid. A typical combination is boric acid (H_3BO_3) plus borax (see above).

Some developers also use a silver solvent, so that at the same time as the film is developing, silver halide grains are being dissolved and the silver redeposited on the developing grains; this is akin to 'physical' development, which is covered briefly below. Solvent developers give fine grain, at the expense of reduced emulsion speed. Traditional silver solvents such as sodium thiosulphate and potassium thiocyanate give serious dichroic fog with most modern films, so modern developers use an excess of sodium sulphite plus sodium chloride.

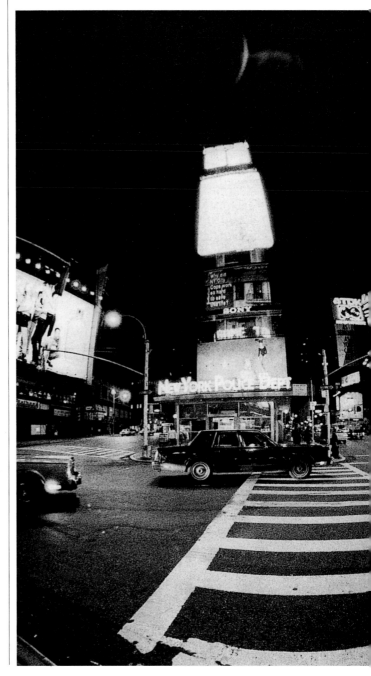

PROCESSING MARK

Ignore the picture: look above it. That 'moon' is a stress mark caused by kinking the film while loading it into the stainless steel spiral. These marks can be even more of a problem with 120, which is both thinner and wider. Many photographers find that plastic spirals are easier to load than stainless steel. (Technical data forgotten)

Although distilled or purified water is superior to tap water for making up developers, the advantage is not as great as most people imagine, even for stock solutions. An old trick is to use boiled water which has been left to go cold: this contains less oxygen than tap water, and may also contain fewer minerals. The majority of people compromise nowadays and use purified water for stock solutions and tap water for making up working solutions.

WALLPAPER

When we stripped the walls in the hall of our house, we found seven layers going back to the original 1890s arsenic-green wallpaper. The subject tonal range in this shot was less than 3 stops, but by increasing development (Ilford Ortho Plus in Kodak D76) it was increased to more than 4 stops. Gandolfi Variant 4x5, 150mm f/5.6 Apo Lanthar. (RWH)

Other developing agents

Although the PQ and MQ developer types are overwhelmingly the most common today, there are others, and some still survive in reasonably common use. They are given below out of interest, and may be helpful if someone tells you about a 'pet' formula.

The most popular is probably pyrogallic acid, or pyrogallol, or just plain pyro, otherwise known as 1:2:3-trihydroxybenzene, $C_6H_3(OH)_3$. This is a fairly high-contrast developer which preferentially stains the image during development and can be controlled with great finesse by varying the bromide concentration. It dates back to the 1840s, and makes wonderful negatives for contact printing, but it also stains fingers and dishes black. It is rarely used for papers.

Amidol (2:4-diaminophenol hydrochloride, $(C_6H_3)H(NH_2Cl)_2$) is highly regarded as a paper developer but is rarely used for film.

Chlorquinol (1-chloro-2:5-dihydroxybenzene, $ClC_6H_3(OH)_2$) is a developer type which can replace hydroquinone but it is rarely used nowadays.

CORKSCREW

To make a proper lith, with no mid-tones, contact print a conventional negative onto lith film; develop in lith developer to get an interpositive; contact your interpositive onto lith again; develop in lith developer to get an internegative; retouch as needed with bleach and pigment, to lose dust spots; and contact print your final lith internegative. De Vere 8x10, 14in f/9 Cooke Apotal, Ilford Ortho Plus. (RWH)

Under-exposed Under-developed

Under-exposed Normal development

Under-exposed Over-developed

Normal exposure Under-developed

Normal exposure Normal development

Normal exposure Over-developed

Over-exposed Under-developed

Over-exposed Normal development

Over-exposed Over-developed

EXPOSURE AND DEVELOPMENT
These nine negatives show the effects of both exposure and development. Look at overall density, shadow detail and *highlight detail: large variations in exposure and latitude are required to show real differences. The film is Ilford FP4 Plus rated at EI 100, exposed* *at the metered reading and at 2 stops over and 2 stops under, while development was for five minutes, ten minutes (taken as 'normal') and 20 minutes in* *Kodak D-76.* Linhof Super Technika IV 6x9 with 6x7cm roll-film back, 135mm f/8 Schneider Repro-Claron. (RWH)

THIS PAGE AND OPPOSITE **FILM/DEVELOPER TEST**
This is just a test exposure, hand-held with a 'baby' Linhof and taken from the front door on Ilford 100 Delta Professional cut film and processed in Kodak D19 for five minutes. The subject was chosen for its wide tonal range, with sun and shadow. The negative looked unprintably contrasty, but a full tonal range was obtainable on Ilford MG IV paper at grade 1. Printing on Sterling Lith (opposite), on the other hand, resulted in a lith-type image with effectively no mid-tones. (RWH)

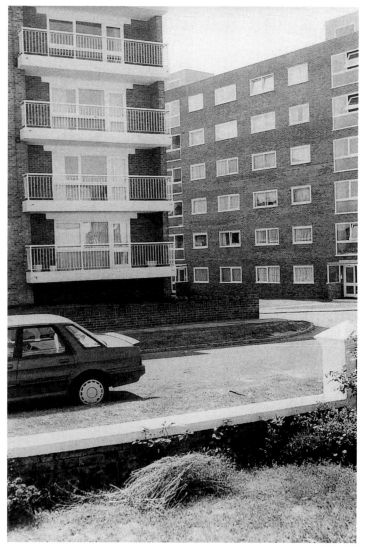

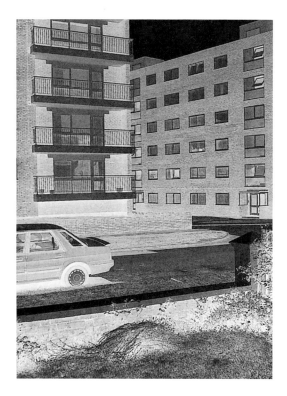

Eikonogen is sodium 1-amino-2-napthol-6-sulphonate, $NH_2C_{10}H_5OH.SO_3NA$; it behaves somewhat like metol.

Ferrous oxalate (FeC_2O_4) is the only common inorganic developing agent; it was popular during the nineteenth century but is not normally used now.

Glycin (p-hydroxyphenylamino acetic acid, $NHCH_2CO_2H$) is again rare, although it is ideal for long, slow development as it produces virtually no fog. A few film developers use it.

Meritol is a proprietary agent and is not normally encountered in formulae for home brewing.

Metoquinone is $(CH_3NH.C_6H_4OH)_2.C_6H_4(OH)_2$ and actually is what it sounds like – a condensation product of metol and hydroquinone in the proportion 2:1. When it is dissolved in an alkaline sulphite solution, it behaves just like an MQ developer.

Ortho-phenylene diamine (OPD) is 1:2 diamino benzene, $C_6H_4(NH_2)_2$. Predictably, it behaves like para-phenylene diamine (PPD, page 111), although it does not stain.

Ortol is another condensation product, this time of orthoaminophenol and hydroquinone and in the proportion 2:1. The chemical formula is $(NH_2 C_6H_4OH)_2.C_6H_4(OH)_2$.

Para-amino phenol base and para-amino phenol hydrochloride are very similar to one another; one is 1-hydroxy-4-amino-benzene, $NH_2C_6H_4OH$, and the other is its hydrochloride, $NH_2HClC_6H_4OH$. They are like metol, but are less allergenic and can also be made up at very high concentrations. They were also highly regarded at one time for high-temperature

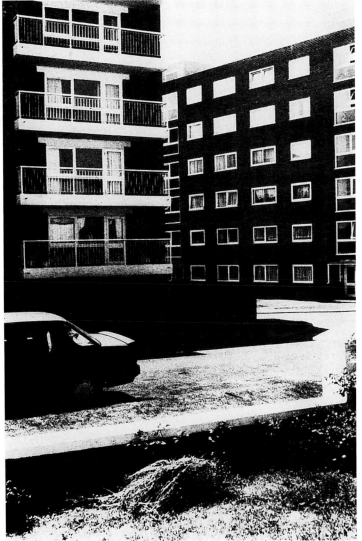

All kinds of other developing agents have been tried, including vitamin C (ascorbic acid, which was first used in 1935), and considerable interest in the latter appeared again in the late 1990s, especially with the launch of Kodak Xtol, which uses vitamin C rather than hydroquinone. Formulae for older developers may be found in old editions of *The Focal Encyclopedia*, but formulae for modern developers are generally treated as trade secrets.

DEVELOPER TYPES

It is possible to vary the performance of a developer by choosing different developing agents, by increasing or decreasing alkalinity, by adding silver solvents, and of course by varying dilution. You can also increase or decrease development time or development temperature, or you can give more or less agitation.

On top of all this, the interaction of a given developer with a given film is not very predictable, so some films just won't 'work' in some developers. As general rules of thumb, however, you can say three things. First, true speed gains of more than 1 stop (ie speed gains without the loss of shadow detail) are unusual. Second, fine grain is normally paid for with lower film speeds, although again, some developers will give finer grain with less speed loss than others. And third, 'pet' formulae, especially the more exotic, can owe as much to the user's imagination as to any scientific truth.

Unless you have very specialist requirements, there is little need for anything other than proprietary developers nowadays: it is worth noting that few if any prize-winning commercial printers use 'magic' formulae. The best advice we can give, weak as it may seem, is to begin with the manufacturers' recommended developers, and to change them only if you don't like the results you are getting or if you believe that some other formula will give you better results. On page 118, however, there is a formula for Kodak D19b, which was originally developed for X-ray use but makes a good 'punchy' (high-contrast) developer for general use, especially with sheet film. It has virtually no compensating effect (see page 29) and gives a steep characteristic curve with a very high D_{max}.

development of films; they are little used for paper.

Para-phenylene diamine (PPD, 1:4-diamino benzene, $C_6H_4(NH_2)_2$) and para-phenylene diamine hydrochloride ($C_6H_4(NH_3Cl)_2$) are similar in both formula and application, and survived for a long time as super-fine-grain developers, although there is little call for them today: emulsion speed losses were up to 75 per cent. Again, they were rarely used for papers.

Pyrocatchin, also known as Catechol or Catechin, is (like pyrogallol) a staining developer; the image is stained in proportion to its development. A number of people still like to use it for film for this reason. It also tans the image during development, which is more important with paper, because tanning or selective hardening of the gelatine is essential for some transfer processes (see Chapter 15).

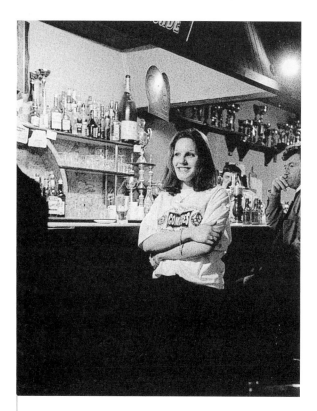

PUSH DEVELOPERS

The 'all-in' picture looks very sharp indeed at a 6× enlargement in the original print, but by the time you go up to 30× it is possible to see that the plane of focus is fractionally behind the girl – although things are

not helped by the fact that the elderly 30mm enlarging lens we used t(make this blow-up is not the sharpest in the world. The letters CBW on her T-shirt are about 0.1mm high on the negative: about ¹⁄₁₀₀₀in.
Leica M2, 35mm f/1.4 Summilux, Kodak TMZ at EI 12,500. (RWH)

It must also be said that it is normally quite unmanageable for general use with anything under ISO 400.

'Standard' and fine-grain developers

Just about any developer will work on any conventional film. In the old days of press photography, it was quite normal to develop sheet film in Dektol paper developer. You will get plenty of film speed, and grain like popcorn. Use a Phenidone-based developer, and you will still get the big grain but the speed will be very low: an Ilford recommendation for grossly over-exposed films (3 stops or more) used to be PQ Universal developer.

Purpose-made film developers will give finer grain, but beyond a certain point the price of finer grain is a loss of film speed. A low-energy developer, normally of low alkalinity, reduces grain clumping; such developers are normally buffered to compensate for the oxidation of the hydroquinone. Another approach is to add a silver solvent, as described above.

'Push' developers

'Push', or speed-increasing, developers may give an effective speed increase of 1 or at most 2 stops. The penalties are modest to begin with. Grain goes up slightly and so does contrast, although the latter can be tamed with a softer grade of paper. Both problems grow worse, however, as you rate the film faster and faster, and sooner or later – typically within 1 stop and at most within 2 – you will begin to lose a certain amount of shadow detail.

For the reasons given elsewhere – that most people do not know what a good monochrome print can deliver – this may not matter too much until it becomes very apparent, and in any case you may not be worried about it. In surveillance photography, in particular, what you normally need are recognisable faces. Even without any special processing, you will often catch light-skinned villains with a good ISO 400 film when it is under-exposed by 3 stops; in other words, when it is rated at EI 3200. Push that same

film, and you will have recognisable faces at 2 stops less: EI 12,500. Use Kodak T-Max P3200 (TMZ) pushed to the manufacturer's recommended limit of EI 25,000 and you will get recognisable faces (as long as they are big enough not to be obscured by the grain) at between EI 50,000 and EI 100,000. Anything much faster than TMZ P3200 would be of limited usefulness for any application: fast films are shorter-lived than slower ones, being more subject to heat degradation and even to cosmic ray fogging.

As a matter of interest, the fastest monochrome film in production when this book was written was a Polaroid CRT (cathode ray trace) recording material at ISO 20,000. It was made in standard quarter-plate pack size (see page 72) and could be used for general photography.

Faster films normally 'push' better than slow ones, and some films are specially designed to respond well to pushing: Kodak TMZ, sold as 'P3200', is at most an ISO 1000 film. Most 'push' developers have high concentrations of developing agents, often with plenty of hydroquinone and strong alkalis. Similar effects can often be achieved with extended development in normal developers, although there may be an increased risk of fog, including (for very long development times) dichroic fog.

Acutance developers

Acutance developers make use of 'edge effects'. Where a dark area meets a bright area, some developers (and some films) will give a slight increase in density at the edge of the dark area, and a slight decrease in density at the edge of the light area, thereby emphasising the boundary. This can greatly increase the apparent sharpness of a contrasty subject such as a test target, but will do nothing for sharpness if contrast is low.

Acutance developers are often known as Beutler-type developers, after the inventor of several popular formulae. They are normally highly diluted, with low concentrations of developing agents so that they exhaust quickly; low bromide concentrations, to enhance this; and low sulphite concentrations, to avoid reaction with oxidised developer products. Agitation is critical. Give too much, and the edge effects are negligible; give too little, and you get 'streamers' from developer exhaustion products.

Developers for extreme contrast

If you are processing lith or line materials, for maximum contrast you will need to use specially formu-lated high-contrast developers. These can also be used with conventional films for special effects. They are available from a number of manufacturers, but if you use them only occasionally, you may prefer to make them up from scratch.

Most of them use high concentrations of hydro-quinone as a developing agent, with caustic soda (sodium hydroxide) as the alkali and plenty of bromide as a restrainer. A formula (Kodak D8) is given on page 118.

Tropical developers

Old photography books frequently refer to 'tropical' developers for use in hot climates. Processing at too elevated a temperature will certainly render emulsions more tender than lower temperatures, and in the old days there was considerable danger of 'frilling' as the gelatine came off the plate at the edges. With the advent of air conditioning and the ready availability of refrigeration (for making cool water-baths) this is less of a problem than it was; and besides, most modern materials can stand processing at quite high temperatures.

However, some developers are designed to work at high temperatures – over 24°C (75°F), especially in instances where rapid machine processing is required – and others are formulated to work at unusually low temperatures.

Two-solution and water-bath development

From time to time, the use of two-solution developers gains popularity. The idea is that they are to a large extent self-regulating and self-compensating. The film is soaked in the first solution, which consists only of developer and preservative without an alkali, and then in the second bath, which contains no developing agents but is quite strongly alkaline. As with Beutler-type developers, agitation is critical: unless you give at least some agitation in the second bath, you will almost invariably get 'streamers' or 'bromide drag'. While we were writing this book we made up a batch of Leica 2-Bath developer from a formula in an old *British Journal of Photography Almanac*; we had not used it for years. The results were so disappointing that we did not bother to publish the formula, as we had intended to do.

A variation on two-solution development is water-bath development, where the film is either put into a developer and then into a water-bath, or switched repeatedly between the developer and the water-bath. Again, this has a compensating effect because the developer is exhausted in areas of high density but

continues to act in areas of low density; uneven, blotchy development is, however, a risk.

If it works for you, it works for you, but these techniques were evolved in the days of very different emulsions and they were also required to 'fit' the negative onto one of a very limited range of discrete paper grades. Today there is little if any reason to use them, unless they give you an effect you like.

Another idea which is periodically fashionable is to pre-soak a film in plain water before development. Film manufacturers are unanimous in condemning the practice as doing more harm than good with the majority of modern emulsions, and conferring no benefit even when it does not actually do any harm. Both films and developers contain chemicals to help wet the film uniformly, thereby ensuring uniform ingress and egress of developing agents, and pre-soaks and water-baths can wreak havoc here.

Monobath development

It is possible to make a 'monobath' which both develops and fixes the film; there is a sort of race, where

WHITSTABLE HARBOUR

Like Dia-Direct of fond memory, Agfa Scala is a direct-reversal black and white film which is processed in Agfa-unique proprietary chemicals – although at ISO 200 it is a lot faster than Dia-Direct. As a camera original it delivers wonderful sharpness, and as a transparency film it captures a long tonal range: the density range of this transparency is well in excess of 6 stops. Nikon F, 90mm f/2.5 Vivitar Series 1 Macro. (FES)

the monobath has to be matched to the material in use. All in all, monobaths sound more useful than they are. We have never used them, although they are popular where rapid access is required and Polaroid materials are impractical.

Reversal development

Agfa Scala is developed by Agfa-licensed labs, and the formulae have not been released. Kodak sell a reversal kit for their own films, which works well once you have mastered it, and for other films we have used formulae gleaned from *The Focal Encyclopedia*, old Ilford manuals, and more; but now we use Scala in the interests of time, economy and consistency.

A typical sequence is first development; wash; bleach; wash; clear bleach stain; wash; reversal exposure (or chemical reversal bath); second development; wash and dry. An interesting alternative, which gives a direct sepia image, is to immerse the film in a thiourea/hydroxide toner after step five above.

Physical developers

Physical development is mainly of historical interest: it has been little used since the 1930s. The film is immersed in a fore-bath of sodium sulphite and potassium iodide, then soaked for a very long time in a silver nitrate/sodium sulphite/sodium thiosulphate solution to which a little Amidol has been added; an old edition of the *British Journal of Photography Almanac* recommends 25 to 30 minutes at 18°C (65°F), with agitation every eight or ten minutes. This gives very fine grain, but it is time-consuming and silver is often deposited where it is not wanted. The actual developing process consists of depositing silver from the solution on the development sites.

Chromogenic development

Ilford's XP2 and Kodak T400CN are developed in ordinary C41 (colour negative) developer: the image is therefore formed of dye clouds, not metallic silver. Because of this, over-exposure gives finer grain rather than coarser, and the Callier effect with condenser enlargers is not seen (see page 153). Latitude is

development happens faster than fixing. Processing in this way is fast and easy, although monobaths are in fact most useful in precisely those circumstances where their drawbacks are greatest: in rapid-access 35mm, where coarse grain, poor sharpness and limited speed tell most.

A monobath is typically a strong PQ developer with a potassium hydroxide energiser combined with a relatively slow, weak, hardening/fixing bath which contains hypo and alum. Fast-developing materials require different mixtures to slow-developing ones, so

enormous, but you generally need to print on paper one grade harder than with conventional films.

The film can be developed conventionally, but results will be poor: the only reason to do so would be desperation, when XP2 was all you had, you couldn't get anything else, you had access only to conventional developers, and you had to have an image in a hurry! XP2 can also be 'cross processed' in E6 (reversal) chemicals, to give a rather romantic-looking monochrome transparency. It will not harm the E6 line.

Polaroid development
Polaroid offers peel-apart prints; pos/neg prints, where you get a negative as well as a print; and also monochrome 35mm films.

The first require little comment, except to say that there is a surprisingly wide range of film types. At the time of writing, Polapan Pro 100 (formerly Type 54) was most favoured for origination for reproduction.

The second type is a variant on the first, with a recoverable negative which must however be cleared in a sulphite solution and then washed and dried if it is to be permanent, so it is not particularly 'instant'. Optimum speed for a good negative is EI 12 to EI 40, despite the ISO 50 rating which gives a good print. The negative has good resolution, and enlargements of up to 6× or even 8× are feasible.

The third type looks like a conventional 35mm film and is exposed in the same way. The whole film is then run through a Polaroid processor, which takes a couple of minutes. The resulting transparencies can be beautiful.

CHOICE OF DEVELOPER
Almost any developer will give you an image with almost any film, but the question is, will it be the image you want? Some films, such as Kodak's seemingly immortal Tri-X, can be developed in just about anything and give an acceptable image. Others, such as Kodak's T-Max, are far fussier, and will only work well with a few recommended developers. Yet others, such as Ilford's Pan F Plus or Kodak's Technical Pan, are idiosyncratic in the extreme: some people never get them to work well, while others get superb results, whether from old standbys or exotic 'pet' formulae.

As a general rule, all but the slowest 'old technology' films can be developed in virtually anything, and will give results which range from acceptable to excellent. It is all a question of what you want.

'New technology' films generally develop best in relatively highly alkaline developers with relatively low concentrations of developing agents – derivatives of the Beutler-type developer. In fact the film manufacturers' own developers are hard to beat: Ilford in particular offer a choice of developers, depending on what you want, whether it be fine grain, acutance, speed or a (slightly subjective) 'best overall quality'. There are, however, many good proprietary developers, such as, for example, Geoffrey Crawley's formulations for Paterson.

Personalising development and EI
All development times are subject to personal preference; they may be increased or decreased until you get the results you want. The same is true of effective film speeds, or EIs. So the question now is just how do you go about personalising development times and EIs, and what sort of adjustments should you make?

As with many other areas of photography, a good deal of nonsense is talked about this, and usually by people who think they know more than they do. If you talk to professional designers of films and developers, you will probably find that they are astonishingly casual about it. You often hear comments such as 'Well, give it five minutes, and if that doesn't give you enough contrast, try six. Or seven.' By the same token, they might say, 'Well, try half a stop extra exposure – can't do any harm.'

The important thing to remember is that you are not going for ISO speed tests: you are going for the effect you like best, and which takes account of your meter, shutter, lenses, metering techniques, chosen subjects, film developer, development technique, enlarger, printing paper, paper developer and printing technique. Ultimately, the only real test is whether you get the prints that you want: all the densitometer readings in the world, and all the tests of equipment and materials, are worthless if you can't get the prints you want.

There are two ways in which you can go about personalising your own development times and EIs: formally and informally.

The best-known way of doing things formally is by using the Zone System. To begin with, you photograph grey cards at different exposures, and then develop the resulting films for different times. Finally, test your negatives with a densitometer. There are whole books about this, but easily the best are those written by Ansel Adams himself (see the Bibliography). A very brief outline of the Zone System starts on page 80 *et seq.*

A simpler approach

A much easier approach than full Zone testing is by trial and error. Will your negatives print well on grade 2 or 3 paper? If not, why not? If contrast is too high, try reducing development time by ten per cent next time. If contrast is too low, try increasing it by around 25 per cent.

Changing development time will also change film speed. If you reduce development time by ten per cent, give an extra ½ stop of exposure. If you increase it by 25 per cent, then reduce exposure by ½ stop.

This should take care of your contrast problems, but you may now have to make another iteration on film speed: you may decide that you still want more shadow detail, or that the highlights are blocking up a little. Again, make your judgement on how well the second film prints before you expose and develop another. The changes will normally be a maximum of ½ stop either way.

Of course, all this assumes consistent metering technique, and the use of the same camera: even if the shutters are within ⅓ stop of one another (which they may or may not be), you might well find that you use a 4×5in camera and a 35mm camera in very different ways – or even that you use a rangefinder Leica and a reflex camera in different ways. If you were conducting a formal Zone System test, however, you would have to go through all that again for each change of camera too, so it would end up being even more time-consuming.

The suggestions given above are no more than a starting point. Slower films and 'new technology' films generally respond more rapidly to changes in development time, both in contrast and in film speed; faster films and 'old technology' films are less sensitive. In particular, with fast 'old technology' films you will do better to try a 15 per cent decrease or 50 per cent increase, accompanied maybe by a 1 stop variation in film speed, in order to see any real changes. This is the basis of contrast control by development, described below.

For what it is worth, we find that we often like to give a little more development, or a little more exposure, than the manufacturers' recommendations. In other words, with an ISO 100 film and 5½ minutes' recommended development time, we would normally rate the film at EI 80 and stick with the recommended development time, or we would rate it at the ISO speed but give it six minutes. With large-format films

SHELL AND DRIFTWOOD

The print on the left was made from the optimum negative of the nine on page 109. What is perhaps more remarkable is the other print, made from the under-exposed and under-developed negative. For technical data, see page 109.

in particular, we have on occasion found that we are happiest with long development times and a ⅓ or ⅔ stop increase in film speed: we habitually rate Fortepan 400 (developed in D19 or in paper developer) at EI 650.

CONTRAST CONTROL BY DEVELOPMENT

Both exposure indices and development times are based on the manufacturers' best guess at how their films will be used. If you reduce development times, you will compress the tonal range of the subject. This allows you to capture a subject brightness range of 1,000:1 or more on the film, although the resulting image may look 'flat' and lifeless, and you also need to give extra exposure. Equally, increasing development times will build contrast – useful if you want to differentiate two comparatively close tones – although this time you must cut exposure, as increased development gives you a higher effective film speed.

Once you have a good personalised development time and EI (as described above), then a rule of thumb is to give 50 per cent more development and ½ stop less exposure when you are photographing a subject with a limited tonal range, or 15 per cent less development and ½ stop more exposure when you photograph something with a long tonal range. If you were just 'pushing' or 'pulling' the EI, then you would do better with a whole stop more exposure with 15 per cent less development and a whole stop less with

50 per cent more, but the ½ stop variation is more useful for contrast control.

Zone System *aficionados* perform all kinds of tests to determine 'N+1' or 'N+2' and 'N–1' or 'N–2' development to expand and contract tonal ranges, 'N' being normal. If you choose this method then buy Ansel Adams's own books. With our simpler '15/50' approach, just take your pictures and print the negatives. If you like the results, fine. If you don't, then change the development time; give 10 or 20 per cent less time, instead of 15, for the tonal contraction, or 40 or 60 per cent more time for the tonal expansion instead of 50 per cent. You should now be very close; at most, you will need one more iteration.

Critics may point out that this is nothing like as rigorous as a Zone System test. Our reply is that until you can get a good picture without the Zone System, little or nothing can be gained by the considerable expenditure of time, effort and materials which a full Zone System test demands. The informal tests, on the other hand, are (or can be) fun, and even the failures should be good pictures, at least technically. They should be capable of producing excellent prints, even if you have to use grade 1 or grade 5 paper (and you shouldn't have to go that far); and they reinforce the message that while photography is a science, it is also an art; and as long as you have a reasonable grasp of the science, the art is more important.

NOTES ON MIXING CHEMICALS

Storing and mixing chemicals requires some care; unless you are familiar with good lab practice (even if only at school), it may be a good idea not to mix your own chemicals. As a reminder, stick to the following rules:

1 Store all chemicals safely away from children. Some are poisonous; some are corrosive; some are irritant; and some are carcinogenic.
2 Work in a well-ventilated (but not draughty) area.
3 Label all bottles and jars clearly.
4 Use only clean vessels and utensils for mixing.
5 Beware of spillages *and airborne contamination*, which can cause marks on sensitised materials as well as posing a health hazard. At least consider a respirator and safety glasses.
6 Wear gloves or barrier creams if appropriate.
7 When making up specified volumes, start with three-quarters of the final volume; dissolve the chemicals in the order given, making sure that each is fully dissolved before going on to the next; and then make up to the final volume.
8 When making up developers, you will often get the best results by dissolving a pinch of sulphite before dissolving the developing agents.
9 Chemicals dissolve faster in warm water, but very warm water may break down some chemicals. Regard 40°C (104°F) as a safe maximum unless otherwise stated.
10 Note whether formulae call for anhydrous or crystalline forms of a given chemical. Common conversions are:

Sodium carbonate anhydrous to crystalline, ×2.7

Sodium carbonate anhydrous to monohydrate, ×1.17
Sodium sulphite anhydrous to crystalline, ×2
Hypo anhydrous to crystalline, ×1.6

11 Most processing times are given at 20°C (68°F), but some very old formulae may be designed for 18°C (65°F), and some can be used hotter, in which case they will normally act faster. Hotter temperatures can however mean more fog; 24°C (75°F) is a safe maximum.

KODAK D19b

Metol	2.2g
Hydroquinone	8.8g
Sodium sulphite (anhydrous)	72g
Sodium carbonate (anhydrous)	48g
Potassium bromide	4g
Water to make	1,000cc

Use undiluted at 20°C (68°F) for four to six minutes, depending on film type. Agitate every 30 seconds or one minute. (See page 111.)

KODAK D8 HIGH-CONTRAST DEVELOPER

Sodium sulphite (anhydrous)	90g
Hydroquinone	45g
Sodium hydroxide (caustic soda)	37.5g
Potassium bromide	30g
Water to make	1,000cc

For use, dilute two parts of stock solution (above) with one part water. The stock developer will keep for several weeks in a bottle. Develop for two minutes at 20°C (68°F). (See page 113.)

◀ CURTAILED DEVELOPMENT

This composition has an enormous tonal range, so the negative was given 2 stops extra exposure and two-thirds the normal development. In this way, a wide range of tones has been captured – but the picture is flat and dull. Gandolfi Variant 4x5, 210mm f/5.6 Symmar, Ilford 400 Delta Professional rated at EI 100 and developed for five minutes in Kodak D76. (RWH)

▼ ▼ NORMAL DEVELOPMENT

A similar composition was given normal exposure and development, and although it does not have the tonal range of the other, it is more aesthetically pleasing – even when some of the tonal range on the negative is 'thrown away', as on the harder print. The Polaroid Type 55 P/N on which it was shot demonstrates enormous reciprocity effects: this was given 4 stops more than the metered exposure, 20 seconds at f/22. Gandolfi Variant 4x5, 210mm f/5.6 Symmar. (RWH)

FROM SHORT STOP TO NEGATIVE FILE

After development, the film may be transferred straight to the fixing bath; or washed beforehand, to reduce alkaline contamination of the acid fixer; or put through a short stop before fixing. After fixing, it must be washed, dried, and put somewhere safe. This chapter also covers (albeit briefly) reduction, intensification and retouching of negatives.

SHORT STOP

The short stop arrests development by neutralising the alkaline environment in which the developer operates. With development times of more than five or six minutes, the need to arrest development quickly is less important, but use of a short stop still prolongs fixer life.

Stop baths are very inexpensive, even if you buy the kind with built-in indicators which tell you when the bath loses its acidity. We just add a few drops of acetic acid to water, which costs very little. Over-strength stop baths can allegedly lead to blistering of the emulsion with carbonate developers, although we have never encountered anyone who has had this problem.

The stop bath should be within 1° to 2°C (2° to 4°F) of the temperature of the developer, although with modern hardened emulsions this is far less important than it used to be. The danger was always reckoned to be reticulation, which is a sort of puckering or wrinkling of the film surface caused by the change in temperatures, but with modern hardened emulsions this is quite difficult to create even when you want to do it.

FIXING

The fixer removes undeveloped silver halides; that is, those halides which were not exposed and developed.

These halides are not themselves readily soluble, so

the purpose of the fixer is to form soluble complexes which are. The traditional fixer was 'hypo' – sodium thiosulphate, $Na_2S_2O_3.5H_2O$ – which forms complex sodium argentothiosulphates, but rapid fixers rely on ammonium thiosulphate which is about twice as fast as hypo. Although a plain hypo bath may be used, it is

BOTTLE AND CORKSCREW
Sometimes, a negative looks a lot better than the print you make from it. The solution? Run it as a negative... We occasionally shoot 8x10in paper just to make negative prints: it's a lot cheaper than 8x10in film, and fun too. De Vere 8x10, 14in f/9 Cooke Apotal process lens, Ilford Ortho Plus. (RWH)

▶ **DRAIN AND WALL, South of France**
Judging a 35mm negative while it is still wet can be difficult: you do not want to look too closely at it, for fear of damaging it with too much handling. It is much better to wait until you can examine it properly on the light box with a magnifier. The texture on which this picture relies was not readily apparent to the naked eye. Nikon F, 90mm f/2.5 Vivitar Series 1 Macro, Ilford XP2. (FES)

STAINED (BADLY FIXED) NEGATIVE

It looks as if this negative was tray-developed with several others which were not kept apart adequately, hence the marks near the collar and lapels in the centre of the negative. A brownish stain beneath those marks indicates that the negative may not have been that well fixed either.

important to maintain the acidity of rapid fixers, or there will be considerable risk of staining. The bath is normally acidified with potassium metabisulphite or with a mixture of acetic acid and potassium sulphite; in the absence of sulphite, the acetic acid would cause the fixer to decompose.

Plain hypo baths can contain anything from about 20 per cent to about 75 per cent of the crystalline chemical by weight, although around 30 per cent is regarded as normal for film. They are most easily made up with hot water at up to about $45°C$ ($120°F$), but for an acid fixer they should be allowed to cool before the metabisulphite is added or the hypo may decompose. We have not made up our own fixing baths for many years, preferring instead to buy concentrated liquid non-hardening fixers. All the ones that we have ever tried are good.

Traditionally, hardening/fixing baths were used to reduce the swelling of the gelatine, but with modern films there is much less need for them; their big disadvantage is that a hardened emulsion takes much longer to wash. On the other hand, it also takes less time to dry. The normal hardeners are alum ($K_2SO_4.Al_2(SO_4)_3.24H_20$), and also chrome alum ($K_2SO_4.Cr_2(SO_4)_3.24H_20$). Formalin is sometimes employed, especially under tropical conditions, but it is an evil-smelling carcinogen.

Fixers (of whatever type) are exhausted in two ways. One is by the build-up of iodide (from the emulsion)

INDIAN SHOPS, Tooting

400 Delta Professional will clear in 45 seconds or so in fresh rapid fixer, which implies a fixing time of 1½ minutes; but it needs three minutes if you want to clear the pink dye. This film should have been developed for longer: it was shot with a very rare Leica copy from the 1950s, which turned out to have a lens that was very 'flat' and lacking in contrast. (RWH)

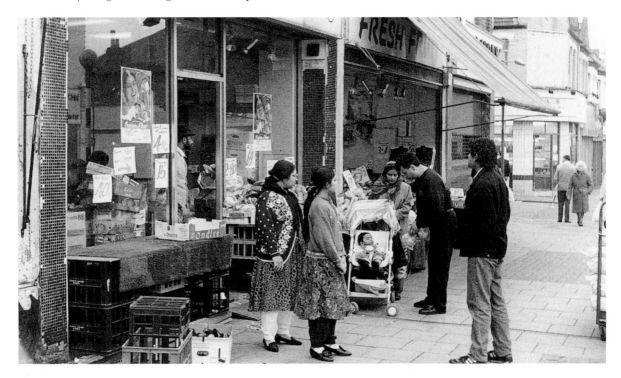

in the bath, which decreases the solubility of the bromide that the fixer is meant to dissolve. The other is by the build-up of silver, which causes the argentothiosulphates to be mordanted to the emulsion, making them much harder to remove by washing (see below). Fixers should not, therefore, be worked to exhaustion.

Fixing times

The classical advice on fixing times is to fix for twice the clearing time, at a temperature within 2° or 3° of the developer, but there are several riders to this.

First, three times is safer, especially with 'new technology' films, although this is a counsel of perfection. Many modern films do however need to be fixed for longer than is necessary to dissolve the silver halide, in order to get rid of dyes incorporated in them. In these cases, follow the manufacturer's instructions.

Second, the best way to determine clearing time is to put a drop of fixer on an undeveloped piece of film: the leader of a 35mm film is fine. Leave it to act for ten or twenty seconds, then immerse the whole film in fixer. Start the timer. When you can no longer see the spot, the film is cleared. Fix for twice or three times this time.

Third, over-fixing can reduce highlight detail, thanks to the solvent action of the fixer on even the developed grains. It may also take somewhat longer to wash the film.

Fixing times and fixer exhaustion

When the clearing time in a part-used bath reaches double the clearing time for a fresh bath, throw it away and start again. This is only a rule of thumb: you could go to three times, or you can actually test the fixer. One way is by adding 1ml of five per cent potassium iodide solution to 25ml of fixer. Any cloudiness

SILVER TEST PAPERS

These test papers give an accurate assessment of the silver content in fixer, allowing you to use it to the maximum while avoiding staining.

should disappear on shaking. If it does not, the fixer is exhausted. A quicker, easier way is to use Johnson's Silver Test Papers: a maximum concentration of 4.5g/litre of silver is normally acceptable in film fixing baths. We use these test papers all the time.

You can if you wish use two-bath fixing. As soon as the film clears in bath 1, transfer it to bath 2. When bath 1 is exhausted (you can identify this by using any of the above criteria), throw it away; use the old bath 2 as your bath 1; and make up a new bath 2. This should guarantee archival fixing.

Fresh fixer clears most films in 30 to 60 seconds – slow films generally clear faster than fast ones – and a litre of working-strength fixer should fix at least 25 rolls of 135-36 or 120, 25 sheets of 8x10in film or 100 sheets of 4x5in. In our profligate days, most would renew the fixer long before that.

WASHING

Washing removes the argentothiosulphates mentioned above. Almost any washing will be 'archival' if it goes on for long enough or if you use enough changes of water. Temperature has some effect, but less than you might think; a simple rule of thumb is to treat 15°C (59°F) as a break point, and to double your washing times if the water is colder than this.

The system we use, and have used for years, is the Ilford approach of three changes of water at around the same temperature as the rest of the processing – but not over 24°C (75°F). After fixing in a non-hardening fixer (this is important, as it will not work with hardening fixers), the tank is drained thoroughly, and then filled with water and inverted five times, quite slowly. Drain; refill; and invert ten times. Drain; refill; invert 20 times. The film should now be thoroughly washed. We use this for all film sizes up to 4x5in. If the film was not processed in a tank, we put it in one to wash. For 8x10in films, we suspend the film in a Nova print washer (see page 165).

In running water and with a good washer, a 15 minute wash should be adequate at any temperature for non-hardened films, or 30 minutes for hardened. Washing overnight (we have done it, by accident) can result in the emulsion becoming so tender that it floats off the support, and is also extremely wasteful of water.

An old trick, of very dubious value, is to wash the film first in a couple of changes of sea water, then switch to fresh water. The sea water gets rid of the hypo, and is itself easier to wash out than hypo.

HARBOUR, Crete

Pictures which look dramatic as tiny, wet negatives can turn out to be rather more difficult to print than you had hoped. In the 35mm negative, only the shapes of the tonal masses are obvious; in the print, you have to get to grips with holding the full tonal range. Nikon F, 35mm f/2.8 PC-Nikkor, Ilford XP2. (FES)

We live 100m from the sea and have never bothered to try this one; we suspect that it could well do more harm than good.

Testing fixing and washing

To test film for residual silver, put a drop of 0.2 per cent silver sulphide solution on the rebate of the negative. Blot it after two or three minutes. Any colour in excess of a barely visible cream indicates the presence of silver salts, due to inadequate fixing or poor washing. Re-fix and re-wash.

To test for residual hypo, put a drop of one per cent silver nitrate on the rebate of the negative. Rinse thoroughly after two or three minutes: otherwise, the reagent will darken on exposure to light. Once again, any colour which is more than a barely visible cream indicates the formation of silver sulphide. Re-wash (or continue washing).

DRYING

For many years, we have used a scheme which we first saw in a long-forgotten photo magazine. After a final two-minute soak in distilled or purified water to which a few drops of wetting agent have been added, we pin both 35mm and roll films diagonally across a doorway. The water runs down to the edge, so the film dries quickly and without drying marks. Except in very dusty climates, this has always given us remarkably clean negatives. One of the reasons we have never bought or made a drying cabinet is that it would be difficult to dry the films diagonally. Cut films are washed in the same way, then pinned by one corner to a strip of wood.

If speed is of the essence, films can be bathed for a few minutes in methylated spirit or other alcohol, or in a proprietary drying agent such as Tetenal Drysonal. After this, they will dry in a few minutes.

An alternative to any alcohol method is to give a brief rinse to the film after fixing; soak in two per cent

▶ **6×7 CONTACT SHEET**

We generally prefer not to contact a whole roll of 6×7 on a single sheet of paper; giving the negs 'room to breathe' seems to make it easier to judge the contacts.

MUSICIAN, Broadstairs Folk Week

A negative which appears unpromisingly contrasty on its own can look significantly better when contact printed, and better again when it is printed. We disagree on the small reflection above the seated man's head; Roger thinks it should be touched out, while Frances likes it. Cover it with the tip of your finger and form your own conclusions. Nikon F, 50mm f/1.2 Nikkor, Ilford XP2. (FES)

formalin solution for ten minutes; wash in six changes of nearly boiling water; and dry with a hair dryer. Again, this dates back to more cavalier days than our own, when hot carcinogens worried fewer people and when big negatives could stand some abuse. It was popular among press men.

INTENSIFICATION AND REDUCTION

In the days before exposure meters, it was not unusual to try to save a grossly under-exposed negative by

intensification, or a grossly over-exposed negative by reduction. This is very rarely necessary nowadays, but formulae can be found in numerous books such as *The Focal Encyclopedia*, old Ilford manuals, *British Journal of Photography Almanacs*, and more.

The most effective intensifiers use mercury, which is extremely poisonous, and to make things worse, they do not always work and the results are not permanent. Chromium intensifiers are less lethal. Sepia toning is quite an effective method of intensification, and has the additional advantage of rendering the negative more archivally permanent.

The most usual reducer is Farmer's reducer, which decreases density without affecting contrast (a 'subtractive' reducer). If contrast is excessive, you need a 'proportional' reducer (which reduces all densities equally) or a 'superproportional' reducer (which has little effect on the shadows, but attacks the highlights strongly). The easiest proportional reducer is a very dilute Farmer's reducer, for which a formula is given on page 128.

Remember that intensification and reduction were desperate measures which were intended to save very poor negatives: the results, especially with 35mm, are unlikely to be of exhibition standard.

HAND-WORK ON NEGATIVES

If you have a big enough negative, you can retouch it. A few very steady-handed photographers can carry out limited retouching on roll-film negatives, but 4×5in is reckoned to be the normal lower limit and 8×10in is safer still. Obviously, enlarging a retouched negative means enlarging the retouching as well.

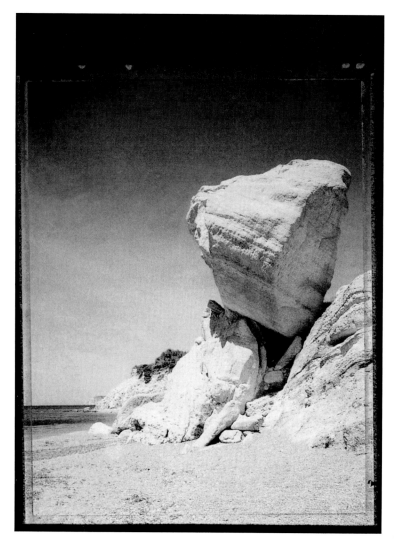

Even with really big negatives, retouching is still very difficult. First of all, you have to think in negative; in other words, to reduce density on the print, you need to add density on the negative, and vice versa. Second, there are only some subjects for which it is suitable. Third, if you make a mistake, you may end up with worse problems than you started with. Fourth, if you look for it, you can generally still see it – and it is out of fashion today.

It is therefore more usual to retouch the print, as described on pages 202–217. If numerous identical retouched prints are called for, then the easiest answer is often to make a large master print and then retouch that; make a copy negative of the master print; and finally print from the copy negative. If (for example) 8×10in final prints are desired, a 12×15in or even 16×20in (40×50cm) master print can be retouched and copied, and the retouching will be reduced in scale instead of being enlarged.

Alternatively, computer retouching may be used. Not only is this easier to master than traditional methods: it also has the advantage that you have the opportunity to go back and undo your mistakes. With traditional methods, they are likely to prove embarrassingly permanent. The only retouching we habitually do is spotting, although we have tried a little pencil work.

Spotting

Pin-holes on negatives make black spots on prints, which are much harder to conceal than

white spots. They are also one of the easiest things to touch out, using a fine-pointed brush: a tiny amount of black pigment will give you a white spot on the print, which you can touch out in the usual way.

Pencil work

Most cut films are provided with a 'tooth' for pencil retouching, although probably fewer than one in 10,000 negatives is ever retouched in this way. For plates, or for films without a 'tooth', there used to be all kinds of proprietary off-the-shelf varnishes, or you could make your own; there are formulae in old photo books.

The most traditional use for pencil retouching is in portraiture, where crows' feet and other lines (which are dark on the print, and therefore light on the negative) are touched in, but skilled portrait retouchers can add modelling and lighten red noses.

A slightly soft (B) pencil, sharp and very lightly applied, is probably the most useful for the beginner; the technique is to use a circular motion, building density slowly and without creating hard edges. Softer pencils add more density faster, while harder pencils may polish the tooth away while adding minimal density. For really heavy retouching, some films can be worked on both sides.

In the great days of monochrome portraiture, some studios used 'retouching machines', which were retouching desks with built-in motors. The negative was vibrated very rapidly (and very slightly) so that the image appeared to be stationary. Merely touching the pencil to the negative automatically produced a 'feathered' edge to the retouching stroke. These machines are very rare today: we have only ever seen one, many years ago, and a friend who was trying to find one in the early 1990s had no luck, but they were apparently re-introduced by Veronica Cass in 1996.

The traditional way to 'fix' pencil retouching on conventional negatives was to hold the negative in the steam issuing from a kettle. This would soften the gelatine, causing the retouching to adhere to it surprisingly strongly.

◀▶ 4X5IN CONTACT PRINTS

A contact print from a 4x5in negative is just about big enough to stand on its own as a photograph: the difficulty can lie in making an enlargement that looks as good.

Other physical retouching

Blocking – removing unwanted backgrounds with opaque pigments or red masks – is feasible on large negatives (8×10in and above) but is hard work.

Knifing – physically removing excess density with a very sharp scalpel blade – requires considerable delicacy, skill and experience. With modern emulsions, which are much thinner than older ones, it is an even more difficult process and we would hesitate to recommend it.

Much the same is true of reducing density locally with metal polish, toothpaste or other mild abrasives applied with a cotton bud. It can be done, but it is very hard to do well.

Weak Farmer's reducer can be used to reduce both small and large areas, but the question (as ever) is whether it is worth the risk.

POLAROID CLEARING BUCKET

Polaroid Type 55 P/N is a special case in that the negative is processed integrally with the print, but it must then be cleared in a sulphite solution for a minute or so before washing. This clearing bucket can be used to store the negatives in sulphite solution for up to 72 hours before they are washed and dried.

COMPUTER MANIPULATION OF NEGATIVES

A modern scanner should be able to handle 35mm negatives in strips, and a good software package should give you the option of working in either negative or positive. On the other hand, given the hands-on nature of black and white photography, few photographers in this medium seem very interested. We have to admit that we count ourselves among them. Besides, output devices capable of giving true photographic quality are startlingly expensive next to traditional darkroom tools.

NEGATIVE FILING

The easiest way to store roll-film and 35mm negatives is in strips in archival polyethylene holders, such as those made by DW Viewpacks in the UK or Print File in the United States. These will not stick to the negatives; they contain nothing which can attack them; you can see the negatives through the holder, which you cannot do easily through the paper kind; and you can even contact print through them. We prefer the ones which take seven strips of six exposures; a seven-strip times five-exposure holder may fit better onto an 8×10in contact sheet, but it is a torture of diabolical

refinement with a 36 exposure film. For notes on the storage life of acetate base films see page 36.

A useful tool, both for extracting films from their sleeves and for handling short lengths of film in the negative carrier of the enlarger, is the Neg Handler. Deceptively simple, this is easier to illustrate than to describe – but it works very well.

With roll films, most sleeves take four strips. This is fine with 6×5, 6×6, 6×9 and even 6×17, but 6×7, 6×8 and 6×12 can be a problem. If you use these formats, look for extra-wide sleeves.

With cut films, and for that matter with 6×12 or 6×17, the easiest bet is probably paper 'neg bags', which are available in all sizes from 6×9cm upwards; they are available from most professional photographic dealers, although dealers catering principally for the amateur may disavow all knowledge of them, or tell you that you cannot get them any more.

FARMER'S REDUCER

Solution A		Solution B	
Sodium thiosulphate (anhydrous)	80g	Potassium ferricyanide	100g
Water to make	1,000ml	Water to make	1,000ml

For use, take 100ml of A and add 5ml to 10ml of B; the more B, the faster the action. The freshly mixed two-part solution should be lemon-yellow, and it deteriorates within a few minutes. (See page 126, and Notes on Mixing Chemicals on page 118.)

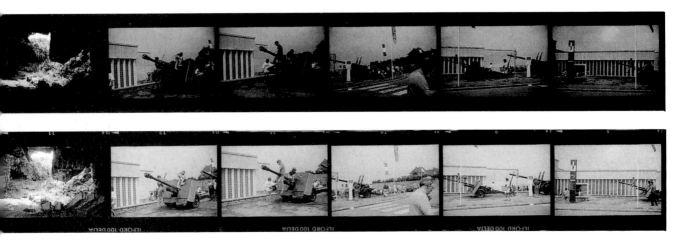

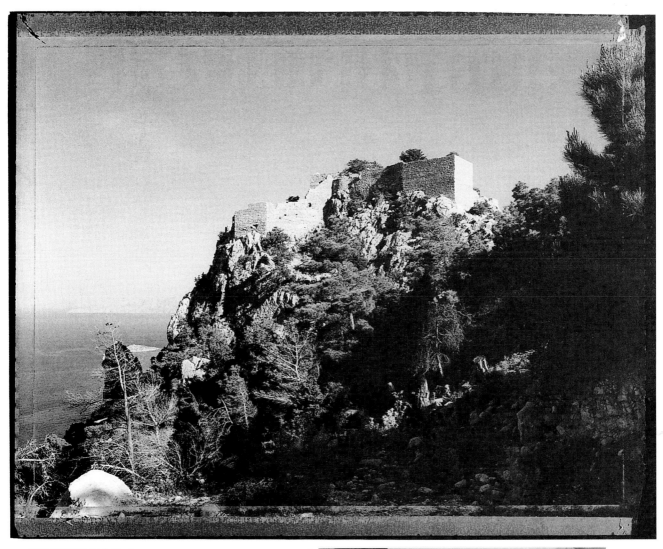

▲ CRUSADER CASTLE, Rhodes

Although Polaroid Type 55 P/N can be processed in the field, it is often easier to shoot one image; examine the negative to make sure that it is sharp and correctly exposed; then shoot another sheet for processing later, discarding the original negative. Toho 4×5m, 120mm f/6.8 Schneider Angulon. (RWH)

NEG HANDLER

The Canadian-made Neg Handler is wonderfully simple and extremely useful. It is particularly handy when dealing with short pieces of 35mm film, in either the negative sleeve or the carrier. (Courtesy Neg Handler)

◀ CONTACT SHEETS FROM 35MM

Two useful tricks when contacting 35mm: Use a sheet and a half of 8x10in paper; and – not always necessary – make two sets with different exposures, one for the light exposures and one for the dark. You still need at least a 6× lupe to judge the pictures, though.

SILVER PRINTING PAPERS

If you are reading this book, you probably have fairly firm ideas already on the relative merits of fibre-base (FB) and resin-coated (RC) papers, and on graded papers versus variable-contrast (VC) papers; but when did you last reappraise your ideas? FB papers used to be incomparably superior to RC papers, and graded papers used to be incomparably superior to VC, but times have changed.

GRADED AND VARIABLE-CONTRAST PAPERS

In an ideal world, we would all shoot perfect negatives which would print without any difficulty onto grade 2 or grade 3 paper, just depending on our personal preference, the equipment we have and our technique.

However, the world is not ideal, and we are all fallible. From time to time, therefore, we may need softer papers to tame excessively contrasty negatives, and harder papers to get more 'punch' from soft, flat negatives. This is quite apart from the aesthetic advantages of the different grades.

Once upon a time, there was only one contrast grade of printing paper. When 'vigorous' and 'soft' papers first appeared, printing on them frequently entailed significant quality losses. Over the years, more and more grades appeared, and quality differences between them diminished. Today, there are up

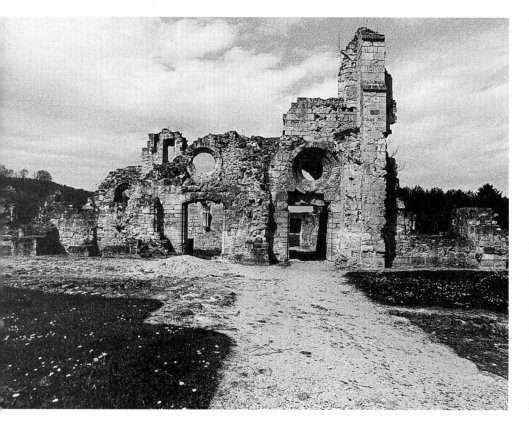

RUINED ABBEY

This picture was shot on an 'old technology' film (Fortepan 100) and is somewhat lacking in mid-tone differentiation. On Ilford Multigrade IV, the mid-tones were flat at lower contrast grades, and the picture was unacceptably contrasty at the higher grades. Sterling RC VC does not have such a wide range of contrast grades as Multigrade IV, and cannot hold the same highlight detail, but it can open up mid-tones. Nikon F, 35mm f/2.8 PC-Nikkor. (FES)

▶ **TREE, California**

The broad tonal range here makes considerable demands on both highlight and shadow detail. Ilford Multigrade IV can hold extremes better than any other paper and is a natural for printing this negative. Nikon F, 35mm f/2.8 PC-Nikkor, Ilford SFX 200 with heavy red filter. (FES)

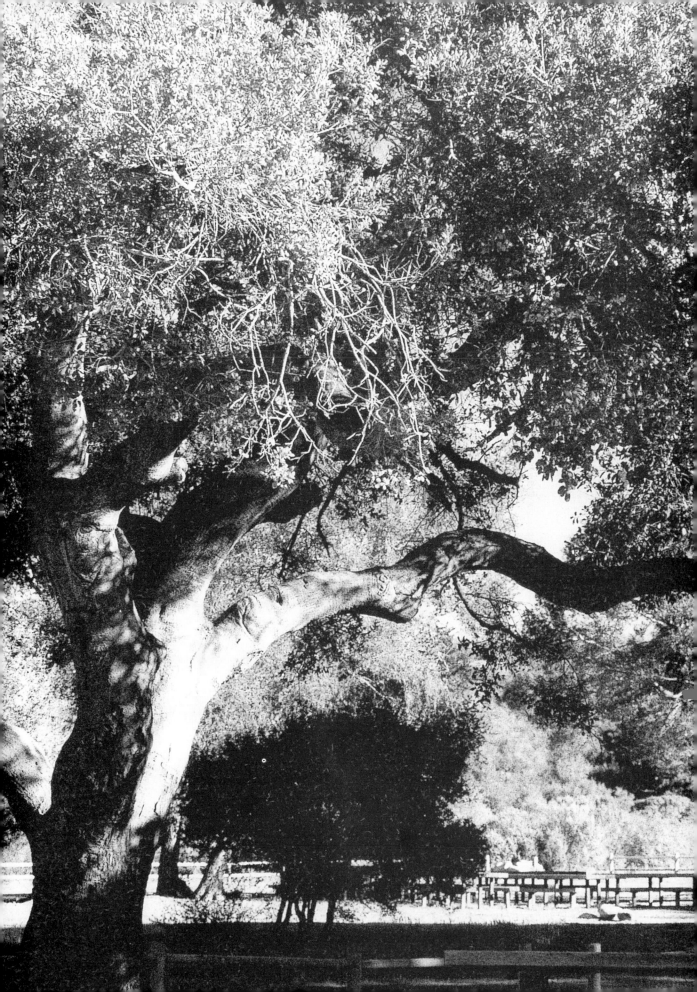

CHURCH DOOR

The same negative may well print differently on different papers. For example, Ilford's Multigrade IV has a straighter D/log E curve than Sterling RC

VC. In this picture of a door, the film/developer combination that was used has given poor separation in the mid-tones (above left). The 'belly' on the Sterling curve has opened out the mid-tones,

and as there are no real highlights or shadows to worry about, this works better than Multigrade IV (below left). Finally, a little dodging has given a lighter tone in the grass and on the right of

the door – less sensitometrically accurate, but more pleasing (below). Nikon F, 35mm f/2.8 PC-Nikkor, poorly processed XP2. (FES)

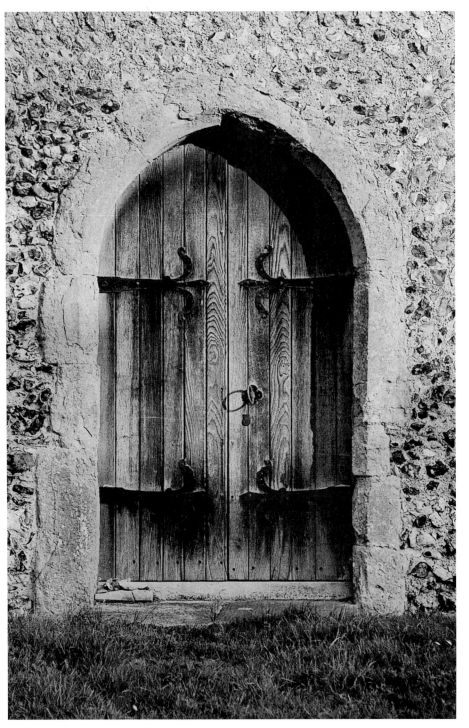

to seven grades: 00 (extremely soft, normally available only with VC papers); 0 (very soft, not always available); 1 (soft); 2 (normal for condenser enlargers); 3 (normal for diffusion and also cold-cathode enlargers); 4 (hard) and 5 (very hard). There are, however, quite broad variations on these, so that one manufacturer's grade 5 (in particular) may be quite a lot harder than another's.

Graded papers

With graded papers, if you need more contrast you simply go to a harder paper; if you need less, you go to a softer paper. It does not matter what sort of enlarger you are using, old or new, or what the light source is. Normally, paper speed is constant up to grade 4, and grade 5 is half as fast. There may or may not be a grade 0; there is never a grade 00.

When VC papers were first introduced in the 1940s, and indeed into the early 1970s, there was no doubt that graded papers gave a wider range of grades – really hard grades were effectively unobtainable on VC – as well as better image quality at any given grade. Today, the range of grades obtainable with VC is typically greater than with graded papers, and while it is true that there are some 'premium' papers which are available only as graded, even the manufacturers have been known to admit privately that these are to some extent a sop to traditionalists. Yes, they have their own 'look', and if you prefer the look of graded papers to what you can get with VC, use them; but there are many world-class printers who use and indeed prefer VC.

Variable-contrast papers

With VC papers, the contrast of the image depends on the colour of the light. Add magenta (M) filtration, and you get more contrast; add yellow (Y) filtration, and you get softer contrast.

This is achieved by using two or even three different emulsions (mixed together, not coated one atop the other) which have the same blue-light speed but different green-light speeds. Ilford Multigrade IV has three emulsions, each of which on its own would produce a partial or short curve. All three have to be exposed fully to produce a full curve, which is the sum of the three partial curves as can be seen from Fig 20; the separation between the curves, controlled by the amount of green light (magenta = 'minus green') is what controls the contrast.

As well as a wider tonal range, VC papers also allow half (or quarter, or one-third) grades; the option of

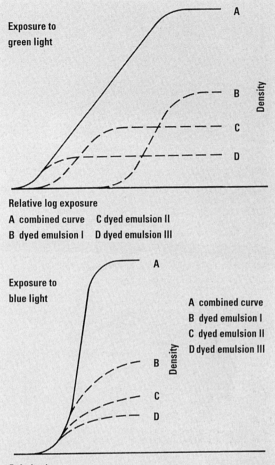

A combined curve C dyed emulsion II
B dyed emulsion I D dyed emulsion III

A combined curve
B dyed emulsion I
C dyed emulsion II
D dyed emulsion III

Fig 20 Additive curves for VC
This sketch shows how there are three emulsion components in Multigrade paper, each with different sensitivities to different colours of light, and how the three 'mini curves' add to give the overall characteristic curve. By varying the colour of the light from the enlarger head, the height of any one of the curves can be increased or decreased, thereby altering the sum of the three curves and the slope of the overall curve. (Courtesy Ilford)

exposing part of the paper at one grade, and part at another; and all of this from one box of paper instead of five, six or seven, some of which you may use only very rarely. Again, paper speed is typically constant from grade 00 to grade 4, with an extra stop needed for grade 5.

It might seem, therefore, that VC papers are the only way to go; and many photographers, including ourselves, believe that this is so. There are, however, some drawbacks.

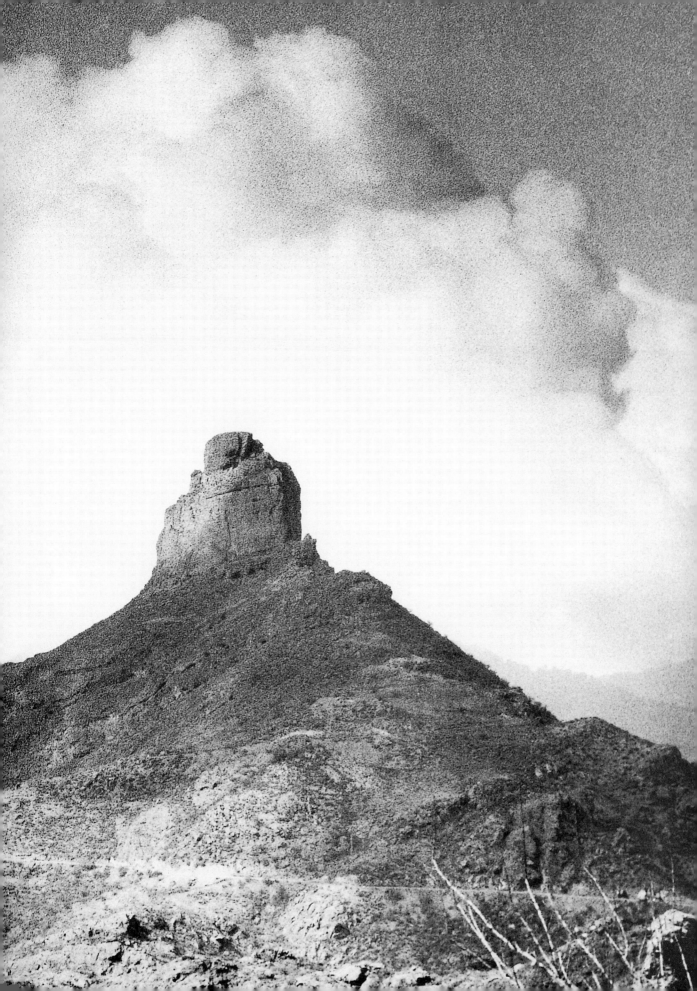

PAGES 134–5 **ERODED HILL, Gran Canaria**

Without pre-flashing, this picture is all but unprintable. After a ¹⁄₁₀
second pre-flash at the working aperture but without a negative in the
carrier, the formerly leaden hill came alive against the brilliant cloud.
Nikon F, 90mm f/2.5 Vivitar Series 1, Ilford×P2. (FES)

The first is cost: VC paper costs more than graded, although as already mentioned this is offset somewhat by the fact that you only need one box, and in any case graded FB papers may cost more than VC RC. Apart from cost, most of the other arguments come down to one thing: the question of VC filtration.

Far and away the easiest approach is with a purpose-built VC head, on which you simply dial in the contrast grade you want. If you don't have a VC head (which we have on only one of our three enlargers) then you need to use separate filters, or the filtration on a colour head.

Separate filters are all very well, and you can get half-grades, but if your enlarger does not have a filter drawer, you have to use below-the-lens filters. Also, changing filters is more fiddly than just going to a different box of paper.

LOCOMOTIVE, Selma, Alabama

The left side of the test print (above) was pre-flashed for ²⁄₁₀ second at
f/8 to get it over the inertia point of the paper; as you can see, there is
considerably more tonal differentiation in the sky, but the contrast is
flatter and there are no good whites in the clouds. In the final print,
therefore, the pre-flash was cut to ¹⁄₁₀ second and the contrast was
increased by a grade. The net result (below) is higher effective
contrast but with greater tonal differentiation – a very desirable
combination. Nikon F, 90mm f/2.5 Vivitar Series 1 Macro, Ilford XP2, printed
on Ilford Multigrade IV. (FES)

KARL AND LUCILLE SCHULTZ
The negative from which this was printed was taken by the late Art Schultz, Frances's father; it was more than 50 years old when she printed it. Her older brother and sister are seen here. Old negatives can range from the very soft to the very contrasty, and may vary widely in density: amateur photographers seldom used exposure meters in the 1940s, and processing was often hit or miss.

Many cold-cathode heads give idiosyncratic results with VC filters: grades are not evenly spaced, and extremes may be unobtainable. This is because the light from a cold-cathode head is not necessarily continuous-spectrum. Some of the older heads, which give off a very blue light, are next to useless with VC filters. With these, graded papers are all but essential.

Finally, some enlarger heads in conjunction with some enlarger lenses and some VC papers are alleged to exhibit quite spectacular focus shifts with changes in paper grade, because of paper sensitivity to UV light. If you find that your prints are sharper at some paper grades than at others, you probably have this problem. The easiest way around it – and it does not happen with all light sources, papers or lenses – is to put a weak UV filter in the light path. Except at the highest-contrast grades, most VC heads or filters should remove enough UV for focus shift not to be a continuing problem.

Other contrast-control techniques
Different paper developers can give more or less contrast, even with a single grade of paper. Some photographers do actually use two developers, side by side, splitting the processing between them to give the ultimate control of contrast. This is quite apart from control of negative contrast by development (see page 117). The variation however is minimal: maybe half a grade, or a grade at most.

Despite these disadvantages, it is clear from the above that in our view – and probably in the view of the majority of modern printers – VC paper enjoys definite advantages over graded paper, unless you are using an enlarger which makes VC inconvenient or even impossible. There are those who disagree. If you are one of them, there is no need to switch to VC paper, but you may still be agreeably surprised if you do try a box.

FIBRE-BASE AND RESIN-COATED PAPER
Historically, paper emulsions were coated onto paper in the same way as negative emulsions were coated onto glass. Some such papers are still available today, but the brightest white is about a 60 per cent reflectance. In 1866, Sanchez and Laurent introduced baryta-coated papers. Baryta or 'blanc fixe' (barium sulphate in gelatine) provides the smooth, white, inert surface on top of which the emulsion is coated. It also gives a maximum reflectance of at least 80 per cent – significantly brighter than non-baryta-coated, and

therefore able to record a longer tonal range. This set the style which continues to the present day.

The structure of a conventional photographic FB paper therefore consists of paper; baryta; sensitive emulsion; supercoat. The paper must of course be exceptionally free from anything which could affect the image, including in particular residual acids and sulphur. It can vary quite widely in weight, although even single-weight (SW) paper is closer to what most people would call thin card. The baryta makes it still thicker and stiffer, of course.

The advantages of double-weight (DW) FB paper are first, that it does not go as limp as single-weight during processing; second, it is more durable when unmounted; third, it is less prone to curling during air-drying; and finally, it can be more attractive when mounted on top of a support, as (for example) when it is dry-mounted (see page 194). The same is even more true of triple-weight.

On the other hand, single-weight FB paper is

BRIDGE, Marshside, Kent
The same paper can react totally differently to different light sources. This was printed using a cold-cathode enlarger; compare it with the same picture on page 64, which was printed at the same nominal contrast grade using a diffuser enlarger. For technical data, see page 65.

cheaper, washes faster and dries much faster, all for obvious reasons. In a 'window' mount, where the edges of the paper are invisible, it is aesthetically indistinguishable from double-weight. Because it is thinner and lighter, it is also easier to mount, and if it is dried using a rotary or flat-bed glazer (see page 164), it dries even flatter than heavier paper.

The baryta layer typically contains 'optical brighteners' – these are fluorescent dyes which make the base brighter. The emulsion normally contains a very small amount of developing agents to act as an anti-oxidant and, in the case of some papers, larger quantities of developer so as to ensure rapid, even development.

RECULVER TOWERS
This is a watercolour paper, brush-coated with Silverprint liquid emulsion. Only a single contrast grade is available, so you have to process your negatives to suit it, but you can influence contrast by varying the coating thickness (thicker coatings have more contrast). Nikon F, 15mm f/2.8 Sigma fish-eye, Ilford SFX 200 with heavy red filter. (FES)

Resin-coated papers

Strictly, even RC paper is fibre based. The principal difference is that with an RC paper, there is a polyethylene coating over the paper which stops the water (and all the rest of the processing chemistry) from soaking in. Also, instead of a baryta layer, there is a titanium dioxide layer, for brightness and sharpness.

The plastic coating means that RC paper can be washed and dried more quickly than FB – and, in the case of air-drying, flatter. It also means that even a 'middleweight' paper is quite stiff, and that it retains this stiffness when wet. These are all clear advantages. What, then, are the objections? The first which most will raise is to do with permanence, so we shall look at that now, but there are others.

BRIGHTON PAVILION

One of our early experiments in brush-coating. The improbable domes and minarets of the Prince Regent's folly are given a dream-like interpretation: this picture is like a vision seen for a moment, and not seen clearly at that. Nikon F, 35mm f/2.8 PC-Nikkor, Ilford Pan F. (FES)

The resin layer in early RC papers tended to crack as a result of free radicals given off by the titanium oxide, although both Ilford and Kodak had solved that problem by the end of the 1970s, not least by incorporating stabilisers in the paper base which acted as a reservoir for them. It may also be that emulsions on RC papers are more sensitive to oxidative pollutants, but unfortunately, research on image permanence is notoriously irreproducible and accelerated ageing tests do not really replicate actual ageing. As one emulsion chemist put it, 'We're not secretive or deceitful – just ignorant.' Accelerated ageing tests certainly do not tell the whole story, and anecdotal evidence repeatedly suggests that under certain storage conditions, particularly on display, RC paper may still be less permanent than FB.

Toning greatly improves the permanence of any paper, and sulphide-toned prints are probably equally so whether RC or FB; but for archival prints for long-term display, FB is probably still the best bet. For dark-stored prints, both seem to be about equal.

BIPP CONFERENCE

The large figure on the right is projected on a screen; the small figure on the left is talking to him on the telephone, from England to Australia. The picture was made with the only camera to hand, a Pentax Espio 928 compact, on the only film to hand, an ISO 400 colour print film – but in fact it printed remarkably well on Forte Equitone panchromatic paper. (RWH)

OTHER CONSIDERATIONS IN PAPER CHOICE

There are some characteristics which RC and FB paper can share, and do; others that they could share, but do not; and some which they cannot share. Most of the arguments about which is 'better' are centred around the latter two, although opponents of RC say that it lacks the technical quality of FB in terms of tonal range and separation of tones.

The quality argument is hard to sustain in quantifiable terms with modern papers. In particular, advocates of FB paper maintain that it has more shadow detail. This is not borne out by the densitometer. It may be that there are subjective differences, but even these are often as much a question of prejudice as of observation: with a print behind glass, in particular, it really can be impossible to tell the difference.

'Warm' and 'cold' tones

Generally, FB papers offer a wider choice of image tone: 'warm' or brown-black and 'cool' or blue-black. Even so, different brands of RC vary widely in image tone, and if (for example) you find Ilford Multigrade too neutral, you could switch to Sterling RC VC for a warmer image tone.

To a large extent, image tone is a function of grain size. The very finest-grained images, when they first appear on printing-out paper (see page 144) are reddish purple in colour before they are fixed and become yellowish brown afterwards, because the fixer has a slight solvent action on the exposed grains. Historically, chlorobromide papers were generally warm-toned, while bromide papers were more neutral, but today a great deal can be done by controlling crystal size and hardening.

Many photographers prefer in any case to modify the tone of the developed image by the use of toners (see page 202). Some papers respond better to these than others, and a paper which does not respond to one brand or formula of toner may well respond to another, even though they may be apparent similarities between the formulae. Again, this is true of both RC and FB papers.

Paper surfaces and colours

The most usual FB surface is often known as WSG (white, smooth, glossy) which is self explanatory, but the baryta layer can be impressed with a range of textures. So can the paper itself, whether there is a baryta layer or not. Equally, the emulsion can be coated with another gelatine layer which incorporates starch or other small particles, or which simply dries to a different texture from gloss.

This makes possible a wide variety of different paper surfaces. Over the years, these have had many names: glossy and matte (or matt) are obvious, but 'lustre', 'pearl' (and 'oyster'!), 'silk', 'tweed', 'suede' and 'tapestry' are just a few of the other terms which have been used. Some are rather more descriptive than others, but the only way to understand them properly is to see samples.

Of the glossy surfaces, an air-dried glossy print – that is, one which is simply hung up to dry, or put on a drying rack – has the least shiny texture; in fact, it is a sort of lustrous matte. A heat-dried but unglazed glossy print is shinier, because heat causes the surface structure of the gelatine to compact somewhat.

Glossy, glazed prints are widely believed to have the longest tonal range, but Ilford tests show a slight decrease in D_{max} with glazing, perhaps because of a change in silver morphology. In any case, if you are going to hang a picture on a wall, an air-dried glossy print or even a matte print may appear to have a greater range and more subtlety, simply because it does not have the same sort of 'hot-spot' reflections as the enamel-like surface of a glazed print. For photo-mechanical reproduction, the standard is glossy, unglazed, either air dried or heat dried: strong surface texture may mean that a print is difficult or impossible to scan.

The normal surface for RC is again glossy, which when air dried is rather glossier than air-dried or even heat-dried (but unglazed) FB paper, but less glossy than glazed FB. If dried with hot air, RC glossy is glossier, but it is still not as glossy as a glazed print. Textured surfaces are far less readily distinguishable from the FB variety, but the choice is smaller.

When it comes to colours, there is again a smaller choice than there used to be. From Kodak alone there used to be snow-white, white, cream-white and old ivory. Today, there is mostly just white, although some 'whites' are warmer than others. If you want an off-white, you can always dye the emulsion or (with FB prints) the paper base. Cold tea is very effective and, on the best evidence available, it should act as a preservative rather than the opposite: tannin, a significant constituent of cold tea, is used to preserve leather and should also preserve gelatine.

Tactile quality and hand-colouring

While there is no doubt that FB paper has a tactile quality which most people prefer to RC, that quality is often more obvious to the photographer than to the viewer. With a mounted print, it may not be readily apparent; and with a mounted print behind glass, it is frequently impossible to tell FB from RC. If the print is being made for reproduction, there is absolutely no way that you can tell a good RC print from a FB print. All but a few of the prints for this book were made on RC paper.

On the other hand, there is no real question but that RC papers in general, and glossy RC papers in particular, take hand-colouring less well than FB.

OTHER SILVER/GELATINE PRINTING MATERIALS

The types of paper described above will meet the needs of the vast majority of people, but they are not the only choices. For instance, Kentmere provide conventional bromide papers coated onto unusual supports in a variety of colours, although at the time of writing the once-popular silver-base paper was not available because of problems in getting a sufficiently flawless silver substrate: few customers are as fussy as photographic companies when it comes to wanting paper without flaws.

Photographic emulsions can be coated as readily onto fabric as onto paper; linen is a practical choice because it is tough, light, strong, flexible and chemical resistant. The only linen we have tried came from Fotospeed in the UK. The remarkable thing about it is how tough it is: it can even be washed with conventional soapflakes if the image gets dirty, so you can make clothes out of it! It is difficult to process because it goes very floppy in the developer, and it is expensive, but it is also fun. It is processed in conventional chemistry.

Omitting the baryta coating (see page 137) allows the paper texture to be seen through the emulsion, and limits the whites to the white of the paper base. Many photographers

like this effect, and use it creatively. Some also use such paper to make paper negatives.

Omitting the supercoat (this is the thin layer of toughened gelatine which protects the emulsion from physical damage) gives a rather different surface texture, and is prized for this alone by many photographers. There are also some techniques where the supercoat is an impediment to the efficient working of the process, such as bromoil (see page 199) and bromoetching (see page 198). The best-known non-supercoated papers are SW Art from Luminos and Document Art from Kentmere.

Liquid emulsions are precisely what their name suggests: the same emulsion that is coated onto paper, in liquid form. They normally have to be heated (and

coated onto a warm support), so strictly speaking they are not truly liquid as purchased.

Nor are they easy to use. Coating them onto paper requires a certain amount of practice if you are to avoid lumps, and getting a casual 'brushed-on' look requires even more practice. So does absolutely even coating across the entire image area, which is why so many people go for the 'brushed-on' look.

TRUCK, NEVADA
Never neglect the opportunity to try an unfamiliar paper, especially if someone gives you a free sample. This XP2 neg of a truck in a Nevada ghost town printed perfectly onto a Forte graded paper, with a tonality (and image colour) reminiscent of platinum printing. Nikon F, 90mm f/2.5 Vivitar Series 1 Macro. (FES)

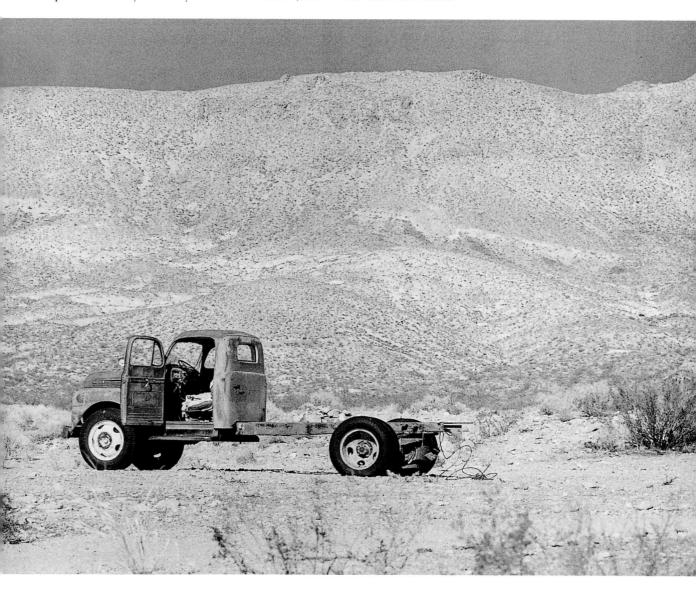

If you have visions of coating stones, tiles, metal plates and so forth, you need to know that getting the emulsion to stick is not always easy. Two useful tips are to put on a 'subbing' layer of very dilute emulsion (or even of household gelatine), or to paint the surface to be coated with a water-based varnish or paint. Even then, you may need several attempts.

The results can however be worth the effort. You can coat watercolour papers for fairly conventional pictures, or almost anything else for less conventional ones. Liquid emulsions are available from a number of manufacturers, although you may find that you need to experiment with several before you get the results you want. We have had good results with Liquid Light, Fotospeed and Silverprint, but others are probably good too.

Processing is conventional; it is during the washing stage that there is the greatest danger of the emulsion coming off the support.

Non-standard silver-based emulsions

The above materials all use comparatively normal emulsions, but there are others which either use different silver halides, or are made differently, or incorporate other ingredients in the emulsion. These include contact papers, printing-out papers, lith papers, panchromatic papers, rapid-access papers and stabilisation papers.

Purpose-made contact papers are rare today. They are slow, chloride papers (typically $\frac{1}{50}$ the speed of bromide papers) for contact printing large negatives under daylight. They are developed and fixed in the conventional manner.

Still rarer are printing-out papers (POP). These are not developed at all. The print is exposed through the negative until the image reaches the desired density – the silver chloride in the paper simply darkens in the light – after which the print is washed, toned to give the desired image colour, and then fixed in the usual way, all under feeble artificial light. Before fixing, the image is reddish purple; after fixing, unless the image is toned, it is more of a yellowish brown. The change in colour is caused by the solvent action of the fixer on the silver grains. At the time of writing, POP was still available from at least two sources, Bergger in France and the Chicago Albumen Company in Housatonic, Massachusetts. Kentmere in England make the latter. On the other hand, almost any paper can be used for printing out, if you give it a long enough exposure.

An important point about contact printing on POP,

▶ **SPINY NORMAN**

It probably will not show in reproduction, but with lith films and papers there can sometimes be a brownish stain (from the developer) in areas where there is not quite enough density to record black. The eyes, and especially the left eye, exhibit this in the original print. Nikon F, 90mm f/2.5 Vivitar Series 1 Macro Ilford XP2 original. (FES)

or with some other silver-based contact processes, is that the paper can contaminate the negative and cause spots. Our ancestors used to varnish their negatives for this reason; today, the usual answer is to put a sheet of very thin Mylar film between the negative and the paper.

Lith papers have a significantly higher contrast even than grade 5 conventional papers, and are used principally in graphic design or for making dramatically contrasty prints. There are currently very few suppliers. The most usual paper is probably Sterling from India, which is exported both to Britain and to the United States.

If you want to print from a colour negative onto black and white paper, you will get some distortion of tone. To overcome this, Kodak Panalure and Forte Equitone are panchromatic black and white papers which will give very reasonable renditions from colour negatives. Exposure can be very sensitive indeed, and colour films are often revealed as surprisingly grainy, but these papers work.

They must however be handled in total darkness (for obvious reasons); they are considerably more expensive than normal papers; and perhaps most tellingly of all, modern VC papers actually give surprisingly good results from colour negatives. The results are so good, in fact, that one cannot help wondering how long panchromatic papers will survive, in what must be a fairly modest-sized market.

Rapid-access papers incorporate developing agents in the emulsion. In conjunction with suitable developers, they develop significantly faster than conventional papers, especially if (as is often the case) they are also designed to be processed at elevated temperatures. At their best, they are more than adequate for high-quality photomechanical reproduction; at their worst, they are more than adequate for newspaper reproduction. Either way, their quality rarely rivals conventional papers, besides which their days may be numbered as they come under increasing pressure from Polaroid materials on the one side and from electronic imaging on the other.

Stabilisation papers are a special case of rapid-access papers, although the difference lies as much in

the processing as in the paper. A developer is incorporated in the emulsion, so development is very rapid indeed, and undeveloped silver salts are converted to inert, insoluble salts with a 'stabiliser' instead of a fixer. Processing is normally by means of a roller transport machine which runs the paper through two successive troughs of developer and stabiliser. After 30 seconds or so it emerges damp rather than wet and takes only a few minutes to dry.

The quality from these papers is never as good as from conventionally processed images, although having said that, it can be surprisingly good – certainly good enough for newspaper reproduction. They can also last for many years if they are kept in the dark: we have stabilised prints which are around 20 years old and which have not faded too badly, or become too discoloured and brown. At any time, these prints can be fixed and washed conventionally. If this is done reasonably soon after processing, they should last as long as any other FB print.

ENLARGERS AND ENLARGING LENSES

Although contact printing preceded enlarging, and even though many photographers habitually contact print their negatives to give them reference pictures before they make enlargements, there can be little doubt that enlarging is much more important to most photographers than contact printing. Therefore enlargers are treated here before contact printers, which appear in Chapter 12.

The general construction of an enlarger will be so familiar to most of our readers that it is hardly worth going into here; however, there are some general observations which are worth making.

'Secret weapons'

There are no 'secret weapons' among enlargers, any more than there are among cameras or materials. Above a certain level of mechanical and optical construction, which is very soon reached, the skill of the operator matters far more than the type of enlarger. This is true even of the different types of light source – condenser, diffuser and cold-cathode – although it is true that most printers today prefer diffuser or cold-cathode heads.

Durability and features

A good enlarger is wonderfully robust and should remain fully usable for many decades, but if you want to use VC materials, you will need filtration; and if there is no provision for it, you will have to cobble together some form of under-the-lens filtration.

Massive construction helps rigidity, but vibration is damped far better in some enlargers than in others. Put a spirit level on the top of the column, or on the enlarger head, then tap it smartly and see how long it takes for the bubble to stop quivering. Better still, if you can test an enlarger in the darkroom, put a scratched negative in the carrier (scratches are easy to see); wind the head up to its maximum height; tap it; and watch the image on the baseboard.

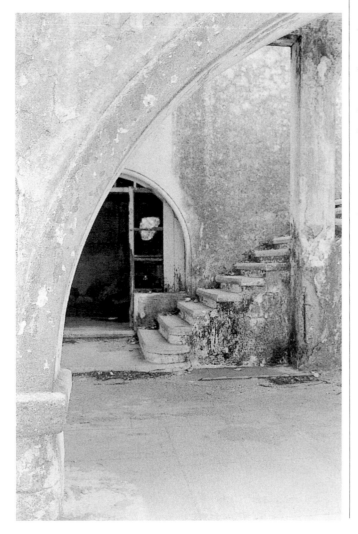

ITALIAN GOVERNOR'S PALACE, Rhodes

This shot of the Italian Governor's palace in Rhodes is an enlargement from a 35mm negative using a Meopta Magnifax with VC head diffuser enlarger. The tonality differs significantly from the pictures on page 147. Nikon F, 35mm f/2.8 PC-Nikkor, Ilford XP2. (FES)

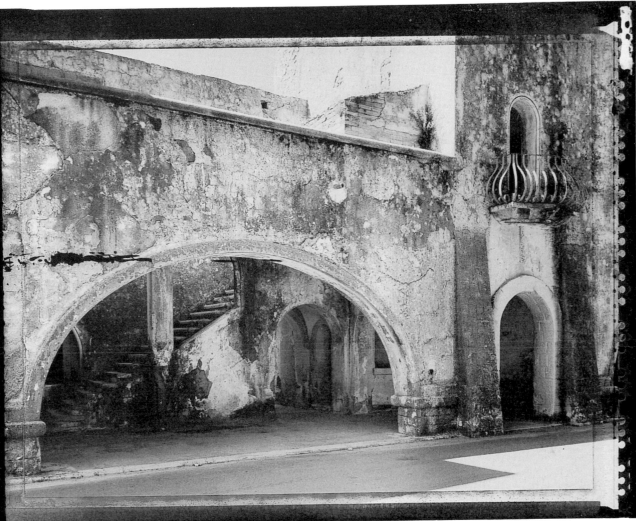

ITALIAN GOVERNOR'S PALACE,
Rhodes

A cold-cathode enlarger is said to give the closest approximation to a contact print, because the light falling on the negative is the least directional; but 'close approximation' and 'the same' are not the same thing. Compare the contact print (left) with the enlargement (above). The scratch is a processing artefact which is caused by the use of an old-style Polaroid bucket (see page 128) instead of the new one. Toho 4x5, 120 f/6.8 Angulon, Polaroid Type 55 P/N. (RWH)

▲ **BLOCKED DOORWAY, Chania, Crete**
Because Ilford XP2 uses a dye image instead of silver grains, it exhibits far less variation in apparent granularity than a conventional film with different degrees of enlargement. Sharpness may deteriorate (although this may not be apparent in reproduction), but grain does not increase greatly . Nikon F, 90mm f/2.5, Vivitar Series 1 Macro. (FES)

◀ **PADLOCKED DOOR, Chania, Crete**
It probably does not matter very much which sort of enlarger you use, as you can adapt your materials and technique (film choice and development, paper choice and development) to suit almost any enlarger; but for sheer ease in producing high-quality enlargements it is hard to beat Ilford XP2 film, a choice of Ilford and Sterling VC paper, and a VC enlarger head. Nikon F, 90mm f/2.5 Vivitar Series 1 Macro. (FES)

If you are afflicted with excessively bouncy floors, you may care to fix the enlarger column to the wall instead of the baseboard; but you can get obsessive about this. If you can always see sharp grain in your 35mm prints, then vibration is unlikely to be much of a problem.

Enlargers and format

There may seem little sense in buying an enlarger which will handle anything larger than you currently use, and it is also true that the smaller the format, the smaller the enlarger; but there are two arguments in favour of bigger enlargers. One is that you may decide to move up to a larger format, or you may sometimes want to print other people's large negatives. The other is that if you are buying a used enlarger, you may be able to find a good, used, professional-quality 6×9cm or even 4×5in enlarger for the same price as a 35mm enlarger of similar quality.

Most modern enlargers are built on a modular system, but even ancient enlargers may accept interchangeable heads, or it may be possible to custom-fit a modern head. Until it was smashed by careless shippers, we had a 13×18cm Durst dichroic head from the late 1970s on a 5×7in MPP enlarger from the 1950s.

Parallelism

One of the most important things in an enlarger is parallelism. In normal use, the negative carrier must

▶ **VE DAY FIFTIETH ANNIVERSARY, Prague**

Normally we correct converging verticals with a view camera or a shift lens, so we had to hunt through our files to find a picture with converging verticals. You can see how it works: the easel was tilted at about 30° and the lens panel was tilted to meet the Scheimpflug conditions. If you cannot tilt the lens panel, you must stop down well for depth of field. If you look carefully, you can also see how shapes are distorted in the corrected version (below): everything is slightly stretched in the long axis. Leica M4-P, 35mm f/1.4 Summilux, Ilford XP2. (RWH)

be precisely parallel to the baseboard. The best enlargers normally have some way of adjusting parallelism, and are sufficiently massively constructed that once it is set, it should stay.

Check parallelism with a spirit level, or scratch a negative from side to side with very fine lines, and focus on these at full aperture. If one side is unsharp while the other is sharp, the enlarger is probably out of alignment. If refocusing brings the unsharp end in but loses the sharp end, this confirms it.

Movements, swing heads and reversing columns

Enlarger 'movements', like camera 'movements', can be used to correct apparent perspective distortion. Tilting the masking frame (easel) without tilting the negative or lens panel means that you have to stop well down for depth of field; if you can tilt the negative or lens panel (or both) as well as the masking frame, you will be able to meet the Scheimpflug conditions and then you no longer have to stop down.

ENLARGER MOVEMENTS

You would never need this degree of movement for correcting verticals, but the picture shows clearly how enlarger 'movements' work. The head as a whole can be swung horizontal for making big blow-ups right across the room (we could in theory do 70× blow-ups from 35mm) and the lens panel also tilts, allowing the Scheimpflug conditions to be met when working with a tilted enlarger easel. You can also see the multicontrast head with dial-in filtration and dial-in neutral density up to 0.60–2 stops.

Movements should not be confused with a swing head or a reversing column. A swing head allows the entire enlarger head to be turned sideways so that it becomes in effect a horizontal enlarger: giant enlargements can then be projected onto the wall. Purpose-made horizontal enlargers were more popular in the past and are still occasionally encountered today. Some of the very earliest employed daylight as a light source: they were used with one end against a window, which was otherwise blacked out.

A reversing column allows the head to be turned around so that it projects the image not onto the baseboard, but behind it. The technique here is to put the enlarger on a bench or table with the column near the edge; weight the baseboard with something heavy so that it does not topple over; and then turn the head

▲ **ENLARGER REVERSED TO FOCUS ON THE FLOOR**
With our set-up, reversing the enlarger column permits a maximum enlargement ratio of better than 35× off 35mm (with a 50mm lens) instead of the 17.5× obtainable with the column alone – but as we can do 16×20in (40×50cm) prints on the baseboard, we do not often need to reverse the enlarger. You can also see our Beard 4-blade easel.

35× BLOW-UP
This is the very middle of the picture on page 14. When working at enormous enlargement ratios like this, allow the enlarger to warm up before focusing, in case the negative 'pops' from the heat. For technical data, see page 14.

so that it projects the image onto the floor beside the bench, rather than onto the baseboard.

In theory, a camera can be converted into an enlarger. You use the camera as the body of the enlarger; the camera's lens, or another interchangeable lens, as the enlarger lens; and a light source on the back of the camera. Support the whole thing on a copy stand or something similar, and you have an enlarger. In practice, the heat from the lamp may damage the camera lens, and the whole set-up is inconvenient, although we do have a Linhof cold-cathode back which fits any 4×5in camera.

Negative carriers

Some negative carriers are more convenient to use than others. This is a matter of personal preference: it is as well, before buying an enlarger, to test it with a scrap negative.

Glassless carriers are always preferable, if they hold the film flat. Glass carriers hold the film flatter, but provide four extra surfaces to collect dust. Some manufacturers make glassless 'gripper' holders, which hold the film in tension for flatness. Anyone who tells you that sharp prints are impossible without a glass

BMW AND STEIB

Any deficiencies in this picture are down to lack of skill: when we shot it and printed it, we knew far less than we do now. Even so, the tonality cannot really be faulted. It was printed with a pre-war Leitz Focomat condenser enlarger on Ilford graded FB paper, which was then glazed. Leica M2, 35mm f/1.4 Summilux, Ilford Pan F.

carrier is speaking only from limited personal experience: it depends on the format, and on the enlarger.

CONDENSER ENLARGERS

A 'pure' or 'point source' condenser enlarger uses a very small source, which must be moved to refocus the beam every time the magnification is changed. Point source enlargers give the greatest possible sharpness and the highest contrast, but they also show up scratches, dust and fingerprints with merciless clarity. The negative is sometimes held in an oil immersion carrier, which ameliorates these problems, but then the negative has to be cleaned before it is put away; and the act of cleaning can itself add scratches.

Most condenser enlargers are therefore of the 'condenser/diffuser' type, where the light source is a large white bulb and precise focus of the light source is less

important; normally, there is no need to refocus the source when changing magnification, although there is provision for this.

Many multi-format condenser enlargers have interchangeable condensers for different formats. Condensers for 4×5in must illuminate that area evenly, but if you put a 6×9cm negative into that holder, you would be throwing away quite a lot of light, with longer exposure times as a consequence. The condenser for 6×9cm gathers most of the same light from the bulb, but pushes it through the smaller format.

There is no need to change condensers unless exposure times are inconveniently long with the smaller formats or there is uneven illumination with the larger formats, but it is worth knowing that it can be done.

Condenser/diffuser enlargers are probably the most commonly encountered variety second-hand. Many have filter drawers above the condensers and are perfectly suitable for VC printing.

DIFFUSER ENLARGERS

The simplest diffusion source is no more than a light bulb behind a piece of opal glass, while at the other extreme it may involve a so-called 'reflex' source, where the light is bounced around inside a white-walled mixing chamber. Mixing chambers are particularly useful with filtered heads, which are described on page 155.

Diffuser enlargers subdue minor flaws on the negative but they also lower contrast: a full paper grade is the normal reckoning. To compensate for this effect, negatives to be printed with condenser enlargers are customarily developed to a lower contrast.

COLD-CATHODE ENLARGERS

These are a specialised form of diffuser enlarger, in that the light source is a fluorescent tube or grid of tubes behind an opal diffuser. Some photographers rave about the quality of the light they give, while others maintain that they are just like any other diffuser enlarger. A cold-cathode enlarger should give the closest equivalent to a contact print, especially if you use an oversize light source (we use a 5×7in cold-cathode head for printing 4×5in images).

Cold cathodes are highly efficient – far less energy is wasted as heat than with incandescent lamps – and the light they give off was traditionally what our forebears would have called 'highly actinic', that is, rich in ultra-violet. This latter can, however, introduce its own problems. One is that the chemical focus of the lens may not be the same as the visual focus: that is, when the image is focused for maximum visual sharpness, the UV light which most affects the paper may be at a slightly different focus. Another is that because the light is not a continuous spectrum, it may respond poorly to filtration for VC papers, and grade spacing may not be even. Adding yellow filtration (try 40Y) will often improve matters, but older tubes should be treated with reserve bordering on suspicion, unless you plan to use only graded papers.

THE CALLIER EFFECT, AND XP2

The reason for the higher contrast of condenser enlargers is that where there is no image, the focused light beam passes straight through the film. Where there is an image, the silver particles both block and scatter the light – the Callier effect. Small scratches

MPP MICROMATIC ENLARGER
Micro Precision Products of Kingston-upon-Thames has been out of business for many years, and this huge old enlarger probably dates from the 1950s. It still works very well, however, and we also use it as a platform for testing other enlarger heads: the cold-cathode head shown can be replaced with many others.

and dust spots have the same effect. With a perfect diffuser enlarger, the light is already fully scattered when it falls on the negative, so there is no building-up of contrast. This is why a cold-cathode enlarger comes closest in tonality to a contact print.

With Ilford XP2 or Kodak T400CN, where the image is made up of transparent dye clouds of varying intensity, there is far less difference in contrast when using different types of light source.

VARIABLE-CONTRAST FILTRATION

All major manufacturers' VC filters are more or less compatible, and are sold in two types. Those that are designed to be used between the light source and the negative can be of much lower optical quality than those which are designed to be used in the light path, and there is no need to be quite so careful to keep them clean; but for large formats, they may need to be pretty large.

The alternative to discrete filters, which are manufactured in half-grade steps, is continuous filtration. This can be done in one of three ways.

Variable-contrast diffuser heads

With a purpose-made VC head, you just dial in the contrast grade that you want, typically from 0 to 5 (00, if available, may require separate filtration). This is by far the most convenient method, and it minimises the risk of moving the enlarger or the negative when varying filtration for different parts of the same exposure. If you can afford it, and unless you are deeply committed to using only graded paper, then this or a VC cold-cathode head (see below) is the way for you to go.

Colour heads

The following equivalents for filtration have been gathered from various manufacturers' sources; you may find that they need slight modifications in order to work well with your colour head.

There are four main 'families', namely Agfa, Meopta, Durst and Kodak. Agfa is on its own; the Meopta family (as far as we can discover) also includes Krokus; the Durst family is Durst, Dunco, Kaiser, Kienzle, Leitz and Lupo, but is split in two by the fact that some have a 170M maximum and others have a 130M maximum (noted in the table as 'Durst 170' and 'Durst 130'); and the Kodak family is Advena, Beseler, Chromega, De Vere, Fujimoto, IFF, Jobo, LPL, Omega, Paterson, Simmard and Vivitar. The correspondence between filtration and paper grade is given in the table below (full information was not available for Agfa).

Variable-contrast cold-cathode heads

A VC cold-cathode head uses two tubes, the relative powers of which can be adjusted in much the same way as the filtration on a conventional VC diffuser head. There are two disadvantages with VC cold-cathode heads: one is that they are expensive, and the other is that, as with all cold-cathode heads, efficiency falls rapidly when they are used to print negatives smaller than the maximum size they are designed to cover.

ENLARGER LENSES

If you accept that eight line pairs per millimetre (lp/mm) equates to critical sharpness at normal viewing distances of 25cm (10in) – this is a good average

◀ **BATHING BEAUTY**

This is from a negative taken in the late 1920s. Nowhere is it critically sharp, but the slight softness enhances the subject. Being able to print big, old negatives is a strong argument for buying a larger-format enlarger, even if you plan to shoot only 35mm. (Schultz Collection)

GRADE	AGFA	DURST 170	DURST 130	KODAK	MEOPTA
00		150Y	120Y	199Y	150Y
0	120Y	90Y	70Y	80Y	90Y
0.5		70Y	50Y	55Y	70Y
1	30Y	55Y	40Y	30Y	55Y
1.5		30Y	25Y	15Y	30Y
2	20M	0	0	0	0
2.5		20M	10M	25M	20M
3	110M	45M	30M	40M	40M
3.5		65M	50M	65M	65M
4	290M	100M	75M	100M	85M
4.5		140M	120M	140M	200M
5	420M	170M	130M	199M	

the negative; and with a poor enlarger lens, it will not matter how good the definition is on the negative.

It is no exaggeration to say that at any one time there are probably fewer than a dozen types of enlarger lens on the market which are suitable for making big enlargements from 35mm. Some may be available on the used market, and a few may be available at bargain prices from people who do not know how good they are; but as a general rule, it is not unreasonable to say that you want not just the best manufacturers, but the best lenses that those manufacturers make. A first-class 50mm enlarger lens can cost more than a first-class 50mm camera lens.

With larger formats it becomes less and less critical, and at 8×10in just about any half-way decent coated enlarger lens will do. Also, you have to retain a sense of proportion. Some would have you believe that an enlarger lens is all but worthless unless it can resolve 200 lp/mm, while others try to apply resolution criteria for lenses for 35mm to lenses for larger formats, which is unnecessary. We know one excellent photographer (Lewis Lang) who regularly makes 20× enlargements from 35mm, and is correspondingly critical of lens quality; but at a 10× enlargement, which is as large as many people ever go, almost any good lens will do.

Also, as print sizes rise, so do viewing distances – just about in proportion. This means that a 16×20in (40×50cm) print is likely to be viewed from twice the distance of an 8×10in print, and sharpness requirements on the print are therefore halved. The sharpness requirement on the negative is therefore unchanged. People who insist on 'sniffing the print' will, however, require more sharpness.

distance for an 8×10in print, or for examining a bigger print more closely – then a 7× enlargement off 35mm requires 7×8 = 56 lp/mm even if you have a perfect enlarger lens. This would be regarded as pretty good edge definition for most prime lenses, and as very good central definition for most zooms.

No enlarger lens is perfect, of course, and to get 8 lp/mm on a 7× enlargement you would probably need 65 to 70 lp/mm on the negative. The less perfect the enlarger lens, the more definition you will require on

Focal lengths

The 'standard' focal length for enlarging has traditionally been more or less equivalent to the diagonal of the negative for which it is used: 50mm for 35mm, 80mm for 6×6cm, 105mm for 6×9cm, 150mm for 4×5in, 210mm for 5×7in and 300mm for 8×10in.

◀▶ **MUSICIANS, Murphy's**
Murphy's is a town in California's Gold Country, and this pair are part of the town band. These two interpretations of the same negative are very different: one conveys the brightness of the sunny afternoon, and the other focuses far more attention on the gleaming instruments. Nikon F, 90mm f/2.5 Vivitar Series 1 Macro, Ilford XP1. (FES)

Some prefer slightly longer lenses than this, such as 60mm for 35mm and 180mm for 4×5in, on the grounds that it is easier to make a lens of longer focal length cover a negative adequately. Others point out that if you are working in the range of 1:10 or less, as you normally are in enlarging, then shorter lenses will cover perfectly well: this explains why there are some extremely good 40mm enlarging lenses for 35mm, which allow a usefully greater magnification on the baseboard for a given column height. Illumination is however inevitably less even across the whole field with a shorter lens.

As usual, this provides fertile ground for obsessives. We suggest that you buy the best lens you can afford, with a money-back guarantee, and make the biggest enlargement you can with it. If you are making enlargements on smaller pieces of paper than the whole image area, expose areas from the edge as well as the centre. Process and check the images. If they are sharp enough for you, and if the illumination is even enough for you, then the lens is good enough for you.

Working apertures
Some stop all the way down, in the belief that it will give them better sharpness. Unless they have a really bad enlarger lens, they are wrong, as diffraction limits the performance of any lens at small apertures.

Some work wide open. They have heard of diffraction limits to resolution, and prefer to ignore the fact that few lenses give their best wide open. Not only will resolution be lower, so will contrast; and illumination may be less even.

As a general rule, therefore, f/8 should be regarded as a minimum working aperture and f/4 as a maximum, with f/5.6 as a happy medium. Another way of looking at it is to follow the traditional advice to stop down 1 or 2 stops from maximum aperture. If you are really worried, try making test prints of a demanding, detailed subject at ½ stop rests throughout the aperture range of your lens; some photographers reckon that they find a 'sweet spot' where resolution is detectably better than even half a stop either side. In any case, such precision is necessary only with 35mm; with roll film it is less critical, and with cut film it really does not matter very much.

THE DARKROOM

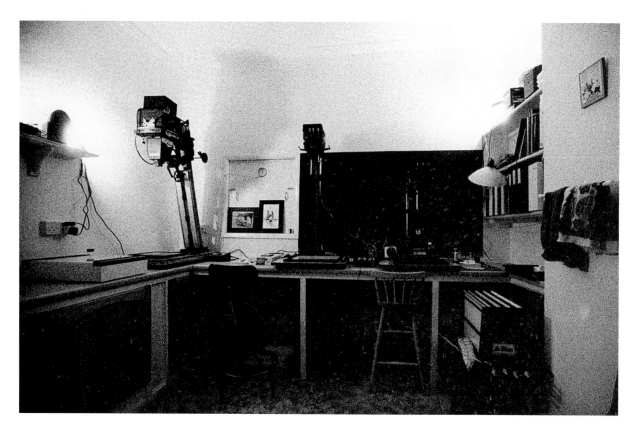

Most of our readers will already have a darkroom, or access to one, and will be familiar with the principles of darkroom design: ventilation, truly safe safelighting, and so forth. Even so, many people pay less attention to improvements in darkroom equipment than they might, so (as with paper) it may be time for a reappraisal of long-standing ideas. For example, there is the option of processing in Nova deep tanks. These are so important in our own darkroom that we make no apology for discussing them first, before going on to other darkroom aids in alphabetical order. We have omitted some of the more obvious tools, such as dodging 'wands', on the grounds that readers will already be familiar with them.

DARKROOM: ENLARGER SIDE

Like the other general picture of our darkroom, this was shot by safe-light alone; you can see them, one on the left and one on the right. The wall behind the two 6×9cm enlargers is painted matt black; the wall beside the 5×7in enlarger isn't. It doesn't seem to matter very much. The 12×16in four-slot Nova tank is on the right. Nikon F, 14mm f/2.8 Sigma, Kodak TMZ rated at EI 12,500.

NOVA DEEP TANKS

The first argument in favour of Nova deep tanks concerns the life of chemistry. A tray of developer which is relatively shallow and with a large surface area, oxidises rapidly. A deep tank, which has a much smaller area exposed to the air for a given volume of

▲ DARKROOM: SINK SIDE

The Nova tank we use for film processing is on the right; then the Paterson drying racks; then the Paterson Major washing tank; and the window is blocked with a quickly removable piece of MDF, allowing for easy airing. We find it useful to have a small tank for washing small prints and a larger tank (Nova 12×16in, on the second shelf down next to the Nova 8×10in Quad) for washing larger exhibition prints.
Nikon F, 14mm f/2.8 Sigma, Kodak TMZ rated at EI 12,500.

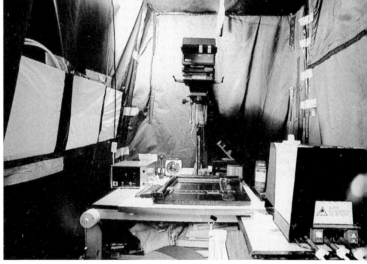

NOVA TENT INTERIOR

For almost eight years, all our prints for publication were produced inside this Nova tent. Just 105cm (42in) square, it holds an enlarger and an 8×10in Nova Quad four-slot tank for processing.

chemistry, oxidises much more slowly. Chemistry can therefore be left in the tank, ready to use, for days or even weeks.

The second argument concerns temperature control. A deep tank, surrounded with a water-jacket, provides a stable temperature and is easy to regulate: the heater(s) can either be left on continuously or switched on half an hour to an hour before you want to start printing.

The third argument concerns space. A four-slot 8×10in Nova tank has a 'footprint' of approximately 350 × 250 mm (14×10in). For nearly seven years – in fact, until we started on this book – all our prints were produced in an 8×10in Nova Quad tank in a Nova tent darkroom just 105cm (42in) square. During the time spent in the Nova darkroom over the course of seven years, we illustrated over a dozen books and countless magazine articles. In the last year or so, we

NOVA CLIP

The Nova clip is one of the secrets of the Nova system. The two steel pins leave two tiny punctures, like a spider-bite, at the very edge of the print.

have also joined a local camera club and submitted a number of pictures for exhibitions.

The fourth argument concerns time. If your Nova tank is full, you can start printing in five minutes or less – and at the end of the session, you just wipe up any drips and put the floating lids back on the slots. As working professionals, time is very much money for us; and for anyone who has a full-time job or other commitments, it is hard to deny the desirability of being able to snatch half an hour here and an hour and a half there, without having to spend ages on setting up and cleaning up.

Now we have a much larger darkroom, with three enlargers permanently set up, we also have several Nova tanks, up to 20×24in (50×60cm). There is no point in going into detail here, because Nova tanks come with full instructions, and because many readers will prefer to stay with trays; but suffice it to say that each slot of an 8×10in processor takes about 900ml of chemistry, and after every few prints (between five and twenty, depending on the developer in use) you drain off a few millilitres of developer and top up with fresh. Developer in a deep tank lasts roughly as long as developer in a part-full bottle, so if you mix up (say) 1,200ml or 1.5 litres you will be able to print for several days, whenever you can spare a few minutes.

Nova tanks and 'fine art' printing
Of course, you cannot easily develop a print by inspection in a Nova tank – but this can be a blessing in disguise. By forcing you to work to a standardised time, the Nova tank removes the temptation to 'snatch' an over-exposed print out of the developer

before it is fully developed. Yes, you have to remake the print, but it will be a very much better print. The only conventional silver/gelatine paper which we develop by inspection is ultra-high-contrast lith paper (see page 144).

Nor can you rub selected areas with your finger, the combination of heat and agitation 'bringing up' a local detail. If this is an integral part of your technique, you may be unhappy with a Nova tank. Even if you insist on making large prints in trays, however, the Nova tank is unequalled for making work prints, reference prints, and small prints for publication.

As noted elsewhere, we also use a Nova tank for processing cut film from 6.5×9cm to 8×10in. The same considerations apply as to paper development: this is a tank which stays on full time, now that we have our larger darkroom.

ANALYSERS
An analyser is essentially a 'smart' version of an enlarging exposure meter, as described below. As we were finishing this book, we had the opportunity to try the RH Designs Analyser, and we were very impressed indeed. In fact, now that we are used to it, we would hate to have to live without it. It helps to determine not only exposure, but also paper grade.

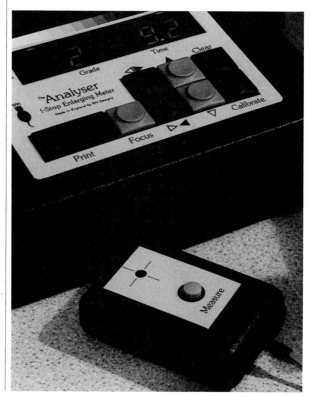

At the simplest, you take one reading of the minimum density of the negative projected onto the baseboard, another of the maximum density, and let the meter do the work. You can learn more, faster, about exposure and contrast grades with this tool than you could with anything else – although an experienced printer will be able to do much more with it, and will treat its readings as recommendations rather than as immutable settings.

CONTACT PRINTERS

Simple printing frames date from the days when printing-out paper (POP) was still widespread. They are like rather elaborate (but ugly) picture frames with a split, hinged back, the purpose of which is not clear until you know how they were used; see page 199 for an illustration.

At one time, they were thrown away by the hundredweight, or sold for next to nothing. Today,

TREE, Marshside, Kent
Printing from 4×5in tends to be a rather different undertaking to printing from 35mm: somehow, there is more incentive to play with contrast and dodging and burning. This is a final 8×10in work print (from Polaroid Type 55 P/N) before going on to a 12x16in exhibition print.
Walker Titan SF, 210mm f/5.6 Schneider Symmar. (RWH)

◀ ANALYSER
The RH Designs Analyser was one of our major discoveries when working on this book. We borrowed it for test and would now hate to be without it.

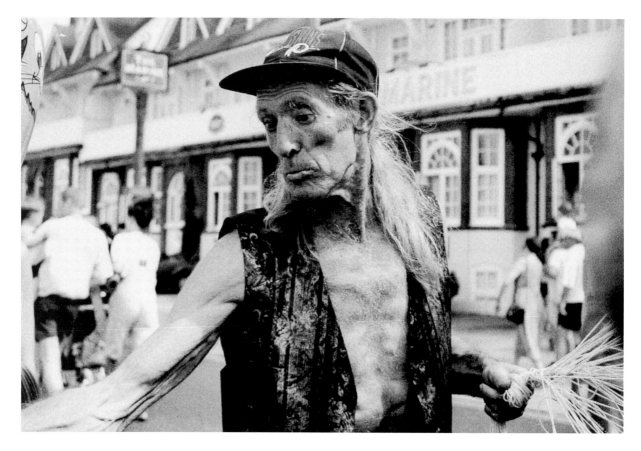

with a resurgence of interest in alternative processes, they are harder to find – and big frames are very hard indeed to find. New printing frames are available, but they are expensive.

Contact printers with light sources
Many alternative processes are very slow, and require high-intensity (and high-UV) sources. Sunlight is fine, but inevitably it varies in intensity and printing is not much fun on a rainy day. Carbon-arc sources, high-energy discharge tubes and other artificial sources are therefore employed in the interests of consistency and convenience.

Equally, full control in contact printing on conventional developing-out papers can be achieved by having a grid of bulbs which can be turned on or off (or positioned as needed). These are situated behind a diffuser panel, which blends the lights from the bulbs and also supports pieces of cotton wool or cut-out paper shapes to allow dodging of specific areas.

DENSITOMETERS
A densitometer, as its name implies, measures density. A reflection densitometer shines a beam of light onto a print (normally at 90°), and compares the reflected light (at 45°) with this. A transmission densitometer shines a beam of light through a negative, and compares the transmitted light with an unobstructed beam.

Densitometers are basic tools in sensitometry, but it is a moot point how much use they are to the working photographer. The vast majority of photographers would benefit more from practice in taking more pictures and making more prints than from buying a densitometer and running endless tests.

Like many pieces of specialised equipment, it is something to buy when you realise that your photography is being hampered by not having one: too many people buy them long before they need them. We do not own one, although we keep thinking about it.

EVALUATION LIGHTS
Evaluating prints in the darkroom is not easy. Ideally, you should have two evaluation lights: one relatively weak, say 40W, and another much stronger, say 100W. Use whichever will correspond better to the light in which the final print is going to be hung; use the powerful light for prints for reproduction.

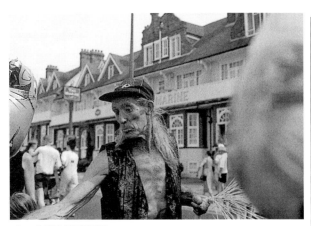

◀ ▲ BALLOON SELLER

A picture can sometimes be 'saved' – or at least, its faults ameliorated – by cropping in the darkroom. In the blow-up, the lamppost growing out of the balloon-seller's head is less obvious, and the irrelevant material on the right has disappeared completely. Nikon F, 35–85mm f/2.8 Vivitar Series 1 Vari focal. (FES)

Some photographers use blue-tinted 'daylight' or 'craft' bulbs, but we are not convinced that they are worth the effort or expense.

FILM DRYERS

The emulsion on wet film is fragile; it can stick to things; and it seems to be a magnet for dust. Several ways around this have been proposed.

The worst we have encountered have been dryers designed to dry the film on the reel. In our limited experience they are slow, unreliable, and tend to leave water-marks even when the film is rinsed in distilled or purified water. Rather better are purpose-made film drying cabinets, although rigid cabinets are a lot easier to use than the soft-side variety. To date, however, we have yet to find anything better than the technique described on page 124.

FILM PROCESSING TANKS

The choice between plastic and stainless reels, and plastic and stainless tanks, for 35mm and roll films is entirely personal. We have always found that the quickest and easiest approach is to use high-quality

PROCESSING TANKS

Developing tanks are very much a matter of personal choice: some prefer single-format stainless steel spools in stainless steel tanks like these Kindermanns, while others find plastic tanks and reels easier to use, like the Paterson with its adjustable spools for 35mm, 127 and 120/220. The ancient Paterson Universal (no longer available) is particularly useful, as it can be adjusted for 16mm as well.

British-made spirals in stainless steel Kindermann tanks with plastic lids. Metal lids never seem to seal very well, but our two Kindermanns must be 20 years old and still work perfectly.

For cut film, the choice is generally between those tanks which fill and empty quickly but leak, and those which do not leak but take an age to fill and drain. We prefer the latter; the long-gone Dallan stainless steel tanks are our favourites.

We have our XP2 processed commercially by a professional lab, and process our conventional films in a Nova deep tank (see above). The only thing to avoid in a Nova tank is excessive agitation, especially of large formats in small tanks (8×10in in 8×10in), which can lead to uneven development.

MASKING FRAMES

For a relatively simple piece of equipment, it can be amazing what a good masking frame costs – but when you use a good one, you see why they are worth the extra, and they last forever. Four-blade easels (we use a Photon Beard 16×20in/40×50cm) are the most versatile and make black hairline borders relatively easy, but two-blade easels are quicker for small, routine prints; borderless easels also have their advocates. With two-blade easels, look for a good range of adjustment on the paper stops opposite the blades. Fixed-border easels are very limiting.

METERS

Arguably, you cannot really understand how to use an enlarging exposure meter until you already know how to get a good print without a meter – at which point, you don't need one. Even so, they can prove useful for the beginner in establishing a rough figure

for exposure time, and the more advanced printer can use them to check the contrast range of a negative as projected on the baseboard, although going too far off axis may result in faulty readings.

In general, though, a generous attitude towards test strips is a good idea and will prove more efficacious than an enlarging exposure meter. Combine the two – lots of test strips and a meter, or better still an analyser (see above) – and you will have the best of both worlds.

PRINT DRYERS

The easiest way to dry prints is by hanging them on a line from a clothes-peg at one corner. This is however slow, and unless the prints have plenty of room, there is some risk of their sticking to one another so fiercely that they cannot be separated without damage once they are dry; even re-soaking may not work. Also, traditional single-weight FB papers will normally curl ferociously.

Curling can be reduced, and sticking eliminated, by drying the prints face down on nylon net – in one cellar darkroom with exposed joists, we had net curtain fabric pinned between them – but drying is still slow, and you may need a lot of space.

Still slow, but economical of space and without risk of sticking, is a Paterson or Kaiser print dryer: these hold the prints in rows. Another slow, traditional method was to use books of blotting paper, although these began to smell after a while.

If you want to dry your prints faster, there are three options open to you.

Alcohol drying
Only lightweight papers respond well to a simple alcohol bath and conventional drying. The brave may care to try drying papers by soaking them in alcohol, pinning them to a stick, and then lighting the bottom edge of the print. Keep waving the stick to minimise the risk of charring. We have tried this but we cannot recommend it.

Radiant-heat and warm-air drying
Because they curl very little in drying, RC papers can be placed on a rack and dried with warm air or (more rarely) radiant heat; we recommend the Nova dryer. A single print can be dried with a hair dryer.

Glazers
With the decline of FB paper and a decline in the taste for glossy glazed prints, glazers are less often

seen than they used to be. The classic commercial glazer was a big, rotating, heated drum which drew prints into its maw at one end on an endless 'blanket' and spat them out glazed a few minutes later. Amateur glazers were normally of the flat-bed type: the print was squeegeed onto a glazing plate ('ferrotype plate' in America), and then the plate and print together were held onto a heated base with a 'blanket' in tension over the top.

Unless the prints are well washed, they can of course contaminate the blanket, and flat-bed glazers are slow and are really only suitable for handling a few prints at a time. Both flat-bed and rotary glazers can also be used for heat drying of FB papers (note that RC papers may melt, even with the heat at its lowest setting) without glazing: on a rotary glazer, the print is placed with its face to the blanket, rather than to the drum, while on a flat-bed glazer the glazing plate is simply omitted.

These 'heat-dried glossy unglazed' prints are glossier than normal air dried, because the heat and pressure compacts the microstructure of the gelatine surface, but they are still slightly less glossy than RC and a good deal less glossy than glazed prints. If they stick to the blanket, use a hardening fixer, but remember that this entails longer washing.

GLAZER
The huge old Kodak Glazing Machine Model TC actually lives in a corner of the studio: we very rarely use it any more, although it is useful for drying FB prints rapidly. They must be hardened (with a hardening fixer, or a separate hardener) if they are dried face out, or they will stick to the blanket.

The glossiest prints of all are obtained by cold glazing onto plate glass, but we have not tried this for many years. The results can be astonishing, but full separation from the glazing plate does not always take place, and when it does not, prolonged soaking may be necessary to remove the stuck areas. With both cold glazing and hot glazing, pre-soaking the print in glazing solution (this is hard to find, but is still available from Pébéo in France) will greatly increase your chances of success.

PRINT WASHERS

In the same way that no safelight is truly safe (see below), just about any print washer will eventually wash adequately. Also, any print washer is better than washing prints in the bath or in a tray, which works but is time-consuming and wasteful of water. See page 172 for more about washers and washing.

PROCESSING MACHINES

There is a certain charm in the idea of a processing machine, where you stick the picture in one end and it comes out fully processed at the other. In practice, though, processing machines do not make sense for most amateurs or even small-volume professionals, as set-up and cleaning times are very long indeed – quite out of proportion to the time saved in making anything less than a couple of dozen 8×10in prints at a single session.

We used to have a stabilisation processor (see page 145), but we decided that the slight inconvenience of conventional processing was a small price to pay for better quality and far better permanence.

PROOF PRINTERS

Several proprietary models are available which sandwich a cut-up roll of 35mm or 120 film with a piece of paper; they are more convenient than a simple sheet of glass. We use one from Print File.

A useful trick is to make two sets of proofs off the same negatives, giving one a couple of stops more exposure than the other. You can then use one set to assess the shadow detail, and the other to assess the highlights. Another printers' trick is to make both high- and low-contrast contacts.

SAFELIGHTS

No light is truly safe: sooner or later, almost any safelight will start to fog almost any material. It is therefore important to limit exposure: get out the paper only when it is needed, expose it, and process it.

Safelight screens can deteriorate with age, so periodical safelight testing is not a bad idea. A quick but rigorous test is to pre-flash the paper to a level which gives the faintest perceptible grey on development, and then leave it out with a couple of coins on it in the brightest part of the room for the longest time that a

NOVA WASHER
The 12×16in Nova washer – here with just an 8×10in print in it – has two wash slots on one side; a four-slot clearing tank in the middle; and two more wash slots on the far side. We keep meaning to have an extra (third) tap added to the sink, just for the print washer.

sheet of paper is likely to be left out – five minutes, maybe. The pre-flashing will show up unsafeness far faster than just leaving the coins on the paper.

Also, some safelights which are safe for graded papers may not be safe for VC papers, which are sensitive to green light as well as blue. Check your safelight designation with the paper manufacturers' requirements, and if you are not certain, then check as described above.

'High-tech' sodium vapour safelights allow more light for a given level of safety and do not deteriorate with age, but they cost a lot more, make colour recognition more difficult in the darkroom, and may be too bright for some small darkrooms. Do you really need that much light?

In any case, unsafe 'safelights' are not normally a major problem, and even cheap safelights are usually fully effective if they are used in accordance with the manufacturers' instructions. The most common problems arise from using too bright a bulb (which will also fade the filter faster); using the lamp too close to

LINDOS

If you want to print 'all in' you will have to make an appropriately sized negative mask. It is no problem with this 4×5in Polaroid negative, but with 35mm you will often have to file out (and smooth, and re-blacken) the edges of the negative carrier. Toho FC-45A, 120mm f/6.8 Schneider Angulon. (RWH)

the paper; using the wrong safelight colour; or from white-light leaks into the darkroom.

In theory, some panchromatic materials may be inspected intermittently with weak, indirect green lighting – but you are unlikely to be able to see anything useful, so it is not really worth trying. Ortho materials can be inspected with a deep red safelight, but again, the time-and-temperature method is likely to be far more successful.

STIRRING RODS

Buying a purpose-made stirrer/mixer may seem like an extravagance until you try one. Paterson International gave us one while we were working on this book, and we wish we had bought one long ago. They make mixing much easier.

THERMOMETERS

To this day, the best thermometers are still mercury-in-glass, and a lab-grade thermometer of this type will give the most accurate readings you can conveniently get. On the other hand, mercury thermometers are expensive; mercury is toxic (although this should not matter unless you make a habit of smashing thermometers); and you do not really need, nor can you necessarily sustain, the kind of 0.1° accuracy which is commonplace with lab thermometers. For most applications, accuracy of 1°C (2°F) is adequate, 0.5°C (1°F) is ample, and 0.25°C (0.5°F) is overkill. Of course, repeatability should be higher than this: a combination of a 1° error with 1° variations in repeatability can mean a 2° error, which is quite unacceptable for precise work.

Many photographers therefore use spirit thermometers, bimetallic thermometers, and digital thermometers, although it is always a good idea to keep a mercury thermometer for calibration because digital thermometers, in particular, can wander badly. We habitually use spirit or mercury thermometers for film development, and spirit or digital thermometers for keeping a check on the working temperature of solutions.

TIMERS

Although there are many more exalted process timers, a simple stop-clock is generally easiest to use. It may be a two-control type or a three-control type. One control starts the timer; a second control, or the same control as the first, stops it; and another control resets it to zero. We bought a three-button electric Smith's clock after our two-control mechanical Smith's clock died: it was only 22 years old, at that.

You must be able to start, stop, and reset the clock quickly and easily. Multiple-stage timers and multiple-readout timers are often fiddly to set and reset, and even some stop-clocks can be a nuisance if you have to fiddle around on the back to rotate a knob, as on an alarm-clock. The control should be a single lever or button, which can be reset smartly.

A technique which some people use, and which is prima facie attractive, although we have never tried it, is to use a tape recorder to record a processing sequence: agitation every 30 seconds, say, drain developer at seven minutes, add short stop, drain short stop, fill with fixer...

Enlarger timers

A foot switch makes it much easier to turn an enlarger on and off if you are counting the seconds, watching a clock with one eye, or counting the beats of a metronome. But easier still is an automatic timer which switches the enlarger on; times the exposure; and then turns it off. You can give an overall seven seconds, say; then another seven seconds to burn here; and then another seven seconds to burn there.

Electronic timers can normally be set in $\frac{1}{10}$ second increments from 0.1 second to 99.9 seconds, and they are both more accurate and more consistent than mechanical timers. Mechanical timers can normally be set from 0 to 60 seconds in one-second intervals.

The advantage of the electronic timer declines rapidly beyond about ten seconds. You do not need $\frac{1}{10}$ second variations at this point, because full seconds are adequate; errors in setting become less significant as a percentage of the full exposure; and repeatability is normally quite adequate for photographic purposes. In the four-to-ten-second range, the extra control of $\frac{1}{10}$ second increments may be useful, and at less than four seconds most mechanical timers offer unreliable times with poor repeatability.

Remember, though, that exposures of a second or less may lead to 'hot' (reddish) light, because a substantial proportion of the entire exposure time is occupied with the bulb heating up and cooling down again. This is most significant in colour photography, but it could conceivably lead to problems in monochrome too, especially with VC papers.

KARL SCHULTZ

You may be surprised at the quality which is obtainable from very old negatives: this picture of Frances's older brother must have been shot around the beginning of World War II, by their father Art Schultz.

PRINT PROCESSING

Much of what was said in Chapter 8 about film processing can also be applied to print processing. The basic chemistry is the same, although there are also some significant differences.

First, the coating weight – the amount of silver-bearing emulsion – is much less with paper than with film. Second, while it is quite common to increase film development times in order to increase contrast, paper is normally developed to finality. Third, image colour is important in a print, but not in a negative. Fourth, after development and fixing, washing can be rather more demanding.

Coating weight

The lower coating weight of papers means that development is faster, as is fixing. This is made abundantly clear if you use the same developer for both film and paper, as used to be common in the days of large format photography. Where a paper might be developed to finality in a minute or two, film would still be gaining in contrast and density at five minutes. Coating weight, incidentally, is no guide to image quality: the skill of the emulsion manufacturer, and the type of material, are both more important. 'Silver-rich' papers are something of a myth.

Development to finality

Development to finality means that all the developable silver is developed. This in turn means that the scope for adjusting contrast by development is slender. This was not always so. In the 1950s, it was

TOWER OF BIG BEN

Fotospeed's high-speed chemistry allows 20 to 30 second development with standard (non-developer-incorporated) papers and 30 second fixing. Results are fine for reproduction and we have seen exhibition prints which are inferior. Nikon F, 90mm f/2.5 Vivitar Series 1 Macro with heavy red filter, Ilford XP2. (FES)

LAKE, northern California
Cover up the foreground, and the background is very flat indeed; but the extra contrast of the land in front of the lake means that the land behind it also appears adequately contrasty. Nikon F, 90mm f/2.5 Vivitar Series 1 Macro, Ilford XP2. (FES)

quite normal to develop a paper for two to three minutes, and to be able to squeeze a bit more contrast out of it by prolonging development to maybe five minutes. There were also different developers, for high or low contrast: in effect, more or less energetic developers. Variations of a contrast grade or more were possible by varying development times and developers. Modern papers develop much faster, in anything from 30 to 90 seconds, and although lower contrast is obtainable with softer-working developers, there is very little scope for getting extra contrast either by developer choice or by extended development.

Image colour
As we have described on page 141, image colour is to a large extent the result of grain size. Smaller grains are yellower, while larger grains are more blue-black. The colour which a particular paper/developer combination will give therefore depends on both the paper and the developer. After development, fixing and washing, it is of course possible to vary image colour very widely with the use of toners, as described on pages 202–210.

CHOOSING A PAPER DEVELOPER
Developers seem to have personalities; something which goes beyond any reasonable scientific explanation, but is undoubtedly there. Of the dozens of different proprietary formulae available, there is no doubt that most photographers will be able to get very good results with most developers, assuming they use them in accordance with the manufacturers' instructions. But there will very likely be a couple that any one photographer simply will not get on with, and there will be a couple of others which will deliver results that have that extra touch of magic which makes the photographer fall in love with them.

Because we write for a number of photographic

STALE DEVELOPER

If your prints suddenly go 'flat' and you cannot seem to get a good result, no matter what you do, the answer is probably exhausted or stale developer. The process is normally quite rapid: you lose the 'edge' for a print or two, but write it off to bad technique or a bad negative, then suddenly it's hopeless. Leica M2, 90mm f/2 Summicron, Ilford XP2. (RWH)

magazines, we have the chance to try numerous developers, and quite honestly, we rarely find a bad one. The main differences are in capacity, dish life, image colour and speed of working.

A litre of working-strength developer will normally process something between 20 and 30 8×10in prints, depending on the dilution of the developer, the extent of the dark tones in the print (dark prints exhaust developer faster), and how critical the photographer is. Exhaustion is usually surprisingly rapid: if your prints suddenly go 'flat', and you can't seem to get a good print whatever you do, then replacing your developer may be the answer. With or without use, most proprietary developers will last up to about 24 hours in a tray, or a week in a Nova tank.

As regards image colour, a great deal depends on

fashion and on individual photographers' tastes: what is an 'unpleasant green' to one may be a 'pleasant olive' to another. Most manufacturers categorise their developers into 'warm tone' (brownish), 'cold tone' (bluish) and 'neutral', and they generally live up to their names. Even so, the interaction between papers and developers is unpredictable, so a particular developer may give a very warm tone on one paper and a substantially neutral tone on another, while another may be the exact opposite. In general, we have found that choice of paper is more important than choice of developer in determining image tone.

Speed of working is very much a matter of personal choice, and because of the Nova tanks we like to work fast. Some people like longer development times, so they can dabble their fingers in the developer for a while and 'rub up' dark areas, but there seems little point in going beyond about 120 seconds with modern papers. In the other direction, although there are developers which purport to give a good image in 30 seconds, we find that 45 seconds is the minimum with which we are normally happy. Speed of working can of course be increased by running the developer hotter. Running at temperatures above 24°C (75°F) may

however tenderise the emulsion unacceptably with some developer/paper combinations, and this will lead to scratching.

Home brews

After something of a nadir in the 1970s, home-brewed developers have enjoyed a considerable resurgence. The value of many of them is questionable – they have more appeal for the inveterate experimenter than for the photographer who is trying to turn out prints for exhibition – but equally, once you hit upon one which you like, you may become a passionate devotee. We are particularly fond of Amidol developer, used hot and strong. It gives remarkable shadow detail, a very neutral image colour, and an overall quality which one friend described as 'like fibre paper – on resin coated'. A formula for Amidol is given on page 175.

SHORT STOP

The function of the short stop is the same for paper as for film: to arrest the operation of the alkaline developer by placing it in an acid medium (it is no use with Amidol, which will work in an acid environment), and to reduce contamination of the fixer. The cost is so low that you can afford to throw it away fairly often, especially if (as we do) you make it up from 10ml to 15ml/litre of glacial acetic acid. Always add acid to water (AAATW – the words are in alphabetical order) when making up dilute acid, and remember that acetic acid may only be highly concentrated vinegar, but it is corrosive and an irritant: see Notes on Mixing Chemicals on page 118.

The life of a made-up stop bath in a tray is about three days, or a month or more in a deep tank or in a bottle. Test capacity with litmus paper: as long as it is still acid, it is still working.

FIXERS

Much the same observations apply to paper fixing as to film fixing, except that you cannot actually see when the paper is fixed so you have to go by the manufacturer's recommendations for time. Modern rapid fixers, used at film strength (1+3 or 1+4 instead of 1+9), can save a great deal of time compared with traditional 'hypo' – fixing is complete in 30 to 120 seconds, depending on dilution, instead of five to ten minutes – and fixing is not one whit less efficacious or permanent. Indeed, the reduced immersion time means that FB papers have less time to soak up fixer, and should therefore wash faster and more efficiently. Capacity is not significantly increased by using

ART SCHULTZ, c1930
This is not actually an old, stained print; rather, it is a modern print from the old negative (see page 122) which has been partially fixed. Any inadequately fixed print will exhibit the same sort of staining, but it will normally take far longer to manifest itself.

stronger fixer, though: bromide and silver build-ups are the factors which limit paper fixer life, and only quite low silver levels are acceptable (1g/litre).

Two-bath fixing is as good an idea with paper as it is with film. If you are working on the basis of the number of sheets processed, a typical figure is 20 to 30 sheets of 8×10in paper per litre. Made-up fixer should last for a week in a tray, and a month or more in a deep tank.

Hardening fixers are rarely necessary with prints. They can extend washing times significantly, and can also make toning difficult or impossible. The only times you might need them is when you are working

◀▶ **SABATTIER EFFECT**

One print is 'straight'; the other was briefly exposed to light part-way through development and exhibits the partial reversal of tones and intricate pattern of lines associated with the Sabattier effect (pseudo-solarisation). A lith neg made from this print might produce some quite interesting effects. Nikon F, 90mm f/2.5 Vivitar Series 1 Macro, Ilford XP2. (FES)

not recommend the latter. Wash aids are all but essential after hardening fixers.

Washing tanks

The thing to avoid in a washing tank is 'dead spots' where the water is changed slowly, if at all. This is the problem with washing prints in a tray: they tend to clump together, and there are some areas which are hardly washed at all. Separate wash slots for each print are virtually essential.

With RC prints, where washing is very quick (two to ten minutes), there is no need for an elaborate, 'archival' washing tank. We use a Paterson Major tank, which is convenient and efficient, and reasonably priced. Even a fairly inefficient tank should do all that is required in less than a quarter of an hour.

With FB paper, the emulsion washes quite fast but the fibres themselves are the problem, and this is where we roll out the heavy guns, using a wash aid and an archival wash tank.

Washing temperatures

Opinions on this are astonishingly varied. Most wash tests are conducted at 20°C (68°F), and the best current research seems to indicate that you will never need to do more than double recommended wash times even if you work at 4°C (39°F), the lowest temperature at which water normally comes out of a tap. Owing to the anomalous expansion of water, this is the lowest temperature which water boards can accept without serious risk of damage to their pipes. At temperatures between 4°C (39°F) and 20°C (68°F), you are on your own, but at (say) 10°C (50°F), a 50 per cent increase in wash times (as against 20°C (68°F)) should be adequate.

Going in the other direction, the risk with excessively warm water (much over about 25°C/80°F) is that it will make the emulsion too tender and prone to mechanical damage.

How long should you wash for?

How long a print should be immersed is the $64,000 question, and can be answered on four levels.

with hot solutions (over 90°C/30°F), or if you plan to heat-dry the prints using a glazer (see page 164).

WASHING

If a print has been adequately fixed, almost any washer will do the job; it is just a question of how long it takes. If it has not been adequately fixed – in particular, if the fixer contained too much silver and you are using FB paper – then it will never be archivally washed: the emulsion will dissolve and fall off before the washing is finished.

Wash aids

There are two kinds of wash aids. One is a sulphite bath, which helps displace thiosulphate residues by ion exchange (a calcium sequestering agent is also included), and the other is the so-called 'hypo eliminator', which is alleged to work by converting thiosulphates to sulphates – these are inert and also more soluble, and so are more easily removed. Opinions are divided on both: Ilford unreservedly recommend the former as a means of saving time and water, and do

The art of illusion: it will not show in reproduction, but somewhat to the right of this gentleman's ear there is a Nikon F2 with (at a cursory glance) the word Nikon quite clear on the pentaprism housing. Then you put a magnifier on it, and it dissolves into a blur of grain. The brain is supplying the shape, like the celebrated 'canals' of Mars. Try this trick with some of your own apparently super-sharp pictures. Nikon F, borrowed 28mm f/3.5 Nikkor, Ilford XP2. (RWH)

First of all, just about any washer should give archival permanence with RC paper with a five-to fifteen-minute wash.

Second, just about any washer will give archival permanence with FB paper as long as you wash for long enough. The best will give you a perfectly adequate wash (one which will be enough for many years or even decades) in an hour, and an archival wash in a couple of hours. Lesser washers may take twice as long, however, and those prints which have been fixed in a hardening fixer will again double the washing time.

Third, you can buy a reputable 'archival' washer from someone like Nova, Zone 6, Salthill or Kostiner and then follow the manufacturer's instructions, preferably with the use of a wash aid. Kodak used to recommend 30 minutes at 15° to 25°C (59° to 77°F), followed by six minutes in a wash aid, followed by ten minutes' more washing, though more recent research suggests that you can go straight into the wash aid bath from the fixer with only minimal loss of capacity in the wash aid (10 to 20 per cent), followed by 20 minutes' washing in running water. Alternatively you might give a vigorous five-minute wash; then ten minutes in the wash aid; and finally a further five minutes' wash.

Fourth, in order to put an end to constantly relying on dead reckoning you can actually test your prints with silver nitrate, using Kodak's HT-2 Residual Hypo Test Solution. It will, however, be necessary to make this up from scratch, but the complete formula (together with full instructions for use) is given on page 175. Everything that we have said here is very much the counsel of perfection, but if you are genuinely concerned about archival permanence, it is undoubtedly the way to go.

▶ CINEVIDEO

The sign on the ornate lamppost is burned out to a featureless white – but that is not what catches your eye. The dramatic graffiti-style décor is much more arresting, and this is best captured with a relatively hard paper grade. Nikon F, 35mm f/2.8 PC-Nikkor, Ilford XP2. (FES)

DRYING

Drying tools and techniques are covered in Chapter 12; the only thing worth adding is that you can buy 'flatting' solutions (humectants) which reduce curling, but we have never seen any references to what effect (if any) these have on permanence. The few prints treated in this way which we have handled, have a rather unpleasant feel, so we have never explored this route.

KODAK HT-2

Acetic acid (glacial)	7ml
Silver nitrate	2.5g
Water to make	200ml

Always add acid to water. Add the acetic acid to 150ml of water; dissolve the nitrate; make up to 200ml; and store in a well stoppered brown bottle in the dark. This solution will stain clothing, hands and photographic materials.

Finally, place one drop of Kodak HT-2 on the scrap margin of a washed and blotted but still damp print (preferably not a display print!) and allow to stand for two minutes. If the result is anything more than a very pale straw tint this indicates inadequate washing.

(See Notes on Mixing Chemicals on page 118.)

AMIDOL PAPER DEVELOPER

Sodium sulphite (anhydrous)	25g
Potassium bromide	1.5g
Amidol	6g
Water to make	1,000ml

Use at stock strength for two to three minutes. Capacity is low at maybe ten 8×10in prints per litre and the solution will only keep for a few hours, although adding 5g/litre of citric acid can make it last for several days.

Amidol takes the form of light, feathery crystals which can easily become airborne: for safety's sake a mask or respirator is a good idea. Pure Amidol is highly soluble, but old, impure or oxidised Amidol will not dissolve fully: increase concentrations of Amidol by 10 to 20 per cent and filter the developer before use. The precise formulation is incredibly uncritical: we have found a dozen formulae, all different. Amidol concentrations of 4g to 10g/litre can be used; sulphite concentrations of 15g to 50g/litre are reported; and bromide runs from 0.5g to 2.5g/litre. Use 1.5g/litre for prints destined for toning.

PILLAR BOX

In memory of our own dear Queen Victoria... This VR (Victoria Regina) logo on a pillar box is a study in texture and tone – the sort of thing often associated with large-format cameras, but quite feasible with 35mm, if you print very carefully. Nikon F, 90mm f/2.5 Vivitar Series 1 Macro. (FES)

THE ART OF PRINTING

There are several very good books by master printers on the art of printing: our favourites are cited in the Bibliography, and we would not dream of trying to cover as much ground in a single chapter as they do in a whole book. What we propose to do instead is to state the obvious (which is surprisingly often overlooked, because people are too busy riding their hobby-horses to give useful advice) and describe a number of tricks which we have found useful – although we must emphasise that merely because they work for us, we cannot guarantee that they will work for you.

This point about personal experience is very important indeed, as many printers will try to tell you that theirs is the only way of doing something, yet you may be totally unable to replicate their results. If after due persistence you find that this is the case, then you should simply try something else.

THE NEGATIVE

The easiest way to get a perfect print is to start out with a perfect negative. While this may not always be possible, it is worth reflecting that if you have consistent problems with getting good prints, maybe you should try changing your negative exposure and development techniques, or even your film.

In particular, if you constantly need hard paper (grade 4 and above) then you may well be under-developing your negatives; the main exception to this is Ilford XP2, which rarely prints on anything softer than grade 3. This is not an inherent defect: it is a result of the extremely long tonal range of the film.

◀▶ **BOOTS**
These boots on a bench in downtown New York City made a perfect still life, but a straight print is too dark on the left (far left). The answer was to dodge the left-hand side somewhat (the large picture opposite). The second small picture (left) was however over-worked; the right-hand side was burned slightly, leaving an awkward light 'halo' around the upper boot. Nikon F, 90mm f/2.5 Vivitar Series 1 Macro, Ilford HP5 Plus. (FES)

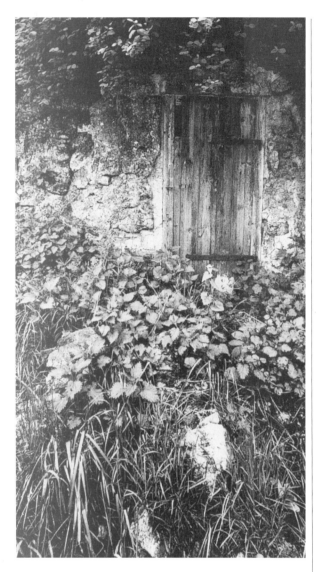

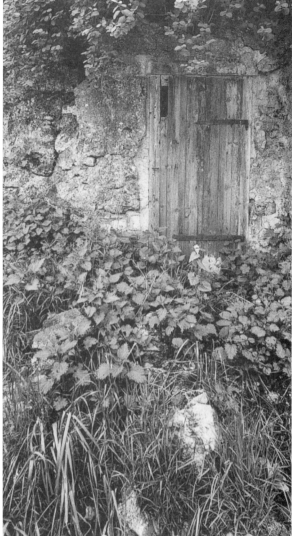

By the same token, if you habitually need grade 1 paper or softer, your negatives are too contrasty and you would do well to cut development times.

MATCHING THE NEGATIVE TO THE PAPER

Although the effect of different contrast grades of paper is obvious enough, something which is less obvious is the way in which a given film will 'mesh' better with one type of paper than with another.

To a very great extent, this is a question of the shapes of the characteristic curves of the film and the paper. Although for many years we used Ilford films and paper without the slightest hesitation – indeed, with the finest results for which one could wish – there were always some negatives which were excessively difficult to print. These were normally (although not

DOOR, Bavaria

This picture has already appeared on page 8 – and here are two further (and different) interpretations of it. The one with more contrast is on Ilford Multigrade IV, while the other was printed with exactly the same exposure and contrast grade on Sterling RC VC. For technical data, see page 8.

invariably) on non-Ilford film stocks, which we tested in the course of writing for various magazines, or just for the fun of it.

Then, by chance, we tried printing one of these 'difficult' negatives on Sterling paper – and it printed as if by magic. Other 'difficult' negatives did the same, almost without exception: if they would not print on Ilford, they would print on Sterling.

We did not, however, simply switch our allegiance.

The films which had printed well on Ilford paper continued to print better on Ilford paper, so suddenly we had two separate, parallel lines of printing paper. Now, if a negative won't readily come up well on Ilford, we switch to Sterling. We also use Sterling with non-Ilford films, especially with Polaroid pos/neg film, but Ilford XP2 and Ilford Multigrade IV still remain our materials of choice for the vast majority of pictures.

BASIC PRINTING TECHNIQUES

An over-exposed print is flat and muddy, while an under-exposed print is pale and dull. A well exposed print has a good range of tones, though not necessarily a full range of tones from the maximum black of which the paper is capable to a pure, paper-base white, and a pearly gradation: a 'soot and whitewash' print, with plenty of pure black and pure white but not much in between, is all too easy to achieve. Because gradation is intimately connected with paper grade, therefore, the two cannot be considered entirely separately.

The trick is to decide which tones in the negative are to be the limits of the paper's tonal range, and then to use the softest paper which is consistent with those two tones – unless, of course, you want higher (or more rarely, lower) contrast for a particular aesthetic effect. It cannot be emphasised too strongly that the highlights and shadows should be a matter of what you *want* to record, not what you *can* record: attempting to record too long a tonal range, no matter how faithful and literal it may be, is not always as satisfactory as choosing a narrower tonal range in the subject, and exploring that more fully.

Eventually, experience will tell you what exposure and which grade are needed, and you will get very close just by looking at the negative; but even then, the iterative process

described below is how you refine both exposure and contrast. It may be slightly more extravagant in materials than conventional approaches, and it may take longer to get an acceptable print, but it will get you a better print. Indeed, it will probably get you the best possible print faster than any other method.

If you are making a large exhibition print – 16×20in (40×50cm), say – then by all means make your initial prints on a smaller size. An 8×10in work

'BEEHIVE' OVEN
The oft-repeated injunction to include both maximum blacks and pure whites in a print is frequently misinterpreted to justify 'soot and whitewash' contrast; but as can be seen, extremes of contrast do not necessarily preclude rich mid-tones. Nikon F, 35mm f/2.8 PC-Nikkor, Ilford XP2 printed on Sterling RC VC. (FES)

◀▲ ST BASILIUS

'The negative is the score; the print, the performance'. The softer rendition of the famous onion domes of St Basilius in Moscow is arguably more technically accurate, and certainly more informative, but the harder one is more how Frances saw the cathedral when she shot it. Nikon F, 90mm f/2.5 Vivitar Series 1 Macro, Ilford XP2.

print should be big enough to allow you to judge tonal relationships, dodging and burning and so forth, and you can then transfer what you have learned on the work prints to the large exhibition print. Normally, you can do all the initial work prints on RC, even if your intention is to make the final print on fibre.

A notebook is extremely useful, especially if you have to work across two or three evenings. Don't use a red pen, as it won't read under the safelight.

Step 1: exposure determination

Guess at the paper grade you are going to need. Unless the film looks unusually contrasty or unusually flat, a good starting point is normally grade 2 for a condenser enlarger or grade 3 for a diffuser or cold cathode. Err on the side of softness rather than hardness, as this will give you a better idea of the full range of tones in the print. Indeed, some printers advocate making your first work print deliberately soft, so you can see all that the negative has to offer.

Your test strip must accommodate both the lightest part of the negative and the darkest. Place it on the baseboard, positioning it with the help of the red filter over the enlarger lens.

Guess at the exposure you will need. Expose the paper. Process it – fully. Do not 'snatch' the print before the manufacturer's recommended development time.

If the test strip is too dark, shorten the exposure time, or stop down, or dial in some neutral density filtration. If it is too light, increase the exposure time, or open up, or take out some ND filtration. Make it a reasonable increment: at least 1 stop, and 2 if you are in any doubt. Expose your second test strip and process as above.

Step 2: contrast determination

When you have the exposure sorted, look at the contrast. Is the image too flat, or too contrasty? Change paper grades accordingly. You *can* change both exposure and grade at the same time, but you risk confusing yourself if you do.

When you have a test strip that you like, make a work print of the whole image. The chances are that it will not be quite how you like it, but at least you now have a basis for further changes. It is a false economy to try to guess which bits will need dodging and burning, and how much, without making a work print.

Also, the chances are that both exposure and contrast may require a little 'tweaking' compared with the test strip, because you can now see how all the tones interact. By all means make another work print, or even two or three, to get base exposure and contrast right – although again, you can combine this with the next step. Make a note of print size, contrast grade, and exposure.

ARNOLFINI

We trawled our archives to find examples of bad printing, the sort of thing a novice does – like this clumsy bit of dodging from the late 1970s. Look at the halo around her head! Nikon F, 58mm f/1.4 Nikkor, Ilford HP5 rated at EI 650 and processed in Microphen. Printed on graded paper using a Leitz Focomat 1 enlarger. (RWH)

print which is more important than exactly how many seconds you gave this bit or that bit, or where the line came in dodging. Your interpretation may in any case change over time, so absolutely precise notes are less useful than just a general idea.

The majority of prints should work well with just these stages. If you find they don't, try pre-flashing, split contrast, or masking.

Working with an analyser

If you use an analyser – especially the RH Designs Analyser described on page 160 – it will give you an excellent 'first guess' on both paper grade and exposure. For at least half of the time, we find that it gives a perfect work print, defined as a print with the right base exposure and contrast, and needing only local correction of each; which brings us to dodging and burning.

Dodging and burning

The odds are that you will want to increase the exposure in some parts of the image (burning) and decrease it in others (dodging). Many printers have great difficulty in being aggressive enough about this – and even greater difficulty in being aggressive enough about it in the right way. The flat, under-exposed head, surrounded with a 'halo' from cack-handed dodging, is all too familiar; but equally, large areas which should be radically lightened or darkened are all too often left closer to their original values than they should be. This is easier to illustrate than to describe.

A further advantage of making 8×10in work prints is that they are harder to dodge and burn than are large exhibition prints, and this will hone your skills considerably.

Note the dodging and burning in your notebook, but don't get obsessive about it: you should acquire a 'feel' for the

Pre-flashing

All emulsions have an 'inertia' (see page 24). If you give less light than a certain threshold value, it simply will not register. If your print has a long tonal range,

with important values in the highlights (the darkest part of the negative, remember), then you may need to overcome this inertia with a very brief pre-exposure to uniform light – exposure which would be fogging if you gave enough of it. This pre-exposure kicks the paper over the threshold and gets you onto the toe of the characteristic curve, so that any light falling on it – even the tiniest amount – will register.

This very brief exposure is typically of the order of one per cent of the overall exposure, so if your main exposure is ten seconds at f/5.6, then your pre-flash would be 1/10 second at the same aperture or (more usually) one second at f/16. The precise value is however determinable only by experiment. Some printers use a second enlarger for the pre-flash exposure: a cheap second-hand model is more than adequate. This allows you to wind the head well up, for an even pre-flash and a convenient pre-flash time. Ansel Adams regarded pre-flashing as a last resort; others regard it as an everyday tool.

Split contrast with VC papers

'Split contrast' is used to mean two things. One is when you expose one area of the paper at one contrast grade, and another at a different contrast grade. This will often enable you to get detail in an area which is either blocked up or burned out in the original, single-grade work print. You can dodge areas with variable-contrast filters, or make two (or more) separate exposures.

The other meaning is when you expose the whole negative for part of the time at one grade, and for part of the time at another. This effect should be duplicable with an intermediate setting and a single exposure time, although many printers find that making two exposures is an easier way to hold detail in two areas which they have had difficulty in fitting onto a single paper grade at any exposure. It does not sound logical or reasonable, but it works successfully for an awful lot of people.

Masking

Some printers make masks of various types which they use, in effect, to dodge and burn the print. Small, shaped pieces of black paper are either placed in contact with the printing paper (which can lead to problems with sharply defined edges to the areas of different exposure) or they are held above it, either on glass or on a dodging wand (which gives softer edges but can still be a problem). At one extreme, masking is indistinguishable from dodging and burning; at the other, it is effectively a variety of combination printing (see page 190).

Of all the print manipulation techniques, masking is the easiest to

▼ ▼ RHODES OLD TOWN

The difference may not be apparent in reproduction, but the dodging and burning required for this shot was rather demanding. First, a cut-out mask (made from a scrap print) was used to give the light area around the door ten seconds extra exposure. Then, the main exposure was made – 20 seconds, but with the door held back for five seconds. Look at the projecting beams, and at the detail in the door itself.
Toho FC45A, Angulon 120mm f/6.8, Polaroid Type 55 P/N. (RWH)

FIREPLACE

As a straight print (left), this is a fairly dull architectural record. Sandwiching it with a neg bag, and printing the whole sandwich (below), gives it a vintage look – as if it were shot on a paper negative at the dawn of photography. Nikon F, 35mm f/2.8 PC-Nikkor, Ilford XP2. (FES)

take too far. One of the most comprehensively and skilfully masked prints that we have ever seen was completely flat and lacking in life. There was detail everywhere, to be sure; but the lighting looked rather unnatural, as in effect it was.

PRINTS FOR EXHIBITION

Ansel Adams himself reckoned that the difference between a fine print and a good print was difficult or impossible to define. A fine print has something which a merely good print does not; it has something of the photographer's soul in it, perhaps.

There is no doubt, however, that a fine print is something which most photographers aim for when they make an exhibition print, and one of the most important aspects of a fine print is often the subtlety of the tones in both the shadows and the highlights. Exposure and contrast can be incredibly sensitive: a variation of a ¼ stop or less can make all the difference in exposure, and a half-grade variation in contrast can be too much. What is more, there may be a constant interplay between exposure and contrast, until both are exactly right.

The most important single thing which you can do to ensure a good exhibition print is to use plenty of paper. Practice is very much what makes perfect. If it takes ten sheets of paper to get exactly the print you want, then very well, it takes ten sheets of paper. If the cost of the paper worries you, compare it with the cost of other things you may enjoy: a bottle of wine, a trip to the theatre (or even the cinema), a hardback novel. You may complain that this favours better-off (or even profligate) printers, but if you want to compete with them, then this is the price. To quote Bob Carlos Clarke, you just go on making more prints until you can't make a better one.

Also, the more practice you get, the faster you will be able to get to the print you want. One printer might use 20 sheets of paper, and end up with a print which another would reject; but the one who rejected that twentieth print could probably get a first-class print in five sheets.

▶ **SCRAP METAL, Portugal**

Both the foreground and the background had to be burned in quite heavily in this picture – which is, of course, the equivalent of saying that the middle had to be held back. The attraction lies in the proliferation of textures; the tones can be made quite similar. Toho FC-45A, 120mm f/6.8 Angulon, Polaroid Type 55 P/N. (RWH)

Visiting exhibitions

A photomechanically reproduced print, in a book or a magazine, can never do justice to the original print; and unless you are used to seeing good, original prints, you can never really judge your own work critically.

Even a local camera-club exhibition can teach you a lot, not just about good prints, but also about bad ones. Out of 40 or 50 black and white prints, you might hope to see ten per cent which were technically excellent (aesthetic considerations aside) and 20 per cent which should never have been exhibited.

Whenever you can, you should go to exhibitions of fine prints – preferably, of fine prints which are not exhibited behind glass, so that you can peer at the surface of the print. In one sense, you should not worry as much about technique as about aesthetics, but in another sense, aesthetics are easily ignored if the print is not technically adequate.

You should also learn to recognise different printing styles. Some are much contrastier than others; some have a preponderance of light tones, others of mid-tones; some make a feature of grain, while others suppress it... All approaches are valid: it is just a question of whether you like them, and (it must be said) of whether they are fashionable. Even at the highly esteemed Royal Photographic Society you can see some truly awful printing, but because it conforms to the prevailing view of the moment (whatever that may be), it is not merely exhibited, but extolled. Unbelievably crude 'hammer-and-chisel' dodging and burning were clear examples of this in the early 1990s.

Size of exhibition prints

For exhibition or display, although 8×10in and 18×24cm are more acceptable than they used to be, they are still rather on the small side. At the other extreme, very large prints (such as 20×24in/50×60cm) are much less common than they used to be; if they are hung among smaller prints, they may have considerable impact or they may simply look ostentatious. The current tendency seems to be for middling-sized prints from 10×12in (25×30cm) to 12×16in or 30×40cm; in the United States you will find 11×14in (28×36cm) is a popular compromise.

The largest size that is normally encountered nowadays is 16×20in (40×50cm), but there is also the question of the size that the image 'wants' to be. Sometimes a small, understated image can have more impact than a big one, and equally, there is no doubt that giant, mural-sized prints of as much as 3×5ft (90×150cm), 4×6ft (120×180cm) and even bigger can have their place.

PRINTS FOR REPRODUCTION

A photomechanical reproduction rarely, if ever, reproduces the tonal range of a fine print, although a skilled photomechanical printer can often compress the tonal range of an original print so that both highlight and shadow detail are preserved; it is just that the highlights are not very light, and the shadows are not very dark, compared with the original print. Of course, an unskilled printer can lose just about everything, and some reproduction processes are a lot worse than others: scanned-in images, output with a cheap printer and then photocopied, are without doubt a recipe for disaster.

◀▶ WALL OF DEATH RIDER

The straight print (left) looks quite good – until you compare it with the dodged and burned one (right). Look at the detail in the shaded side of the face, recovered by dodging, and the extra texture in the hand with the rings, secured by burning. Nikon F 35–85mm f/2.8 Vivitar Series 1 Varifocal, Ilford XP2. (FES)

How photomechanical reproduction works

The vast majority of photomechanically reproduced pictures are 'half tones', where the illusion of tone is created with a matrix of tiny dots. Where the dots are largest and heaviest, there is a dark tone; where they are smallest, there is a light tone.

Many fine dots will give a subtler effect than fewer, coarser dots; this is what printers mean by 'screen size'. A 'fine screen' may have 130 or more dots per linear inch (they are normally expressed in unmetricated 'dpi' to this day), while a coarse newspaper screen may drop below 40dpi. Cheap paper, like newsprint, will 'block up' with a fine screen as the dots run together, so if reproduction is to be good, it requires good paper.

The density of the dots is normally expressed as a percentage, so 100 per cent would be solid ink and 0 per cent would be pure white paper. In practice, even the lightest tones must have five to ten per cent tone in them, and even the darkest tones can only be 90 to 95 per cent inked.

This necessarily limits the quality of reproduction of very light and very dark tones in reproduction. Therefore, the first thing the wise printer will do is to make sure that the vast majority of the information in his pictures is in the mid-tones. In fact, the light mid-tones will reproduce best of all. The reason for this is that many printing processes are extremely bad at laying down enough density to be convincing even in the dark mid-tones.

The old advice to provide 'bright' or 'snappy' or just plain contrasty prints for reproduction is therefore very incomplete. Overly contrasty prints will block up into solid areas of greyish black and pure white, like a bad photocopy. It would seem wiser to shoot and print for the light mid-tones, and then you will be in with a chance.

High-quality photomechanical reproduction

The best conventionally printed monochrome pictures normally rely on the same technology as is used for colour printing: four 'colours' are superimposed, cyan (C), magenta (M), yellow (Y) and black (K from blacK – not 'B' because that is 'blue' as in 'RGB' or 'red-green-blue'). This gives a better maximum black and subtler tones.

Duotone uses two sets of dots, usually (although not invariably) in different colours: one neutral black, the other warm or cool. First-rate duotone can be as good as four-colour, the more so as one screen can be set for the shadows and the other for the highlights.

Gravure does not use dots, but instead etches the printing plate to different depths to create different intensities of tone. It is effectively a continuous-tone process and can give superb results. Duotone gravure is even better. Unfortunately gravure is very expensive compared with normal half-tone printing, and it is therefore rarely used nowadays.

Finally, the Woodburytype was an utterly gorgeous process which used a hardened gelatine master (the process was akin to other gelatine bichromate

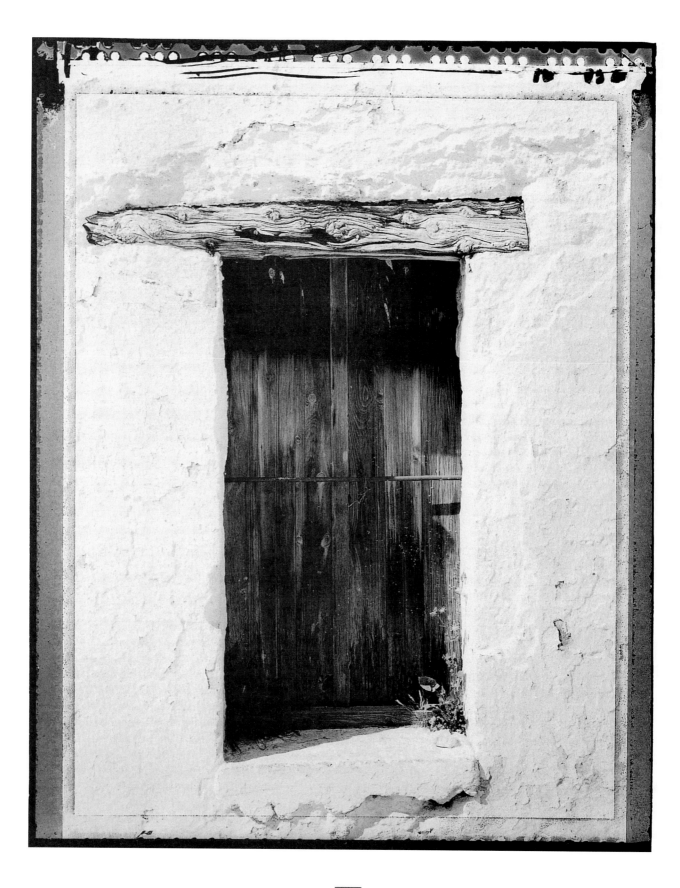

▲ GAVIYAL

The art of cropping is a part of the art of printing. Cropping this Indian gaviyal to a very long, thin shape emphasises the fearsome teeth in the long snout. Nikon F, 90mm f/2.5 Vivitar Series 1 Macro, Ilford XP2. (FES)

◀ GREEK WINDOW

The scope for manipulating the development of Polaroid Type 55 P/N is limited: you can pull the sandwich apart early for less contrast, but it is not as controllable as conventional development. Even so, a little dodging under the lintel and in the lower left-hand corner reveals that there is detail everywhere. The image was slightly under-exposed to capture texture in the whitewashed wall. Toho FC-45A, 120mm f/6.8 Schneider Angulon. (RWH)

CÊPES

Users of 35mm in particular are overly addicted to printing 'all in', as if there were something sacred about the 2:3 ratio of the 24×36mm negative. This shot would have worked better with a Hasselblad, but Frances did not have a Hasselblad with her – so what is wrong with cropping 35mm to square format? Nikon F, 35mm f/2.8 PC-Nikkor.

processes) to make a lead 'printing plate': the master was pressed into the lead under a pressure of several tonnes. The lead mould was filled with pigmented gelatine, which was allowed to set before being transferred to a sheet of paper. It was a true continuous-tone, grainless medium, and the results were beautiful; but it enjoyed only a brief heyday from its invention in about 1864 to the turn of the century, when it was superseded by faster, cheaper processes.

Print sizes for reproduction

The standard print sizes for reproduction are 8×10in or 18×24cm. Whole-plate (6½×8½in) was the old standard but it is less popular today, and for some reason (possibly price) A4 has never really caught on.

Standard sizes should always be used where this is possible. Smaller prints are sometimes sent out with press releases, but only if it is known that they will not be reproduced more than 'half up' or 150 per cent. We have supplied 5×7in (13×18cm) prints where we know the picture will be reproduced at quarter-page or less, and even 4×5in Polaroids. Overly large prints (bigger than A4) are not popular with publishers and printers as they are inconvenient to handle.

MASKED AND COMBINATION PRINTS

Combination printing, which uses several negatives to create one final image, was very popular with our

Victorian ancestors. The leading exponent was probably O.G. Reijlander, whose famous *The Two Ways of Life* was assembled in 1857 with over 30 negatives. Cut masks, and careful assembly, were required: it would probably be easier to do this sort of thing with a computer today.

Rather simpler combination prints are surprisingly easily made, the classic application being the addition of clouds to a print with a 'bald' sky. If you have never tried it before, the technique is really remarkably simple, and is as follows.

Focus the main image on the enlarging easel in the usual way. Lay a sheet of glass on top of the image, with a piece of thin card on top of that. Sketch the outline of the horizon. Cut along the line to get a mask and countermask. Use one to make the exposure of the main subject, with the sky masked off; then print the sky image with the main subject masked off. That's all.

Combination prints can look very contrived if the lighting is not consistent: sunny shadows under a brooding sky will rarely work, and a strongly side-lit scene will look odd against a sunset. The scope for disasters is even greater in more complex combination prints, as is evidenced by the vast majority of computer-assembled images. On the other hand, modern masters such as Jerry Uelsmann make superb combination prints following traditional methods, often using two (or more) enlargers sequentially to simplify set-up.

Cut and paste

Straightforward cut and paste, using two or more different prints, can be surprisingly effective. Use a sharp scalpel to cut out the images, and wherever possible, follow an obvious line in the picture. To minimise the obtrusiveness of the cut edges, 'feather'

COMBINATION-PRINTED SKY

In the first picture, the sky is completely 'bald'. In the second, sky detail has magically appeared. What happened is that two negatives were printed sequentially: one of the cottage, which Roger shot with a 'baby' Linhof and a 65mm Schneider Angulon on Ilford Ortho Plus, and the second of a sky, which Frances shot with a Nikon on Ilford XP2, although she cannot remember which lens she used. Note also the slight burning of the road on the right, to suggest a brighter day than the first shot, which clearly was taken under very flat light. We used two enlargers, but you can do it with one. Sketch the shapes on a piece of plain paper to assist in aligning the two negatives.

BACK STREET, Rhodes

On this trip to Rhodes, Roger was shooting Polaroid Type 55 P/N with a 4×5in camera, and Frances was shooting 35mm – although this looks more like a 4×5in shot. Very careful exposure, and careful printing, can blur the distinctions between the formats. Nikon F, 35mm f/2.8 PC-Nikkor, Ilford XP2. (FES)

them with abrasive paper or blacken them with a fibre-tip pen. Cut and paste is also the technique for multiple-exposure panoramic shots.

FINISHING AND PRESENTATION

All too many good prints are let down by poor finishing – or in some cases, by a lack of understanding of presentation. A print should be free of blemishes such as spots and dust marks; it should be an appropriate size for the application; and for many applications, it must be mounted, matted or framed. Even the lighting must be considered.

Finishing

A print is not really finished until its blemishes (if any) have been removed.

Dust on the film, before exposure, will result in white (clear) marks on the negative, which in turn give rise to black spots on the print. It is extremely difficult to reduce a black spot to a tone which matches the surrounding tones, so the best thing to do is to turn it into a white spot and then retouch that. Large-format negatives can be spotted directly, but users of 35mm and roll-film cameras will generally find it easier to bleach out the spot on the print. This is most easily done on a wet print, and in any case, in the interests of permanence the print should be washed after any chemical treatment. You can use proprietary bleaches such as Fotospeed (which is the one we use), Pébéo, Spotone or Kodak R-23; the formula for the latter is given on page 195.

An alternative to bleaching is knifing, where a very sharp scalpel is dragged very lightly across the surface of the print, physically removing the gelatine and the silver image inside it. While this can be done 'dry' and is therefore quicker than bleaching, it is extremely difficult, and even good knife work may mar the surface of a print if it is examined critically. Knifing RC prints is even more difficult than working with FB.

Black spots on the negative – typically dust – translate into white spots on the print. As with clear spots on the negative, prevention is better than cure, but at least the cure is easier than it is with black spots. There are four important things to remember.

First, with really tiny spots, tone is normally far more important than colour. Almost any tone which matches reasonably closely will do, regardless of a precise colour match.

Second, with larger areas it is generally easier to build up the defective area slowly than to attempt to fill it in with a wash. Both tone and area should be built up spot by spot. In this way, a skilled finisher can even 'lose' awkward marks like a hair on the negative.

Third, with larger areas (including hairs), colour is important: warm-tone prints require warm-tone retouching, and cool-tone prints require cool.

Fourth, practice will make spotting much quicker and easier. An experienced finisher can do more in

Overleaf INTERIOR, Minnis Domestic Supplies

Contact printing from 8×10in is quite unlike enlarging: dodging and burning are more different than would seem possible. Ideally, this crowded and contrasty negative should have been printed on printing-out paper, where the inherent self-masking quality of the paper would have tamed the contrast. Reg, the proprietor, moved slightly during the two-minute exposure on Ilford Ortho Plus. A better choice would have been Ilford HP5 Plus, pushed to EI 800 – ten times faster than the Ortho Plus. De Vere 8×10, 121mm f/8 Schneider Super Angulon. (RWH)

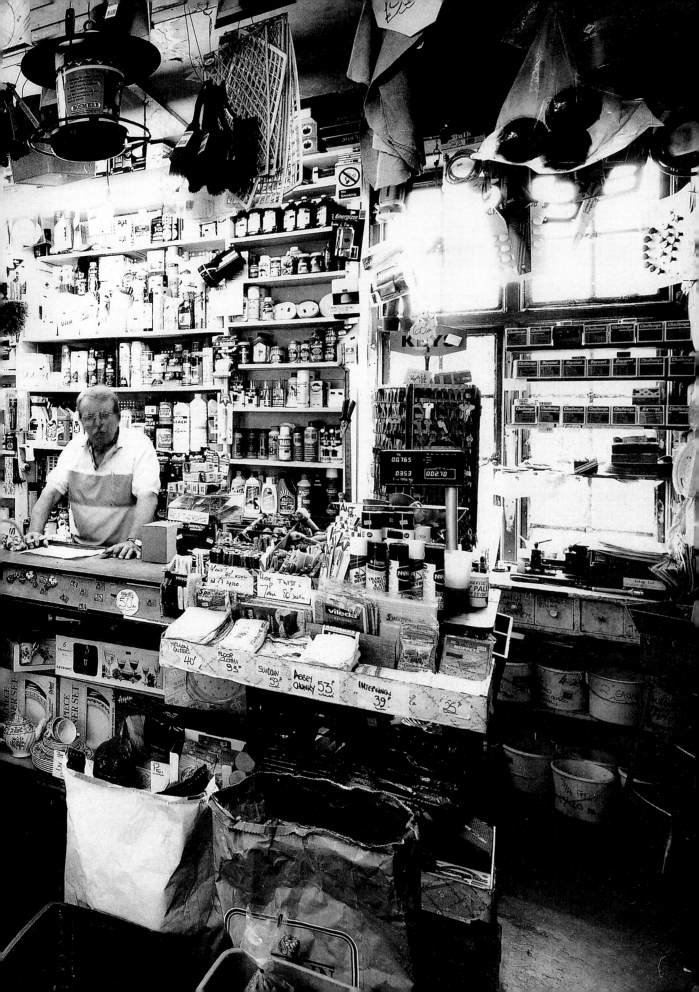

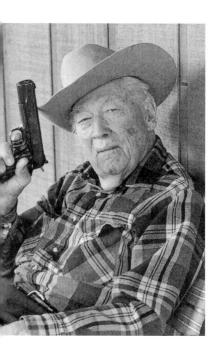

ARTIE SCHULTZ
The different formats often behave more alike than they have any right to do, although it would have been extremely interesting to shoot this portrait on an 8×10in camera (or at least on 4×5in) and see how much difference it made to the formality of it. When Frances's father died at the age of 83 he had been shooting for over 70 years and had never fired a shot in anger. Nikon F, 90mm f/2.5 Vivitar Series 1 Macro, Ilford XP2. (FES)

two minutes than a novice can in half an hour. Save scrap prints for practising on.

Spotting media and tools

In media, you have a choice between dyes and pigments. Dyes are (or should be) invisible in use, because they sink into the surface of the print, while pigments will be glaringly visible on all but the roughest of print surfaces if the print is observed at an angle. On the other hand, pigments are much easier to use because they can be wiped off, while dyes have to be washed out (if you can get them out at all). The novice may therefore be better advised to work with pigments until he or she has gained sufficient experience to use dyes. Besides, when it concerns prints for reproduction you might as well use pigments, because the variations in surface texture will not be visible in the reproduced image.

Although you can make up your own pigments and dyes, using (for example) umber or burnt sienna to warm up lamp black, there are several proprietary kits on the market which save you the trouble and are more reliable to boot. In pigments, we use the Kaiser paintbox (ours is the older Schmincke version), which gives a choice of six tones of warm black and six tones of cool black; any desired tone or colour is easily mixed. In dyes, we use the SpotPen system, which is available in both neutral and warm tone; a set of ten brush-top pens makes spotting very easy indeed.

Unless you use the SpotPens, which incorporate

their own superfine-point brushes, you will need spotting brushes. Buy the best quality that you can find. Even if they are ten times the price of a cheap, plastic-handled point brush, they are still not very expensive and they will last half-way to forever. Although the very smallest sizes such as 000 may seem most useful, quite large brushes are often easier to use: they will hold more pigment and are more flexible, but they will only come to a good point if they are of the best quality. Use the brushes fairly dry: flooding is a major error among novice spotters.

A headband magnifier, such as is worn by jewellers and watchmakers, will make spotting much easier. Being able to work with both eyes, hands free, leaves you to concentrate on the work in hand.

Retouching

'Blocking out' unwanted backgrounds is most easily carried out with an airbrush and masking film or masking fluid. A suitable white blocking medium is Schmincke's Aeroweiss, which is remarkably opaque. Work on as large a print as you can manage, and make a copy negative afterwards: this will enable you to make multiple copies, and will disguise the handiwork on prints intended for exhibition.

True retouching, in the sense of substantially modifying the print through hand-work (as distinct from merely removing flaws, or blocking out), is somewhat beyond the scope of this book. A skilled retoucher can do almost anything, as witness the old Soviet custom of airbrushing out 'non-persons' from Party photographs after they had fallen from favour; but this is more to do with drawing and painting than it is to do with photography.

Matting, mounting and framing

A matte, mount or frame has two functions: it protects the picture, and it may enhance it by complementing it. Prints for reproduction should never be mounted, as most are scanned and a mounted print cannot be wrapped around a scanner drum.

Some exhibitions specify standard sizes for mounts: the print may be any size within the mount. With small pictures (8×10in and below), large mounts will only 'work' if the picture warrants it: an overly large mount with a small picture can easily look pretentious unless the picture itself is first class.

For general display, mount sizes are as much a matter of fashion as anything else – as are mount and frame colours, which are additional variables – but the type of mount and whether the print is framed or not

will have a considerable influence. Flush mounts are much less fashionable than they were, as are flat dry-mounted prints: window mounts or sunk mounts are more usual. We have found that if you cultivate a good framer and mounter, it costs little more to have window mounts cut than it does to cut them yourself.

A heavy frame can often sustain a large mount; but a narrow frame may work less well.

Signing prints

This is a vexed question. On the one hand, it can look pretentious. On the other, why should a photographer not sign a print? And besides, some buyers like their prints signed, on the image area at that – although you can equally well sign the back, preferably in pencil. It is a question of personal taste, and (to some extent) of subject matter: a signed portrait often works better than a signed landscape. By the same token, signing a portrait on the image area is somehow more acceptable than signing a landscape, where the signature looks better on the mount.

Lighting

Last of all, how is a print to be lit? As mentioned on page 62, a print which is to be hung in a dim corridor should be printed differently (and lighter!) than one which is to hang somewhere brightly lit. Alas, like so much else, this is often beyond the control of the photographer; but it is better to be aware of things which are beyond your control, and make what allowance you can based on your best guess, than simply to ignore them.

KODAK R-23 IODINE LOCAL REDUCER	
Potassium iodide	30g
Iodine (resublimed)	10g
Water to make	200ml

Use on a soaked, blotted print. Clear the iodine stain with a 20 per cent solution of hypo (crystalline) and wash well.
 (See Notes on Mixing Chemicals on page 118.)

CRUSADER CASTLE, Lindos, Rhodes
The intention here was to capture two things: the baking heat and the massiveness of the castle. The tiny figures of the mother and child, bright against the black door, define the contrast limits of the paper; then, the sunlit parts of the wall were printed as light as possible while still retaining texture. Nikon F, 35mm f/2.8 PC-Nikkor, Ilford XP2 printed on Sterling RC VC. (FES)

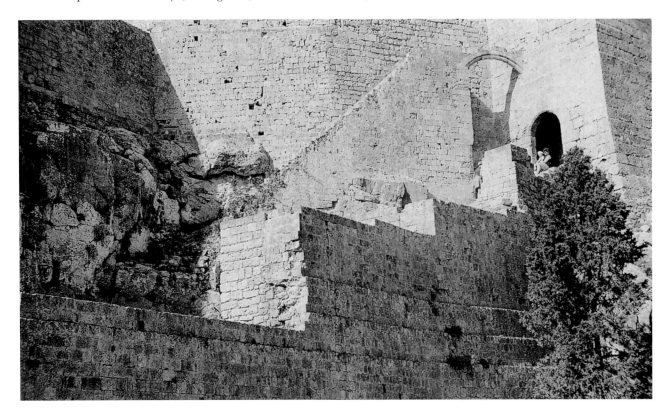

ALTERNATIVE PROCESSES

Since the 1980s, there has been an increasing interest in so-called 'alternative' processes – which might more accurately be called 'obsolete' or (charitably) 'obsolescent' processes. They date from an earlier age, before silver-halide photography conquered all, and they are embraced for a number of reasons: because they yield a particular quality which is simply not obtainable in any other way, or in reaction to the increasing automation of modern photography, or just for novelty's sake.

These tend to be 'love it or hate it' processes, and it is not unfair to say that they are well outside the mainstream of monochrome photography. Even so, they warrant some mention here. There are whole books devoted to many of these processes, which can in the right hands deliver fascinating images, but for reasons of space they can only be described very briefly here. The Bibliography gives some pointers on where to look for further information.

Because many of these media depend on texture and colour, they can really be appreciated only as originals; even as colour reproductions, they may not be particularly good, and as monochrome reproductions they may simply look like bad conventional prints. Most are more difficult to achieve than silver-based photography, but they offer very different ways to obtain a different look, more control, or greater permanence – and sometimes all three at once. Most are very insensitive, so enlargements are impractical: contact printing is required.

It is advisable to interpose a thin sheet of Mylar or something similar between the negative and the paper when using many of these processes, in order to eliminate the risk of damage to the negative; silver-based processes, in particular, can stain negatives quite badly.

In the pages that follow, we have stayed with old photographic usage by referring to potassium *bi*chromate, in place of the more modern term, potassium *di*chromate. To refer to 'dichromated gelatine' somehow just didn't seem right.

'BATHING BEAUTY'

'Bathing beauty' appears on page 154 as an enlargement – but there is a certain charm in making contact prints by alternative processes: in this case, Argyrotype. Think how good this picture could look in a small, antique silver frame.

▶ **CYANOTYPE**

The Cyanotype process is better known as the ancestor of the blueprint, but as this excellent study shows, it also has considerable creative potential. This was printed using a Fotospeed cyanotype kit.
(Andrew Davis)

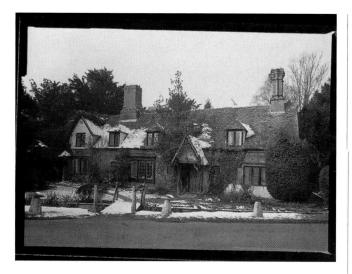

Albumen prints: Prior to the adoption of gelatine as the preferred medium for photographic emulsions, egg white (albumen) was used to coat the paper before sensitising it with silver nitrate. This remained the norm for printing papers from about 1850 to about 1880.

Argentotype: Sir John Herschel invented this process in 1842. Ferric oxalate (and some other iron salts) together with silver nitrate, mixed with starch, were used to coat plain paper. The ferric salts were converted to ferrous, and metallic silver from the nitrate formed the image.

Argyrotype: Also known as the Van Dyke process, this is a variant (by Dr Mike Ware) on the argentotype. At the time of writing, Argyrotype kits had recently become available from Fotospeed in England.

Artigue process: This relied on a bichromated gelatine sensitised material containing carbon. After contact printing, which hardens the gelatine in proportion to its exposure to light, the unwanted, unexposed material was removed mechanically by sloshing a slurry of sawdust and water over the surface of the paper: unlike carbon or carbro printing (see below) no transfer was required.

Blueprint: Invented by the prolific Sir John Herschel in 1842, and christened by him the cyanotype, this is a pos/pos contact-printing process which relies on the reduction of ferric salts to their (blue) ferrous equivalents. Some photographers still use it creatively, but it is of limited application.

Bromoetch: Over-expose a conventional print; develop it to finality; fix; wash; and then reduce the image in repeated baths of the etching solution given below. The net effect is akin to that of an etching, with particularly good blacks. The etching solution is made up as follows:

Sodium chloride solution 25%	1 part
Potassium permanganate solution 5%	1 part
Sulphuric acid 4%	1 part
Water	7–10 parts

HOUSE, rural Kent

When you begin to experiment with 'alternative' processes it may be a good idea to begin with small negatives (this is 6.5×9cm, exposed in a 'baby' Linhof with a 65mm f/6.8 Angulon). It saves on the cost of materials and also shows you the kind of resolution you can expect. The print on POP (top) is sharpest but least romantic. The Argyrotype (centre) is less sharp but still recognisably photographic. The gum bichromate print (bottom) looks like something from the dawn of photography – although this is due in part to poor choice of paper. (RWH)

Use repeated baths until the highlights clear; wash well; fix in fresh acid fixer; and then wash again.

Bromoil: This uses conventional paper, but it must be non-supercoated. The process involves bleaching the print and then applying a special greasy bromoil ink with a special stiff bromoil brush. The process relies on the image areas accepting ink more readily than the non-image areas: the texture of the ink and the skill of the operator with the brush are critical. Overly dry ink will not adhere; overly thin ink will be absorbed where it is not wanted; and poor technique at dabbing on the medium will result in lack of tonal control. Bromoil kits are available from a number of specialist suppliers.

Bromoil transfer: These are made by sandwiching a damp (but not wet) fresh bromoil print face-to-face with a sheet of non-photographic paper and running it through a press. Lithographic and copper-plate presses are ideal. The image is reversed left for right. If this is important, the negative should be printed face-up to 'flop' the master bromoil.

Calotype: The other name for this – Talbotype – gives some idea of its origins. The paper is sensitised as follows: first, with a bath containing iodides of potassium and silver; second, by washing the partially dry paper to remove excess potassium iodide; and third, just before exposure, with a bath of silver nitrate, acetic acid and gallic acid. The image is intensified after exposure with more of the silver nitrate/acetic acid/gallic acid bath.

Carbon printing: This process was commercially perfected in 1864, principally in a search for permanence, although as with every other process there were (and are) photographers who prefer the image to conventional silver photography.

It relies on specialised 'carbon tissue': paper coated with carbon or other pigment suspended in gelatine and sensitised with an ammoniated solution of potassium bichromate, so that the exposed parts of the image become insoluble while the others are left soluble. Development consists of washing away the soluble gelatine, but it is not as easy as it sounds. After exposure, the tissue is placed on a sheet of transfer paper; it is then soaked to remove the original paper backing and the soluble parts of the image.

A normal carbon print is laterally reversed, so for a normal-reading print the image is often transferred again: a temporary support takes the place of the transfer paper, after which the laterally reversed image is reversed again onto the final sheet.

Carbro printing: Introduced as 'Ozotype' in 1905, this begins with a plain bromide print on non-supercoated paper. This is fully developed, fixed, washed and dried; a broad border around the image is advisable as a precaution against 'frilling' or non-adhesion of the emulsion in later stages.

Next, specialist 'carbro tissue' is required. This is similar to carbon tissue (see above) and must be sensitised. It is squeegeed face-to-face with the print, which bleaches during the 20 minutes or so that the two are in contact. The carbro tissue is then pulled off the

PRINTING-OUT FRAMES
The back of a printing-out frame is hinged (right) so that it can be opened to check the progress of the print without destroying the alignment of the negative and the paper. These are quarter-plate frames; the negative in the left-hand frame was exposed in the Graflex in the background.

bromide, placed on a sheet of transfer paper, and 'developed' in hot water so as to wash away the soluble gelatine – much like a carbon print.

The bromide may be redeveloped (in a non-staining developer) and used to make more carbros, or kept as a print in its own right.

'Dusting on': This relies on the differential stickiness of exposed and unexposed sugars – honestly! To make a print, coat a piece of paper with a mixture of potassium bichromate and honey or sugar solution, and leave it to dry in a dark place.

Make a contact print (from an interpositive – this is a pos/pos process), and place the exposed print in a dark, dry place. The sugar will absorb moisture from the air and become sticky, except where it has been exposed to light. With a light, soft brush, dust the surface with pigment, which will stick to the image areas but not elsewhere. This can be 'fixed' with artists' fixatives.

Permanence is very high unless cockroaches, mites

etc, eat the sugary paper. Alternatively, coat glass, ceramics or metal with this sticky solution; use a material which can be vitrified instead of the pigment; and fire the image into or onto the support in a kiln. This is seriously permanent.

Dye-imbibition printing: This relies on the use of a tanning developer which renders the emulsion insoluble where it is exposed – somewhat like a carbon print (see above). This is then dyed and the dyed image or matrix is placed in contact with a special transfer paper which absorbs the dye. This is the basis of dye-transfer colour prints.

Fresson process: This secret, proprietary process is apparently similar to the Artigue process (see above).

Gelatine-sugar Printing: See 'Dusting on', above.

WATCH AND SHELL

One of the infuriating and yet intriguing features of gum bichromate printing is that you can hold surprisingly fine detail as well as rich, subtle gradation, but getting both at the same time is exceedingly challenging. For technical data, see page 61.

Gum bichromate: The paper is sensitised with a mixture of gum arabic, potassium bichromate and pigment. Like other bichromate processes, this relies on differential hardening of the gum, in proportion to the exposure received.

The gum arabic is prepared as a stock solution of 30g of gum arabic in 100ml of water, while the potassium bichromate is a saturated solution (ten per cent). Equal quantities of the two are mixed together for use. The pigment is added as around ten per cent of the mixed solution. Brush coat the paper (which should be sized, and fairly smooth), working in artificial light: it is not sensitive until it is nearly dry.

Contact print the image and then 'develop' it by floating it face down on a deep dish of cold water. Over a period of a quarter of an hour to several hours, the unexposed gum arabic mixture dissolves

and falls off the paper. The end result is very delicate indeed until it is dry.

An alternative way of 'developing' is with a perfume spray or airbrush loaded with plain water: by varying the pressure, and concentrating on some parts at the expense of others, you can control the amount of pigment removed.

Because there is no indication of how fully the image is printing, it is normal either to make test strips or to 'time' it by comparing it with a piece of POP (see above): when the POP is fully exposed, so is the gum bichromate print.

Gum bichromate printing declined as bromoil (see above) became more popular.

Kallitype: The Kallitype process sensitises the paper with a solution of ferric and potassium oxalates and silver nitrate; development (after contact printing by daylight) is in a solution of borax and Rochelle salt (sodium potassium tartrate), and fixing is in an alkaline (ammoniated) hypo bath.

Oil printing: This is similar to bromoil, but relies on a bichromated gelatine (rather than the tanned gelatine of a silver-based print) to accept or repel greasy inks. Oil transfers can be made in the same way as bromoil transfers.

Pellet process: A variation on blueprints (cyanotypes).

Platinum/palladium: Platinum and palladium prints are not only among the loveliest of all photographic prints: they are also among the most permanent. The image is formed of metallic platinum or palladium, in the grain of the paper. The tonal range, in the most delicate greys and rich blacks, is incredibly long and subtle, although the actual contrast range as measured with a reflection densitometer is far less than it might seem – often as little as 16:1 (4 stops or 1.2 log units).

The life of a well-made platinum or palladium print is the same as the life of the paper support itself: many centuries, and maybe several millennia. The materials are, however, hugely expensive, typically 20 to 30 times as much per sheet as conventional silver/gelatine papers.

You can save money by coating good paper yourself (with a mixture of ferric oxalate, potassium chlorate, oxalic acid and platinum chloride), but the expenditure of time will be prodigious and it may take you a long time to get perfect paper; it is easier to buy it ready coated. On the other hand, coating it yourself (preferably with proprietary chemistry) allows you to control contrast across a very wide range by varying the precise composition of the sensitising solution.

BROMOETCH
The original negative, on 8×10in Ilford Ortho Plus, is quite contrasty. It would be ideal for printing on POP, but instead we overprinted it on Sterling RC VC, then etched it back in a bromo-etch bath. The effect is akin to lith, but is not the same. In repro-duction, the peculiar richness of the blacks, especially in the tree trunk, is not apparent.
Gandolfi 8×10, 14in f/9 Cooke Apotal. (RWH)

Sensitised platinum paper is reportedly very sensitive to damp, and great care must be taken to keep it dry: at one time it was sold in airtight tins, although plastic bags now solve this problem. You may even get mottled greys if you work on a particularly humid day.

Exposures to daylight typically run from two minutes upwards (sometimes a long way upwards), but development is quick and easy in potassium oxalate. Clearing is in repeated baths of dilute hydrochloric acid, until the yellow stain disappears; this is followed by a long wash (typically three quarters of an hour or more).

Palladium printing is very similar to platinum printing and was introduced during World War I, when platinum was all but impossible to get. Although platinum and palladium printing declined almost to nothing in the 1950s to 1970s, these processes have now made a considerable comeback, especially in the United States.

Salted paper: Common salt – sodium chloride – reacts with silver nitrate to form silver chloride, and you can make your own printing-out paper this way. The salt is typically mixed with sodium citrate, and also with a size such as gelatine or arrowroot, although some papers work well without sizing. The paper is floated on the salt solution for a few minutes, or it is brush coated, and then dried. To sensitise the paper, brush coat it with a strong solution of silver nitrate, then dry again. Print out under the sun, or any strong UV source, but 'over-print' because considerable density is lost in fixing (in plain five per cent hypo). Gold toning before fixing (but after washing) controls both image colour and density, and can yield prints of immense longevity – and by this we mean centuries or millennia.

As a (reasonably) easy and (reasonably) economical medium, salt printing can be recommended as an introduction to alternative processes.

THE COLOURS OF BLACK AND WHITE

A colour section in a monochrome book may seem rather eccentric, but colour does play a surprisingly large part in black and white photography. The distinction between 'warm tone' and 'cold tone' papers (and developers) has already been made, and 'alternative' media can give a wide range of colours. Colour can also be introduced at the printing stage by using colour paper and a colour head on the enlarger; but in addition to these possibilities, the photographer has the options of toning and hand-colouring. The former operates by changing the colour of the silver image itself, while the latter is a question of laying colour over the silver image.

TONING

There are two reasons for toning prints. One is because you believe the picture will look better in a different colour, and the other is for increased archival permanence.

The archival aspect is easiest to deal with first. The metallic silver in an image can be attacked by a number of different chemicals, most notably sulphur which accounts for the browning and fading of the image. By converting the metallic silver into something which is more stable, the life of the print can be greatly prolonged.

The aesthetic side is another matter, and very much a question of fashion. In the 1970s, it looked as if toning might die out. Twenty years later, many leading practitioners of monochrome photography averred that almost all their prints were toned in one way or another. Many are partially or 'split' toned,

LINDA TREZISE

Wedding pictures often look wonderful in sepia, because there is a timelessness about them which seems tailor-made for the family album. Also, of course, they will last very much longer than any other prints, especially colour: this should still be as good as new in the year 2100, although it was shot in about 1990. Leica M-series, 50mm f/1.2 Canon, Ilford XP2, toned with Fotospeed sepia. (RWH)

▶ **TIBETAN MONKS, Dharamsala**

A warm tone – this was printed on Sterling RC VC – seemed appropriate both for the colours of the subject (warm Tibetan skin tones, earth, wood, trees) and for the more figurative warmth implied in holding hands. Very young children quite often become monks in Tibet, and indeed the monasteries sometimes function almost as orphanages, but no one thinks less of them if they decide later on that they would prefer the secular life. Leica M2, 35mm f/1.4 Summilux, Ilford XP1. (RWH)

PALAIS ROYAL, Paris

A cool or at most neutral tone is best for this formal, rather intellectual sculpture-cum-fountain in the equally formal Jardin du Palais Royal. Nikon F, 15mm f/2.8 Sigma fish-eye, Ilford XP2 printed on Ilford Multigrade IV. (FES)

while some are dual-toned – toned in two different toners sequentially. Both are discussed later.

Dyeing enjoyed something of a renaissance at the same time, mostly with very subtle base tints in buff or cream to recover the effect of the old 'Ivory' and 'Cream' base tints which were discontinued by most manufacturers in the 1960s and 1970s. Cold tea is a traditional dye, and may actually improve the keeping qualities of the print by tanning the gelatine slightly, but proprietary dyes are available from a number of manufacturers.

Proprietary versus home-brewed toners

We invariably use proprietary toners, usually from Fotospeed (Luminos in the United States), although there are many others: the French Photovir series is particularly well known. We have in the past made up all kinds of toners from raw chemicals, and in our experience it is just not worth the effort. Stained highlights are common with most formulae, and buying (and making up, and storing) the often toxic chemistry is just too much like hard work. Formulae are

given here merely so that you will have some idea of how the proprietary solutions work.

Having said this, if you want to get into making up your own toners (including many which are not available commercially, such as lead and nickel), the best place to find formulae is in old *British Journal of Photography* almanacs or in *The Focal Encyclopedia*.

You may also wish to get into chromogenic toning, where the dyes are formed during development (the silver image may be left or bleached), and dye mordant toning, where the silver in the image is converted into a mordant which allows various dyes to lock on to the gelatine where there is an image. Both of these processes allow a very wide range of colours, but their permanence is questionable. Again, the above publications give information on both.

Health warning

Many of the chemicals used in toning are toxic, and in many cases, gloves and a lab coat are essential precautions. Unless a particular formula is guaranteed by its

▶ **ARTIE SCHULTZ**

A non-coloured version of this appears on page 194. This was printed light, although (unexpectedly) it was not toned at all. It was coloured first with Veronica Cass Transparent Oils, applied with cotton buds, and then with Prismacolor pencils for fine detail such as the eyes. For technical data, see page 194.

ROGER

Sepia toning, followed by gold, gives an unusual range of tones often described as 'chalk red' but in our experience closer to peachy-sepia. (Camera, lens and film details forgotten). (FES)

manufacturer to be safe, you should always assume that it is toxic and treat it accordingly. Pay particular attention to eye protection: eyes are, after all, the photographer's most vital asset.

Sepia toning

Overwhelmingly the most common colour for toning is sepia, and numerous proprietary kits are available. There are many ways of sepia toning, but the majority of them rely on converting the image to silver sulphide. The normal approach is to bleach the image with a halogenising bleach, then to transfer the print to a sulphiding bath.

Not all papers take well to sepia toning, and even the choice of paper developer can have some effect on this, so the only option is to experiment. It is not true, however, that RC papers as a whole are unsuitable for toning: they are neither more suitable nor less suitable than FB, and because they wash faster, they may

be useful for experiments with dual toning (see page 210).

Because silver sulphide is more stable than metallic silver, sulphide toning increases archival permanence as well as having an aesthetic impact.

There are several formulae for halogenising bleaches, such as potassium ferricyanide/potassium bromide; potassium permanganate; potassium bichromate/hydrochloric acid; and more. Adding mercuric chloride to a ferricyanide/bromide bleach will give a colder brown, and also intensifies the print somewhat on redevelopment, but of course mercuric chloride is very poisonous.

The traditional sulphiding bath was a solution of sodium sulphide, normally between one and five per cent; this smells strongly of rotten eggs (hydrogen sulphide), and must be used in a well ventilated room.

Alternatively, you can use a thiourea bath, usually at 0.25 per cent, plus sodium hydroxide: varying the concentration of the latter allows some control of the colour of the image. Most modern proprietary sepia toners are of this type, and give better colour with current papers.

Another way to vary the colour is by using sodium thioantimonate (Schlippe's salt) as a darkener, either alone or mixed with another darkener: this adds antimony sulphide, which is orange-yellow in colour, to the silver sulphide.

Direct toning without prior bleaching is also possible: a one per cent solution of potassium polysulphide ('liver of sulphur') will work, as will a hot (50° to 55°C/120° to 130°F) solution containing 20 per cent hypo and 2.5 to 5 per cent potassium alum. The prints may have to be hardened before the latter can be used, although modern materials are less likely to need this. Fresh hypo-alum has a slight reducing effect, but this disappears when the bath gets a bit of silver in it; a few scrap prints will 'take the edge off'.

Gold and selenium toning

These are normally used principally for their improvement in the archival keeping qualities of the print. Both are single-bath direct toners: the print is simply immersed in them for a few minutes.

Gold toners are predictably expensive. The traditional view is that they work by literally gold-plating each particle of silver in the image, but recent research at Rochester Institute of Technology suggests that the suphiding effect of the thiocyanate may be as important: there really is very little gold in a gold toner. Toners normally contain 0.1 per cent gold

chloride and one per cent potassium or ammonium thiocyanate, and should have little or no effect on image colour, although they are said to improve the colour of greenish or rusty-looking prints.

A print which has already been sepia toned will, if it is subsequently gold toned, turn 'chalk red' (the traditional description) or pinky brown (our experience). This can make for some very interesting pictures, and portraits in particular.

Selenium combines with silver to give silver selenide, and if the toning is prolonged a cold-toned or neutral paper will take on a slightly purple-black hue, often described as 'aubergine' or 'egg-plant'. The effect is considerably more attractive than it sounds. Warm-tone papers go brown. Less prolonged toning will still improve the archival qualities of the image. Selenium toning is also said to improve the D_{max} of the image, but we have not tested this; it is not immediately obvious to the naked eye.

Other metal toners

These work by converting the silver image into either an insoluble, coloured silver salt, or a double salt. Some are two-bath, with an initial bleach and a subsequent toner, while others combine the bleach and the toner in a single bath.

The most usual proprietary toners are iron (blue or blue-green), copper (red) and vanadium or cobalt (green), but formulae are available for lead (yellow), nickel (red, violet or blue-green, depending on the final bath) and even uranium (red-brown).

The permanence of prints toned in this way varies quite considerably. Uranium-toned prints, for example, are impermanent and the image can be destroyed in an alkaline environment. A lot seems to depend on precise formulations: research conducted on behalf of Fotospeed indicates that their iron-based toners are all at least as permanent as the original silver image.

Also, some toners (notably iron) will intensify the print, while others (notably copper) will reduce it slightly, so prints intended for toning must be made slightly lighter or darker, according to the manufacturers' instructions.

Although the traditional advice was to choose carefully those pictures which were to be toned, and to match them to the colour, we have always found that there are many surprises: ideas which you think will work, don't, and ideas which you think won't work, do. Tests on second-best and work prints can give you all kinds of ideas.

DITCH AND BRIDGE, Marshside, Kent

Lightly applied, selenium toning has hardly any effect on image colour; with longer immersion, the blacks take on a purplish hue which varies from paper to paper. The only way to see if it works with a particular emulsion is to try it – and the 'same' emulsion may respond differently in RC and fibre form. Linhof Super Technika IV 6x9cm, Forte 400 film, Sterling RC VC. (RWH)

Dual toning

If a print is partially toned in one toner, then (usually after careful washing) in another, the highlights will take on the colour of the first toner and the shadows will take on the second. The crossover in the midtones is unpredictable. When dual toning works, it can be very effective indeed; but it does not always work. Also, the emulsion can become very tender, so some care is necessary to avoid scratching.

PAGES *208–9* LIGHTHOUSE AND MOLE, Chania, Crete
This was toned first with Fotospeed Copper, which gave the highlights their reddish tone, then (after a five-minute wash) in Fotospeed Blue Tone, an iron toner which gave the waves their blue colour. The overall effect is curiously naturalistic. Nikon F, 90mm f/2.5 Vivitar Series 1 Macro, Ilford XP2. (FES)

Split toning

An image may be partially bleached and then toned (with two-bath toners) or it may be just partially toned (with single-bath toners). Normally, the highlights are affected first, while the shadows may either remain pure black or be warmed or cooled slightly, depending on the toner in use. Using toners in this way, to modify image colour slightly, is probably the most popular approach to toning today.

Tools and the work area

Toning, especially if you use proprietary materials, is very simple. A print washer of some kind is essential, because the prints must be washed after bleaching and before toning or, in the case of dual toning, in between each toner bath. A few trays, some graduates, and a pair of rubber gloves are the other tools that are needed.

The ideal work area is a long counter on the wet side of your darkroom, but the kitchen floor or a long table can be pressed into service if need be. An old plastic sheet or plastic tablecloth can be used to protect the surface from spills. The work area should have good lighting because you need to be able to assess the results as you are toning. Lighting should be daylight, or daylight fluorescent, or blue-dipped incandescent bulb.

As suggested above, you can learn a great deal by toning scrap prints. Experimenting with one toner at a time and working methodically according to the manufacturer's directions is probably the most effective way to work. It is all too easy to get caught up in mixing and matching with several different toners. The problem is that you can end up with a really stunning effect and no very clear idea of how you got there. As you get to know the materials, so can you mix and match.

HAND-COLOURING

Like toning, hand-colouring has had its ups and downs, and at the time of writing it was more popular than it had been for many years. Traditional wholly naturalistic colouring, where the aim was to simulate a colour photograph as far as possible, is probably the least important aspect of this revival. Rather, modern hand-colourists use partial colouring on otherwise monochrome images; dramatic colouring, reminiscent perhaps of the Fauve movement; deliberately nostalgic, desaturated colouring; and colouring which is frankly kitsch.

Hand-colouring may not be something everyone can do, but equally, most people find it easier to master than they expect. The effects vary widely, according to whether you use transparent oils, opaque oils, watercolours, dyes or pencils. These media may be mixed, although it is rare to use more than two on one print. All of the liquid media may be applied in a number of ways, including regular brushing, airbrushing, or cotton swabs. Some photographers also use improbable media such as felt-tipped pens, and Kay Hurst of K Studios habitually uses gouache, varnish, and all kinds of other things on her prints.

Application techniques vary according to the medium, the results required and the personal inclinations of the colourist, so it makes sense to examine the media first before going on to the type of print best suited to hand-colouring.

Transparent oils

These are arguably the classic medium for hand-colouring, although they are far better known in the United States than in the rest of the world. Availability is patchy so which you choose will probably depend more on what you can get than on which you might theoretically prefer.

The oldest and probably best-known manufacturer is Marshall's in the United States, who have been manufacturing hand-colouring materials continuously since the early years of this century.

Veronica Cass, a hand-colourist in the United States, runs workshops and produces self-instructional materials, and also sells transparent oils which are manufactured to her specifications. Pébéo of France, the well-known makers of artists' materials, make a fast-drying 'Photo Oil' specifically formulated for hand-colouring.

Transparent oils are generally applied with cotton balls or cotton buds. The paint is taken up on the cotton and then applied to the print very thinly and evenly, using a circular motion. Some hand-colourists use bamboo skewers tipped with cotton for really fine detail. Brushes are used for heavy application and special effects. One of the advantages of transparent oils is that they dry fairly slowly and mistakes can be removed with a solvent or an extender.

COPPER MINE, Portugal
This abandoned copper mine in the Alentejo has the atmosphere of a place far older. In monochrome it is attractive enough, but in colour it has a certain magic reminiscent of old, hand-coloured postcards – but with a completely unexpected subject. Nikon F, 35mm f/2.8 PC-Nikkor, Ilford SFX 200. (FES)

Opaque oils
Although opaque oils are sometimes used for hand-colouring, they were much more popular in the past than they are today. Arguably, they require rather more artistic knowledge than any of the other media, as the photograph is often entirely obscured when the effect is intended to be that of an oil painting.

Some people use opaque oils over limited areas of the print, or in conjunction with transparent oils, to create areas of texture as well as colour. Opaque oils are normally applied with a brush, although air-brushing is feasible. The same applies to other opaque oil-like media such as alkyds and acrylics.

Many so-called opaque and semi-transparent oils, as well as alkyds and acrylics, can also be used as transparent oils: it is a matter of technique. If you apply them thinly enough with cotton wool or cotton buds, the photographic detail will show through. By the same token, if you apply transparent oils very thickly with a brush, then photographic detail will be suppressed or obscured.

Watercolours
Provided you are using a paper which will accept watercolour, any good brand of paint will work. It is however important to choose your colours with care

because there are two distinct ranges of watercolour: the so-called 'student' colours, which are inexpensive, and the 'professional' ones, which are more expensive, often more permanent and frequently more intense.

Watercolours also come in different forms. The most common are cakes and tubes, but there is a company in the United States (Peerless) whose manufacturing policy is to impregnate pigments into leaves of paper: when you want to use the colours you can either use a wet brush to lift a small amount of colour from the leaf, or you can tear off a small corner of the leaf and add water.

Some photographers use gouaches for both brush and airbrush application. As with conventional painting, some artists find they are more comfortable with watercolours than with oils, and vice versa. A great advantage of watercolour is that if you are unhappy with the results, the pigment can be washed off the print and you can start again.

Dyes

Dyes are probably the most difficult hand-colouring medium to master, because they soak into the emulsion immediately and only very limited correction is possible. They can be used on any photographic paper, including RC glossy paper. Another disadvantage is that dyes are usually applied with a brush, and the brush strokes can show if you are not very careful. Dyes are water soluble however, which means that even those which have dried up in their bottles can be reconstituted and used. By the same token, prolonged washing will weaken dyes, although it will rarely remove them fully, and different dyes seem to wash out at different rates.

Dyes have a very different look from either oils or watercolours. The range of colours available may seem very restricted and inflexible, but the better you understand the theory of colour and colour mixing, the more colours you will have at your command. Practising on scrap prints is more important than ever when learning to handle dyes. Some of the leading manufacturers of photographic dyes are Photo-Color, Marshall's, and Veronica Cass.

SUNFLOWERS I AND II

The identical picture can be hand-coloured in a number of ways – not just in different colours, but also using different media. The picture with the cyan vase was coloured with Winsor and Newton watercolours; the one with the brown vase with Veronica Cass Transparent Oils. It is unlikely to be apparent in reproduction, but the textures of the two media read quite differently. Both prints are on Kentmere Art Classic paper, which has a distinctive texture. Nikon F, 90mm f/2.5 Vivitar Series 1 Macro, Ilford XP2. (FES)

▶ **SUNFLOWERS III**

This print was first sepia toned, then gold toned, then hand-coloured using Paterson Photocolor dyes. Although it is not apparent in reproduction, the fascinating thing about these is the way they sink into the surface of the paper, leaving no trace other than the colour. Nikon F, 90mm f/2.5 Vivitar Series 1 Macro, Ilford XP2. (FES)

CHURCH, Auvers

Aficionados will already have spotted the influence of Vincent. The church at Auvers looks much the same now as it did when he painted it – which is not to say that either his painting or this photograph are exactly straight renditions. In order to achieve the necessary distortions, Frances used a 15mm Sigma fish-eye lens on her Nikon F and then distorted the printing paper (Kentmere Art Classic) in an S-curve on the enlarger baseboard. Colours, with heavy impasto, were then added with Marshall's Transparent Oils applied by brush, cotton bud and Colour Shaper. Ilford XP2.

Pencils

Coloured pencils are often used in conjunction with oils or watercolours to colour in details. The best quality pencils give the best results and softer pencils are easier to work with than harder ones. Marshall's do their own range of colours matched to their photo oils; Pébéo do a set of retouching pencils. Other brands which work well include Prismacolor, Karismacolor and Derwent. Like dyes, coloured pencils can take a lot of practice to master. You can allow the strokes of the pencil to show, or you can blend in the colours using cotton buds, charcoal blenders, putty erasers or the Colour Shaper (see page 216).

Other media

Hand-colouring is a highly idiosyncratic art and hand-colourists tend to experiment with anything they can get to stick to their photographs. Food dyes are almost traditional and tend to work in very much the same way as proprietary photo dyes. The only problem is that the permanence is not as good, and one colour may be more permanent than another.

Fibre-tip pens are easy to use and very controllable, but again permanence may be a problem and colour mixing is more difficult than with dyes.

Toners can be used like dyes and painted directly onto the surface of a print, but they are hard to control and not as effective as dyes. Charcoals and pastels work well on some of the textured papers, but you may need to use a fixative to make them permanent and this may affect the permanence of the silver image underneath.

TILE, Rhodes

Fotospeed Fotolinen is a remarkably apt surface for hand-colouring; as with the textured papers, the texture of the fabric adds its own dimension to the finished picture. This is on 8×10in material: if you want to stretch the linen on a frame in the conventional manner of a painting, you will do well to use a larger size. Nikon F, 90mm f/2.5 Vivitar Series 1, Ilford XP2, coloured with Veronica Cass Transparent Oils. (FES)

Prints for hand-colouring

Almost any print can be hand-coloured, although, as mentioned above, some media are more willing than others to adhere· to glossy prints. Many hand-colourists prefer rough-textured papers, like those sold by Luminos in the United States or Kentmere in England. Both companies also sell a non-supercoated art paper which is very easy to work in all hand-colouring media. Some hand-colourists hand coat heavy art papers, and others may transfer their photographs onto art paper by means of a colour copy transfer: they have a four-colour copy made, soak it with a solvent – acetone or xylene/toluene – and burnish it down onto the new support.

Most agree that the best prints for colouring are somewhat thin or light, and many feel that the best results are obtained if the image is sepia toned first. Hand-coloured portraits are almost always sepia toned, because sepia matches all skin tones far better than black and white.

The larger the print, the easier it is to do the fine detail, but equally, the more difficult it can be to get even coverage of large areas. Few people are happy working with smaller prints than 8×10in. The most popular sizes are probably 10×12in, 11×14in and 12×16in; or in metric sizes, 24×30cm and 30×40cm.

The surface requires no special preparation, although it must be clean and should be archivally fixed and washed for best results. Marshall's recommend treating paper surfaces which hold colours strongly with their Prepared Medium Solution (PMS). There are also sprays to give papers a 'tooth' which will take colour more easily. The major manufacturers generally supply instructions with their products, and there are videos and specialist books on the subject.

Hand-colouring and permanence

The more adventurous you get with hand-colouring, the more variables you add into the permanence equation. Some hand-colourists are not particularly concerned about the permanence of the original because they copy their work to transparency. Others, who produce images for display, are very concerned with permanence. If you want the best possible permanence it is best to stick to the known colour manufacturers like Marshall's, Veronica Cass and Pébéo, and follow their suggestions scrupulously. Less conventional colouring materials may not be very permanent. Hand-coloured images from the end of the last century still exist, and we know much more about archival permanence now, so with reasonable care new images should last at least as long.

SAUNDERS CAKE BAKERY,
Canterbury

The effects obtainable with Polaroid Sepia depend partly on the colour of the material (which varies according to development time and temperature) and partly on the fact that you are shooting a large-format original in camera: this is rather different from making an enlargement from a smaller format. MPP Micro-Technical Mk VII, 120mm Angulon. (RWH)

SOLDIER

(Almost) naturalistic effects can be obtained with reasonably subtle hand-colouring techniques; what gives this picture away is the gold in the braid which, paradoxically, is more realistic than would be attainable photographically. Pentax SV, Porst 135mm f/1.8, Ilford XP2, printed on Kentmere Art Classic and coloured with Veronica Cass Transparent Oils and Faber-Castell pencils. (FES)

detail, but it is worth adding that airbrushing was popular in the great days of Hollywood and that early *Playboy* nudes were normally heavily airbrushed.

Checking the art shops will often yield ideas for tools. For example, the Colour Shaper from Forsline Starr was a recent introduction at the time of writing. It is made of composite rubber and comes in a variety of shapes, with either soft or firm tips. It can be used in place of cotton buds for applying transparent oils.

Don't expect much advice from either camera stores or art stores on materials or the application of hand-colouring media. The general attitude is that if you do that sort of thing you ought to know how to do it. If you don't, well, they don't either.

The ideal work area is well lit and (with some media) well ventilated: the solvents used with some oil-based media in particular can be rather overwhelming and indeed dangerous. As with toning, lighting should be daylight, daylight fluorescent or blue-dipped incandescent bulb, in order to judge the colours accurately.

It is generally easiest to work at a slight angle: an easel or a free-standing drawing board works well, although a cheap drawing board resting on a table will be adequate for most people. A small work station or trolley with all materials to hand is a blessing: a useful trick (also courtesy of Nora Hernandez) is to use a hairdresser's work trolley.

Tools and the work area

Like the media used for hand-colouring, the tools are also very idiosyncratic. Most hand-colourists who work with oils, alkyds or acrylics agree on cotton buds. For larger areas some use cotton balls, while others use facial tissues to apply the colour. For tiny areas, a little cotton wool on a fine bamboo skewer works well. A trick (courtesy of Nora Hernandez, a leading hand-colourist based in Central California) is to dip the tip of the skewer in rubber cement before winding it with cotton wool. Long-fibre cotton is preferable because it is less likely to leave fibres behind on your work.

Watercolours and dyes are generally applied with brushes, although watercolours which come in tubes can be applied directly; they are very hard to control that way however.

Transparent oils, watercolours and dyes can all be applied with an airbrush. This is one of those tools which can take years to master properly. There are a number of books on the subject, and this is not the place to go into

CHANIA, Crete

To achieve a truly antique effect, under-expose slightly; print fairly light; and sepia tone heavily. Do not worry if there are few or no true blacks, or if the highlights hover on the edge of burning out – this is the way pictures used to be. Nikon F, 35mm f/2.8 PC-Nikkor, Ilford XP2, printed on Ilford Multigrade IV and toned with Fotospeed Sepia. (FES)

◀ **CATS**

Quite small touches of colour are often enough to add consider-able impact to a picture. Nikon F, 15mm f/2.8 Sigma fish-eye, Kodak TMZ P3200 rated at EI 12,500, printed on Ilford Multigrade IV and coloured with Paterson Photocolor dyes. (FES)

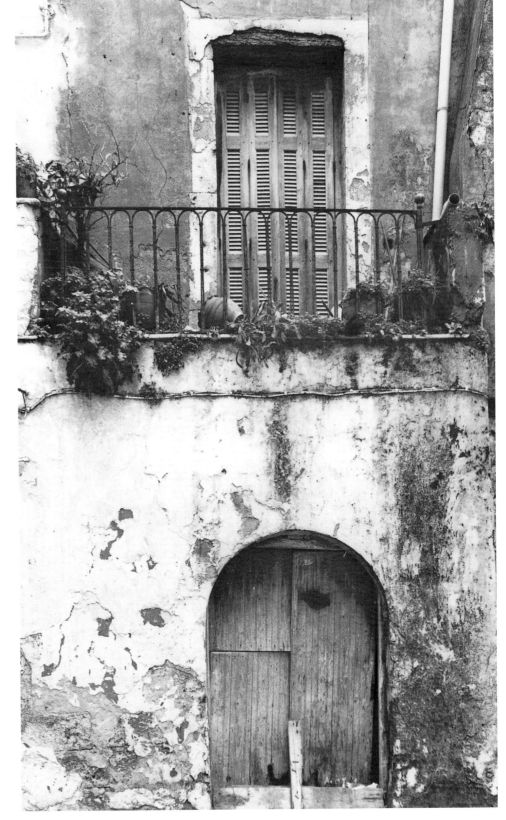

217

AFTERWORD

Photography remains, literally and figuratively, a black art. Literally, because at some point there are pitch-dark rooms involved; and figuratively, because you can never quite tell how something is going to turn out until you try it. The ancient alchemists used to fast before they conducted some of their experiments, or work at certain phases of the moon, or add improbable ingredients to their brews. Photography is somewhat more predictable than this, but sometimes only slightly.

The incantation we must all repeat is, 'If it works for you, it works for you.' Time and again in this book we have pointed out that just because something works for us, it does not necessarily mean it will work for you. We may habitually give a little more development than the manufacturers suggest: others may habitually give a little less. We might prefer a little more contrast; someone else might like a little less. Nothing is therefore right or wrong – everything is, at best, empirical.

What we have tried to do is to give some idea of why things are as they are, and of why some things work and others don't. In other words, we have tried to explain where you are dealing with immutable laws of chemistry and physics, and where you are dealing with choices, opinions and preferences. Of course the two are inter-related, but (for example) the Zone System can be treated on the one hand as little more than a useful vocabulary and summary of procedures, or on the other hand as something very close to a religion. But even if you ignore it completely, you will not be struck dead by a thunderbolt.

This, perhaps, is the most important message we can send. Too many photographers move like weath-er vanes in the winds of influence. They fall under the spell of one photographer and shoot with only a standard lens on 35mm camera, never permitting their images to be cropped – they aspire to capture the human condition. They fall under the influence of another photographer, and work only in large format, photographing what they fondly imagine to be the majesty of nature. Then they fall under the influence of a third photographer, and shoot only portraits against plain white backgrounds.

There is nothing wrong with any of these influences, and perhaps a part of becoming a photographer is to pretend to be Henri Cartier-Bresson for a while, or Ansel Adams, or Richard Avedon. Perhaps, too, the process of becoming a photographer includes working with ultra-high contrast, or grain like popcorn, or available light when there is next to no light available. But in the end, you have to be yourself. You have to do what you must, in the way that you can, in an attempt to get the results that you want. There is, we hope, a good deal in this book which will help you with the technical side of your journey or quest, or whatever you want to call it; but the ultimate answer, the spark which will make you a great photographer or which will at least enable you to take the occasional great photograph, lies within you and nowhere else.

COURTYARD, Teror, Gran Canaria
This picture was profoundly unwilling to print on Ilford Multigrade IV – the fountain under the cross kept blocking up – but when we switched to Sterling, it printed with no difficulty. With another negative, exactly the opposite might be true. Nikon F, 35mm f/2.8 PC-Nikkor, Ilford XP-2. (FES)

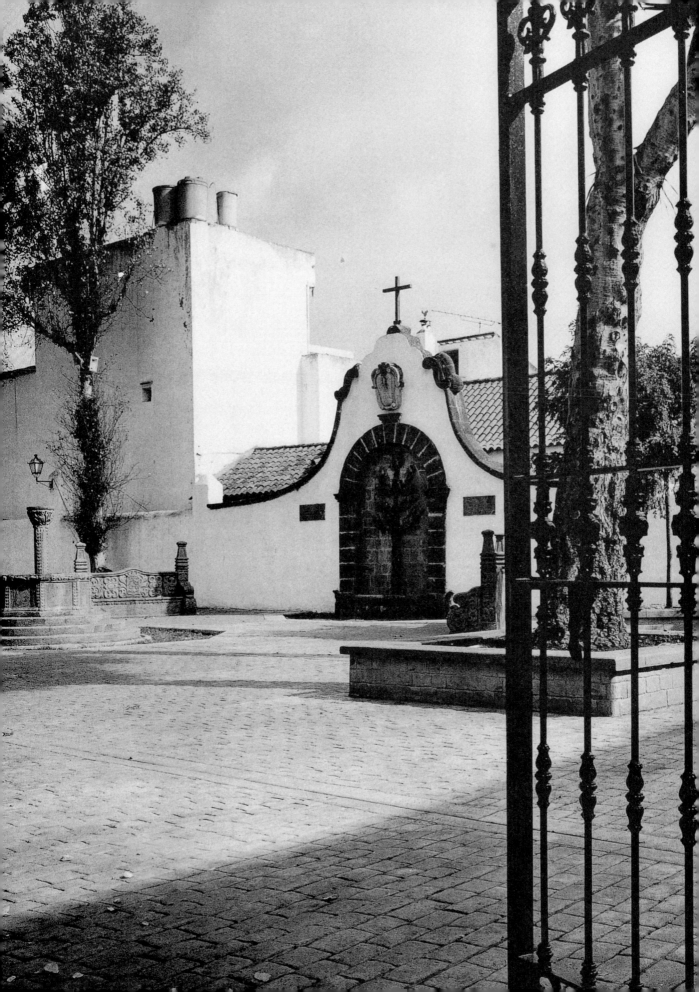

BIBLIOGRAPHY,
MAGAZINES AND THE INTERNET

Below we have listed some of the more useful or interesting books on our shelves. Note that it is by no means essential to buy the latest editions: the basic theory behind monochrome photography has been fairly well established for decades, and the techniques change even less.

Adams, Ansel *The Camera, The Negative* and *The Print* (NEW YORK GRAPHICAL SOCIETY EDITIONS OF 1981 CONSULTED).
Majestic yet very accessible. Do not read any other books about the Zone System before reading these – they are the original and the best. In fact, anything by Ansel Adams is worth reading, whether for information or inspiration.

Blacklow, Laura *New Dimensions in Photo-Imaging* (FOCAL PRESS, LONDON, 1995).
Plenty of useful information on 'alternative' processes, but written in an excruciating American-academic style and assumes absolutely no common sense on the part of the reader. An excellent book if you can stand the writing style; one of us can, the other can't. Beware of low-flying fine artists.

British Journal of Photography almanacs (1859–1963).
For more than a century these summarised progress, gave formulae, showcased photography, and were an indispensable annual purchase for all serious photographers. In 1963 the overall design and approach changed, and the books contained far less information. Early almanacs can be very expensive: we have a straight run only from the 1920s onwards.

Carroll, B.H., Hubbard, D., and Kretschman, C.M. *The Photographic Emulsion* (THE FOCAL PRESS, LONDON AND NEW YORK).
A collection of facsimile papers from 1927 to 1934, with a vast amount of the basic theory in it. Published as part of the Focal Library Classics series in perhaps the 1970s.

Child Bayley, R. *Photographic Enlarging* (ILIFFE & SONS, LONDON, SECOND EDITION OF 1913).
Of interest mainly to those who want to replicate the effects of times past.

Croy, Dr O.R. *The Complete Art of Printing and Enlarging* (THE FOCAL PRESS, LONDON AND NEW YORK, 3RD EDITION OF 1976 CONSULTED).
A basic book, inevitably somewhat dated in style and illustration, but still excellent.

Focal Press *The Focal Encyclopedia* (THE FOCAL PRESS, DESK EDITION 1969).
Older editions of *The Focal Encyclopedia* are more highly regarded by some photographers than newer ones; but as this older one contains all the information we normally want, we have never even bothered to look at a new one. At least one edition is a 'must-have' for all serious photographers.

Hepworth. T.C. *Photography for Amateurs* (CASSELL & CO, LONDON, 1884).
An excellent insight into the effort and expense of photography in the mid-to-late nineteenth century. Tells the reader (among many other things) how to make gelatine emulsion for coating plates.

The Ilford Manual of Photography (THE BRITTANIA WORKS COMPANY LTD/ILFORD LTD).
From the original edition by C.H. Bothamley in the nineteenth century to the last edition in about 1970, this is a wonderfully informative book about the current state of the photographic art at the time when each edition was written.

Jacobson, C.I., and Mannheim, L.A. *Enlarging*
(THE FOCAL PRESS, LONDON, 22ND EDITION OF 1975 CONSULTED – FIRST EDITION DECEMBER 1939).
Probably the ultimate book of theory, but of limited inspirational value.

John, D.H., and Field, G.T.J. *A Textbook of Photographic Chemistry* (CHAPMAN & HALL, LONDON, 1963).
As its name suggests a book for students, with a sometimes surprising mixture of basics and advanced theory.

Johnson, Robert *The Art of Retouching and Improving Negatives and Prints* (AMERICAN PHOTOGRAPHIC PUBLISHING CO, BOSTON, 14TH EDITION, REVISED AND ENLARGED BY ARTHUR HAMMOND FRPS, 1944).
A rigorous text on traditional hand-work.

Larry Bartlett's Black and White Printing Workshop, **text by John Tarrant** (FOUNTAIN PRESS, LONDON, 1996).
A superb collection of worked examples, although hardly a general text. The late Larry Bartlett was a superb printer and this shows how he approached several photographers' negatives.

L. P. Clerc's Photography Theory and Practice, **revised by L.A. Mannheim, edited by D.A. Spencer, 4 vols** (THE FOCAL PRESS, LONDON AND NEW YORK, 'COMPLETELY REVISED' EDITION OF 1970).
The last of the great individual encyclopedists, Clerc's work was first published as early as 1930. Strongly opinionated, occasionally flatly wrong, it is still nevertheless a magnificent work.

Mortensen, William *The New Projection Control*
(CAMERA CRAFT PUBLISHING, SAN FRANCISCO, 1942).
Despite his opinionated and eccentric approach, Mortensen remains a great teacher.

Rudman, Tim *The Photographer's Master Printing Course* (MITCHELL BEAZLEY, 1994).
An excellent book, written in a friendly and easy-to-read style.

Schaub, Grace and George *The Official Marshall's Handcoloring Guide and Gallery* (JOHN G. MARSHALL COMPANY, A DIVISION OF BRANDESS/KALT/AETNA GROUP INC, 1994).
Exactly what its name suggests: a good guide to colouring with oils.

White, Laurie *Infra-red Photography Handbook*
(AMHERST MEDIA INC, NEW YORK, 1996).
Probably the best general book on IR photography.

MAGAZINES
If you are interested in darkroom matters in general, and in monochrome in particular, you may also find it useful to read some of the magazines for which we write and to which we subscribe. Letters to the editor or publisher, mentioning this book, may (although we cannot guarantee it) elicit sample copies.

The British Journal of Photography, WEEKLY, Timothy Benn Publishing, 39 Earlham Street, Covent Garden, London WC2H 9LD.

Darkroom User, (UK, subscription only – no news-stand sales), Foto Format Publications, PO Box 4, Machynlleth, Powys SY20 8WB.

Maximum Monochrome, (USA) NEWSLETTER, MDMuir Publications, 1006 S. 74 Plaza, Omaha, NE 68114.

Schwarzweiss, (Germany), QUARTERLY, Umschau Zeitschriftenverlag, Breidenstein GmbH, Stuttgarter Straße 18–24, 60329 Frankfurt am Main, Postfach 110262, 90037 Frankfurt am Main, Germany.

Shutterbug, (USA), MONTHLY, 5211 South Washington Avenue, Titusville, FL 32780.

View Camera, (USA), BI-MONTHLY, Steve Simmons Inc., 1400 S. Street, Suite 200, Sacramento, CA 95814.

COMPUSERVE
You may find Compuserve's photoforum (Go Photofourm) useful; we may be contacted via the forum, as may Ed Buziak, editor of *Darkroom User;* Bob Shell, editor of *Shutterbug;* and Maxim Muir, editor of *Maximum Monochrome.*

INDEX